USING YOUR
CAMERA

USING YOUR CAMERA

GEORGE SCHAUB

AMPHOTO
An Imprint of Watson-Guptill Publications/New York

George Schaub is the editorial director at PTN Publishing
Company, which specializes in photographic trade magazines. He
is also the former executive editor of *Popular Photography*. The
author of AMPHOTO's *Professional Techniques for the Wedding
Photographer* and *Shooting for Stock*, Schaub lives with his wife,
Grace, in Sea Cliff, New York.

The photographs in this book were taken exclusively by my wife,
Grace, and myself. Without Grace's keen eye and sense of color and
light, this project would have been overwhelming, and I thank her for
her time, energy, understanding, and patience.

I would also like to thank Canon, Eastman Kodak, Minolta, Nikon,
Olympus, and other manufacturers for their kind permission to use some
of the technical art and diagrams appearing in this book.

Edited by Robin Simmen
Graphic Production by Ellen Greene

Copyright © 1990 by George Schaub
First published 1990 in New York by AMPHOTO,
an imprint of Watson-Guptill Publications,
a division of Billboard Publications, Inc.,
1515 Broadway, New York, NY 10036

Library of Congress Cataloging in Publication Data
Schaub, George.
 Using your camera.
 Includes index.
 1. 35mm cameras—Handbooks, manuals, etc.
 2. Photography—Handbooks, manuals, etc. I. Title.
 TR262.S33 1989 770'.28'22 89-5352
 ISBN 0-8174-6350-X
 ISBN 0-8174-6351-8 (pbk.)

Manufactured in Singapore

1 2 3 4 5 6 7 8 9 / 98 97 96 95 94 93 92 91 90

To my father, who lent me his craft,
and
To Grace, always

CONTENTS

INTRODUCTION

In many ways, the study of photography can seem intimidating to anyone who shies away from theories, numbers, and scientific principles. But, in my view, a theory never took a great picture, and so any attempt at teaching photography should emphasize, instead, the practice of the craft. Theories and principles, interesting as they are, needn't get in the way of good pictures. Still, you must have an appreciation of how photography works, of how light and film interact, in order to become a better photographer. In a way, this book reflects the philosophy of the "science for poets" courses offered in colleges, explaining sometimes intimidating principles, as well as what goes into making photography work, without burdening you with an armload of theories and charts.

Once you begin to explore photography, you'll soon appreciate its unique blend of science and art. Its scientific aspect, which includes the application of the principles of optics, physics, and electrochemical reactions, has recently seen the incorporation of memory chips and minicomputers into even the most "basic" single-lens-reflex (SLR) camera. The artistic aspect of photography comes, of course, from the person whose eye interprets the world through the viewfinder. In many ways, the combination is both appealing and challenging, as it allows you a certain freedom in a technological world, and a sense of order in your own form of self-expression.

Photography brings people together with machines that can freeze moments in time and preserve them. These moments can provide an excellent way for you to understand yourself and the world around you. The challenge, then, is to understand enough of the science to be able to apply it to the art. By "art" I don't mean the work that is hung on the walls of museums. To me, art is a re-creation, a way of taking some time out from being merely a productive unit, and appreciating the world. It is also a way of questioning and changing our lives and the way we organize our society.

In many ways, photography is well-equipped for these tasks, as it affords a practical and easy way to inventory your physical and emotional world. It gives you the freedom to examine, at leisure, those fleeting moments of your life captured on film. It also provides a vehicle for recording your instinctive visual reactions to the ongoing rush of energy, motion, and light that surrounds you.

It is said that photographers are merely frustrated painters, that if they could draw they'd be spending time with canvas and brush, rather than film and cameras. This might be the case for some photographers, and it is true that photography, like painting, can inspire a truly contemplative study of the world. But picture-taking differs from all the other visual arts, in that a photographically produced picture is made in a fraction of a second, and can capture expressions and light that are often gone in the blink of an eye. Photography's amazing ability to record, or "grab," instants has changed our perspective. Some say it has even changed history. In any case, it is a form of magic that is unique to modern times.

From the outside, a modern camera is nothing more than a light-tight box with various metal, plastic, and glass attachments and appendages. But inside, it contains a complex mass of gears, motors, electrical circuits, microchips, and light-sensitive cells, all of which serve one purpose: to capture light on the recording medium of film.

It might be argued that, with all this technology available to everyone, there's no longer any need for learning the principles of photography. This may be true for those who take only the occasional snapshot, but, once you begin to see photography as a personal matter, understanding the basic concepts involved makes more sense. As you develop your eye, and occasionally encounter the frustration that follows a failed effort, you'll find yourself wanting to bring some concrete knowledge of picture-taking into play.

An investment in an SLR camera is often a decision to learn more about the craft: rather than allowing an automated SLR to make all the decisions, the photographer begins to fine-tune the shutter, aperture, and other controls that add a personal touch to every shot. Complex automatic features, such as autoexposure and autofocus, have made photography easier and more responsive than ever before, but these systems require some understanding before they can be properly used. However, the intricacies of electronics and microcomputers are less important than understanding what happens when you use them—just enough to turn these automated features into servants, instead of masters.

Getting started with an SLR can seem a major task, because of modes, overrides, program shifts, and hosts of dials and pushbuttons to operate. Though

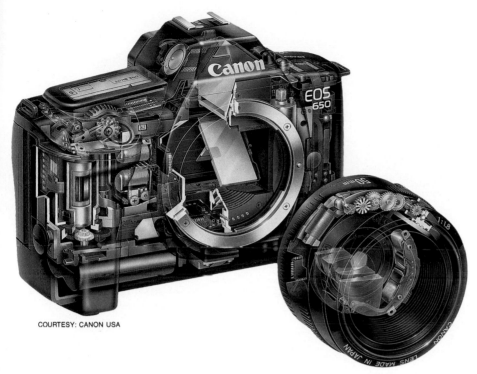

COURTESY: CANON USA

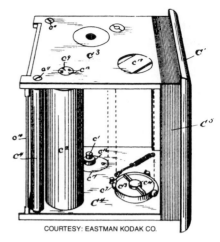

COURTESY: EASTMAN KODAK CO.

The sketch above shows part of the patent papers for the first Kodak camera of 1888. Nearly 100 years later, the modern 35mm SLR, shown on the left, is a highly complex instrument using microprocessors, internal motors, and sophisticated range sensors. The transition from the purely mechanical to the totally electronic took many years of technological evolution.

the jargon and hardware may seem overwhelming, what you're actually faced with are some very basic principles dressed in elaborate, high-tech clothing. In truth, these principles have remained the same for about the last 150 years; however, now we have cameras and film that are faster and easier to use than ever before, and circuits, microchips, autofocusing detectors, and sophisticated meters that perform tasks previously done by hand and eye.

A SHORT HISTORY

Today's cameras are evolved from an instrument called a **CAMERA OBSCURA**, a device that, centuries before the first photograph was made, allowed artists to trace and sketch from nature. This "dark chamber" came in many sizes; essentially it was a light-tight room or enclosure with a lens or small opening on one wall that allowed in light and subsequently formed an image on the opposite wall.

In the mid 1700s, a handy little camera obscura that could be used as a tabletop sketching aid was

devised. It had a **REFLEX** or mirror reflecting viewing system, so that when light traveled through the lens in the front, it was reflected by a mirror up to a translucent glass sheet set in the top of the box, which served as the **GROUNDGLASS** on which an artist could trace or sketch. This arrangement is similar to that used in today's 35mm cameras.

The photography we know today was invented in the early nineteenth century, although all the components—the camera, lens, and even photo-sensitive materials—had been around for many years. Modern photography was a convergence of many principles of science, put into use by people whose research and study was directed toward the possibility of fixing an image from nature onto paper.

It had already been found that certain silver-salt compounds would change when struck by light. In fact, some researchers had actually made images by blocking some parts of sensitized supports to light and allowing light to strike other parts. However, when the silver salt image was brought into a stronger light, it would fade because the areas that had not

INTRODUCTION

Before the invention of photography, artists used a tabletop sketching aid that had a "reflex," or mirror-reflecting, viewing system. When light traveled through the lens, it reflected off an internal mirror to a viewing glass on top of the box, which the artist used as a guide to sketching or tracing scenes from nature. This design was similar to the viewing system in today's SLR camera.

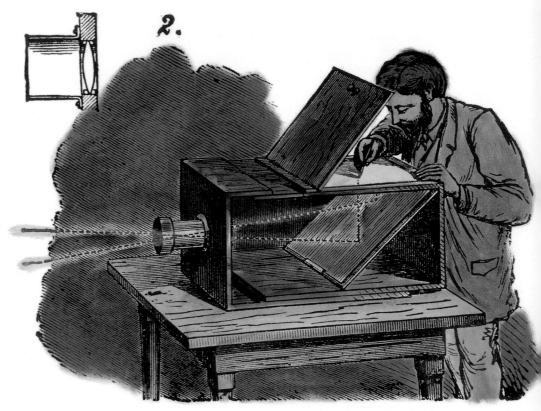

COLLECTION: LILA DE LELLIS. HAND COLORING: GEORGE SCHAUB

Although today's photographic materials last a long time, an image can fade or discolor over time, especially if it is improperly processed or stored. In this print, made around 1910, you can see the loss of detail and the "tarnishing" of the silver itself. In all likelihood, this print was improperly fixed or washed during processing and/or stored in less than optimal conditions.

COLLECTION: GEORGE SCHAUB

been exposed to light began to react and their silver salts would turn completely black. It was only with the discovery of a chemical called **HYPO** that today's photography became possible. This solution made the image impervious to further light action by removing the unexposed silver salts so the relationship of light and dark tones, set up when the image was made, remained the same. Once the process for making pictures from nature in a camera obscura became widely known, it became possible for a new breed of people, called photographers, to begin to "draw with light."

The first film on which images could be recorded was made of light-sensitive silver salts coated on paper, known as a **PAPER NEGATIVE**. It was called a negative because the tones, or light values of the original scene, were reversed: a bright part of the scene would blacken a greater amount of silver, and this would appear dark on the negative; a dark portion of the original scene would cause less change in the silver salts, and would show up as gray, or near-white in the negative. Positive prints, those that resembled the real tones of nature, were made by sandwiching a negative face down against an unexposed sheet of sensitized paper and exposing the sandwich to light. In this process, the tones on the negative would reverse to make a positive. The process needed the help of certain chemicals to turn the silver salts into tones that could be seen by the naked eye. Virtually hundreds of developers and

special chemicals were explored by early photo-pioneers. Many of these researchers risked their lives, and certainly their health, in coming up with the right combination of developer and fixing baths.

The same explorations preceded the perfection of the **FILM**, or sensitized materials. The paper negative first used soon proved to be impractical, since the fiber of the paper would appear in the picture, often obscuring details in the final print. The quest for better quality film **EMULSIONS**, or coatings of sensitive material, and supports—glass was popular for most of the nineteenth century—led to today's plastic-based films.

Modern films still use silver compounds, called **SILVER-HALIDES**, as their light-sensitive material. When exposed to light, these microscopic halides, or crystals, form a **LATENT IMAGE**. When the film is developed, these crystals are amplified to form the negative image, which is then projected onto light-sensitive paper to make positive paper prints.

Those microscopic clumps of silver-halide crystals are also called **GRAINS**; their size determines how sensitive a film is to light. The larger the grains are, the "faster," or the more sensitive, the emulsion. Early photographic emulsions were very slow, compared to today's. This meant that a long exposure time was necessary to record an image on film. Some early films took minutes to get an image; by comparison, the films we call "slow" today can produce a similar image in as fast as ½₅₀ sec.

Grain is the manifestation of groups of microscopic crystals, and the larger the grain, the faster (or more sensitive to light) the film. This enlarged section was printed from a fast ISO 1000 color film.

INTRODUCTION

A PERSONAL APPROACH

All the parts of a picture-taking team—lens, camera, shutter, aperture, and film—make an important contribution to both the technical and creative aspects of photography. Each one brings in another variable, another way to make subtle or obvious changes in the way your pictures will come out. Though one part may play a dominant role in a particular picture, all are designed to work together. Learning about photography, then, is learning about the fundamentals of each of these elements. Of course, the key element is **YOU**—the way you "see" and think about your pictures. So, as you read, apply the discussions to **YOUR** camera and **YOUR** need for practical advice.

First, however, I'd like to tell you something about my relationship with this craft. After nearly twenty years of steady work and study in this field, photography remains a magical and fascinating part of my life. I've come to realize that I continue to learn, not only about tools and techniques but also about myself. Photography has also given me an appreciation of light, form, and motion—gifts that stay with me when I don't have a camera in hand.

Photography is an involving process, not a passive medium, and, as such, it continually calls for my interaction with the world. It has taken me to places I would never have visited otherwise and introduced me to people I might never have met. I have come to know it as a vehicle for self-expression, as well as a way to keep a diary of my life and hold close the memory of those people, places, and moments that are important to me. Photography is a wonderful way to understand the world—and a lot of fun. It provides infinite possibilities, and there seems to be no end to the experimentation, study, and deep enjoyment it offers me year after year. It seems to grow with me.

My goal here is to help you break through the confusion and introduce you to the pleasures and wonders of this craft. I want to clear away some of the jargon and give you a working understanding of photography, so that you can make good pictures with any SLR. It is great when film, light, and exposure create a strong picture by accident. But it is even better when you can do it time after time, when you have some degree of control.

Making effective pictures takes experience, "seeing," and a sense of what you're trying to say. Making **GREAT** pictures means all that, plus a vivid application of technique. In order to get an idea of what goes into acquiring this technique, I will explain the anatomy of an SLR and explore its many parts, discussing how the principles of focus and exposure are applied in today's automatic cameras. I will show you how to put your knowledge to use and to see how your personal decisions—the ways in which you can override automation—can have a major impact on what comes out on the film. And remember, when capturing moments in time on film, keep the miraculous in mind.

The techniques you choose to work with are the ways in which you communicate your point of view. Photography is a way of capturing light and holding a moment of time. Although light can be elusive, and you may not be able to always reproduce on film what you felt when you snapped the shutter, a knowledge of technique can go a long way in helping you capture the emotions and quality of light that originally inspired you to take the picture.

35MM EQUIPMENT AND FILM

THE CAMERA COMPONENTS

THE MODERN 35MM single-lens-reflex, or SLR, camera is a highly sophisticated instrument. It contains complex circuitry, miniature motors, and microchips capable of making decisions based on preprogrammed memories that react to instantaneous changes in light and focus. Today's camera bodies have the "brains" that perform exposure—and in some cases, focusing—calculations. They also handle the more mundane, but no less important, functions of providing a light-tight chamber for film, a mechanism for film advance and rewind, a place for the shutter, and a mount on which to place the lens. Think of an SLR body as a control center from which you can exercise any number of options to influence the way a picture is made. By **PROGRAMMING**, or alerting the automatic features of a camera to your wishes, you can use it as a fully automatic, spontaneous picture-making machine that still allows you to shoot with a personal touch. You also can use it "manually," making decisions based on the information the camera and your instincts provide.

First, you need to understand what those three letters "SLR" mean. A **SINGLE-LENS-REFLEX CAMERA** uses one viewing lens for focusing and capturing light. In contrast, the **RANGEFINDER CAMERA**, which also takes 35mm film, has a separate viewfinder that approximates the view of the lens in use, but is not directly connected with the light path from the subject to the viewing screen.

REFLEX refers to the way light travels from the subject to the viewfinder. In SLRs, light comes in through the lens and is reflected up by a mirror to a focusing screen that is found just below the camera viewfinder. A groundglass is located at the base of a box of mirrors, known as a **PENTAPRISM**. What you see when you look into the camera is a corrected view of the scene made by a double set of mirrored surfaces in the housing. Without this setup, you would see an upside-down image in the viewfinder.

In addition to these components, all 35mm SLR bodies share certain features and functions. These include a viewfinder, film chamber, pressure plate, film-takeup spool, film-advance mechanism, film-rewind function, shutter, shutter release, as well as a coupling device for attaching a lens. Depending on the individual camera, a number of other dials, switches, pushbuttons, and displays give control over picture-making decisions.

When you first pick up a camera, you're confronted with a thin, rectangular body made of plastic, metal, or a combination of the two. On the front of the body is an opening usually surrounded by a circular metal ring. This is the **LENS-MOUNTING FLANGE** that allows you to **COUPLE**, or mount, any number of interchangeable lenses to the body. This ring usually contains contact points or pins; these link the "brains" of the camera with the lens itself.

Every brand of camera has a distinct mounting system. This means that you must use a lens specifically designed for that particular camera, one made by the camera company itself or an independent lens manufacturer. Using an incompatible lens is impossible because it simply will not mount on the camera body.

Camera makers often change the coupling system when they bring out new camera models, making older lenses obsolete. While some older lenses from a manufacturer will fit on its new camera models, they may not be able to communicate with the camera itself. Also, lenses for manual-focus cameras often

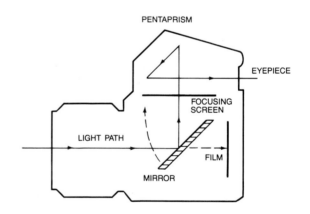

The viewing and exposure system in an SLR moves light in a number of ways. After light comes through the lens, it is first reflected off the camera's mirror to form an image of the subject on a horizontal focusing screen. The light is then bounced back and forth between the mirrors of the pentaprism, the housing atop the camera. These mirrors correct the image so it is right-reading. When the exposure button is pressed, the mirror flips up and out of the way, the viewing screen goes blank, and the film is exposed. Once the exposure is complete, the mirror returns to its original position.

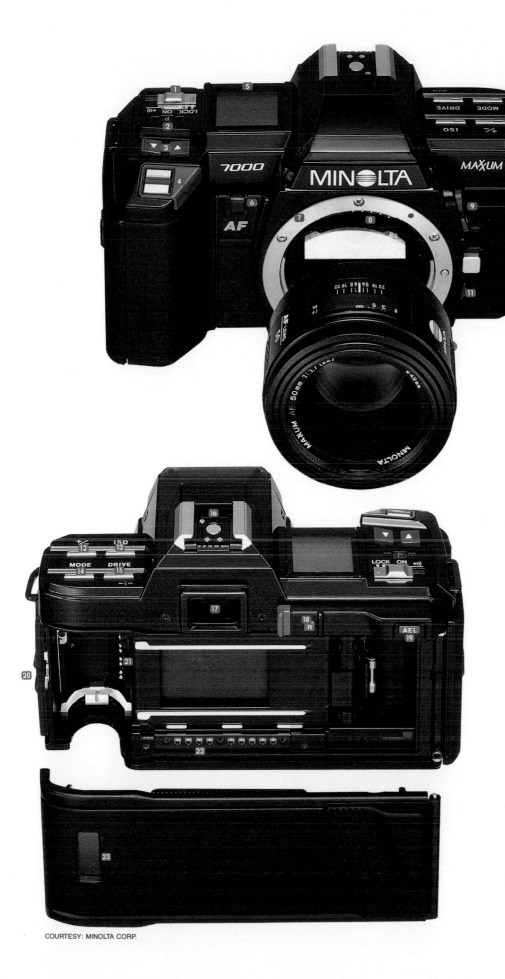

COURTESY: MINOLTA CORP.

Though SLRs vary from model to model, many have the features shown on this camera, an autofocusing electronically controlled SLR:

1. On-off button
2. Reset button
3. Shutter-speed keys
4. Shutter-release button
5. LCD panel
6. Self-timer LED
7. Mounting ring
8. Lens contacts
9. Aperture keys
10. Remote-control terminal
11. Focus-mode switch
12. +/– key
13. ISO setting
14. Mode selector
15. Drive key
16. Hot shoe
17. Eyepiece
18. Rewind switch and release
19. Autoexposure lock
20. Back-cover release
21. DX contacts
22. Accessory back contacts
23. Film-type window

will not function on the autofocusing counterparts of the same brand. Before you purchase a lens, therefore, always make sure it is compatible with your camera.

In order to mount and disengage the lens, you must first push a lens-release button, which is usually located beside the lens on the lower left-hand side of the camera body. This releases any mechanical linkage between the camera and lens.

Before you mount your lens, however, look inside the front, or **THROAT**, of the camera. The first object you'll see is a **MIRROR** angled at 45 degrees; this reflects light coming through the lens onto the viewing screen and/or metering cell in the camera pentaprism. When you take a picture, this mirror snaps up and out of the way. This is the source of the characteristic "clunking" sound of an SLR and allows the light to pass onto the film that sits by the opened shutter directly behind the mirror assembly.

The throat also contains a number of black-coated **BAFFLES** and light-insulating materials. These seal the film, protecting it from light when the mirror is down, and allow you to change the lens even when film is in the camera. Never tamper with these delicate casings; you might disturb their light-blocking qualities.

After you inspect these parts, mount a lens on the camera and take a look through the **VIEWFINDER**. This allows you to see the same picture that will be recorded on film, usually minus about 3 to 5 percent at the edges. Today's viewfinders also serve as information-display centers, where a host of numbers, colored dots, lightning-bolt symbols, and blinking **LIGHT-EMITTING DIODES**, or LEDs, tell you about light levels, shutter speeds and apertures, exposure-mode selection, and, in autofocusing cameras, focus confirmation. The amount and type of information displayed varies from camera to camera. In short, viewfinders allow for complete control of the camera without the need for you to remove your eye from the finder.

The viewfinder's pentaprism housing also contains a **METERING CELL**, which cannot be seen. A few cameras have the metering cell located below the mirror in the camera; some have cells in both locations. This light-measuring instrument provides the data that the camera then translates to aperture and shutter-speed settings.

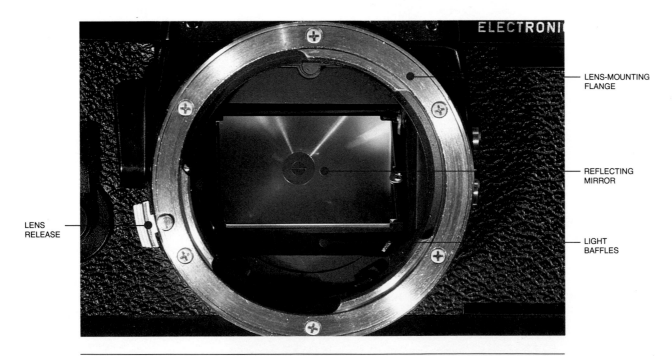

This inside view of the front of an SLR body without a lens shows the light baffles, reflecting mirror, and some of the mechanical and electronic linkages many of today's cameras use to pass information from camera to lens and back again. Each camera system has its own mounting system, so you must use compatible lenses or you simply won't get a proper fit.

Many SLRs also come with interchangeable **FOCUSING SCREENS**. A focusing screen is the glass on which the image appears when you look through the viewfinder. Some screens have a split-image range-finder in the center, surrounded by a **MICROPRISM COLLAR**, all of which is surrounded by a matte groundglass. The split in the circle is a critical focusing aid. When subjects are out of focus, lines or shapes on either side of the split in the circle do not align; when the subject is in focus, they do. The microprism is composed of many prisms of glass that break up the surfaces within a scene, making it easier to focus, especially in dim light.

Focusing screens in autofocusing cameras contain rectangular brackets, located in the center of the frame. This is the autofocusing target: the camera will attempt to focus on any subject within this area. The location of the target can create a problem when you are composing with the main subject out of the center of the frame. In some cases, the autofocus system will give you incorrect readings unless you modify your focusing technique with the aid of an **AUTOFOCUS-LOCK BUTTON** (see page 26).

The next features you should be familiar with are located on the top plate of a modern SLR. This plate has, in addition to the **ON-OFF BUTTON** (sometimes incorporated in the shutter-release), a number of dials and buttons that are used to "program" the camera. Some SLRs have conventional dials with engraved numbers; others have pushbuttons and switches that read out on liquid-crystal displays, or **LCDS**. Both types perform the same functions; the LCDs just add a bit of high-tech window dressing. The **LCD PANEL** is the information center for choosing and confirming different programs and is a checkpoint on camera-operating systems. Some of the information the LCD shows may also be seen in the camera viewfinder; however, in order to minimize distractions in the finder, most camera makers put all the information on the LCD. Some pushbutton or toggle controls on modern SLRs have multiple uses, and the LCD panel indicates which function has been selected by the way it lights up. A **RESET BUTTON**, found on some SLRs is the escape switch that lets you cancel any mode other than the "normal" operations you may have set on the camera; pressing the reset button returns the camera to fully automatic operation.

The **CAMERA BACK** is hinged to the body and opens when you release the **SAFETY-CATCH BUTTON** or lift the

Located on the inside back of the camera, the pressure plate keeps the film flat as it passes from the cassette to the takeup spool. If dust or grit accumulates on this plate, blow it off with pressurized air or whisk it away with a soft brush.

REWIND CRANK with a decisive tug. Professional-style SLRs have completely removable backs, allowing you to replace them with a data back that allows for the imprinting of the date and time on the film or a long-roll film back that can hold up to 250-exposure-length films. Other camera backs work as inter-valometers; that is, they program the shutter to fire over a fixed sequence of time. In the future, these backs will interface with computers and other electronic devices.

Looking inside the camera back, on the left-hand side of the film chamber, you may see a set of gold-plated pins. These are the **DX-CODE-READING CONTACTS**. Nearly every conventional film made today is DX-coded. When you place a roll of film in a camera with DX-reading capability, this code informs the metering system of the **SPEED**, or light sensitivity, of the film in use, and relieves you of the bother of setting the film speed manually. The code is actually a series of black and silver boxes printed on the film cassette. There are two ways of telling if a film is DX-coded: one is the prominent display of the code on the film box and cassette; the other is the presence of an odd checkerboard of squares on the film cartridge. Don't worry if you don't see any DX-code-reading pins in your camera; you can set the ISO code manually on the appropriate dial.

Attached to the camera back is a sort of floating metal plate, called the **PRESSURE PLATE**. Because film has a natural curl to it, more or less emphasized by temperature and humidity, the pressure plate plays the critical role of keeping the film flat as it passes

THE LCD PANEL

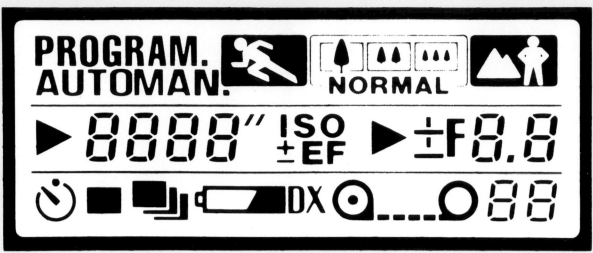

This panel shows all the symbol and number displays this LCD can provide; when it is in use, not all information shows up at once. Starting with the bottom third portion of the LCD, going from left to right, the first display you see is a clock symbol for the self-timer. The black rectangle indicates that you have selected single-frame film-advance mode. The series of black rectangles that follow means that you've chosen continuous film-advance mode. The battery symbol is a battery-check device. When the DX mark stays lit, you have a DX-coded film in the camera.

The first dot-in-a-circle shows that film is loaded; the dotted line confirms that film is advancing through the camera, and the last circular form in the group indicates that you've finished the roll. The last set of numbers is your frame counter.

In the middle tier of this display sits much of the exposure information. On the left side, the delta mark indicates that you have chosen shutter-priority exposure mode. The numbers that follow—shown here by a series of 8s—usually tell you the shutter speed, but the ISO of the film is also displayed here when you are setting it manually. The "B" (for bulb) setting also appears here when you are

shooting long time exposures. The "+ / − EF" mark shows that you have chosen to deviate from the automatic exposure by from 1/3 to 2 or 3 full stops. The ISO mark atop this indicates that you have set the film speed manually, or have overridden the DX-coded speed of the film in the camera. The delta to the right of this indicates that you have chosen to operate in aperture-priority mode. The "+ / −" mark to the right is used to set the exposure compensation on the camera; the numbers next to it read out the degree of compensation that has been set. Next in line is the "F," which indicates the *f*-stop in use on the camera; here it reads "8.8."

The top tier of the readout explains which exposure mode you're in. **PROGRAM** means one of the program modes; **AUTO** means either aperture- or shutter-priority, which is confirmed by one of the deltas on the middle tier. **MAN** shows that you are in manual-exposure mode. The program mode has a number of permutations. For example, the leaning figure to the right indicates program-action mode, in which the camera selects both aperture and shutter speed, but favors a high shutter speed at the expense of a narrow aperture, in the exposure equation. The **NORMAL** sign with the

little trees indicates a "regular" program, an exposure mode where aperture and shutter speed are optimized for general purpose shooting. The big tree means that the camera itself has chosen "program-tele," where the exposure will favor a faster shutter speed over a narrow aperture in exposure calculations, simply because you have a telephoto lens mounted on the camera and the program is set up to prevent camera shake. The two trees mean a "normal-normal" program, where both aperture and shutter speed are given equal weight, for general shooting, and are set by the camera because it "knows" that you have a lens with a moderate focal length—40 to 110mm—mounted on the camera. The three trees indicate "program-wide," which means a narrow aperture (for greater depth of field) is given priority over a fast shutter speed in exposure calculations—yes, the camera knows that you *are* using a wide-angle lens. Finally, the last pictograph of the man and the mountain indicates "Program Depth" mode, in which you bias the program so that a narrower aperture (for greater depth of field) is favored over a fast shutter speed in the exposure calculation regardless of the lens in use.

through the camera. The pressure plate is extremely delicate, so avoid touching it. Any misalignment can cause problems with film flatness, which will adversely affect sharpness in the final image. If any dust or grit lands on the plate, use compressed air and a soft brush to clean it. Be aware that grit left on this plate may scratch the film as it passes.

While you still have the camera back open, inspect the **SHUTTER CURTAIN**, the metal or cloth rectangle that sits squarely in the center of the film channel between the guide rails. When the shutter is released, a set of curtains—a leading and a following curtain—opens and travels across the film plane for a specified period of time. As the light entering the lens then passes through the open shutter, the film is exposed. The length of time in which this happens depends on the shutter speed set by you or the autoexposure system of the camera. The shutter curtain is also quite delicate, so take care never to touch it.

The **SHUTTER** is cocked, or made ready to fire, whenever the film is advanced. The **ADVANCE LEVER** is usually located on the top of the camera body. Motorized-advance cameras have the advance function built right into the **SHUTTER-RELEASE BUTTON**. When you take a picture, a motorized-advance camera automatically brings the next frame of film behind the **SHUTTER GATE**. On manual-advance cameras, the shutter-release button is either near or a part of the advance lever. In these systems, you take a picture, then advance the film, which automatically cocks the shutter. Some cameras allow you to make double-exposures on the same frame of film by providing a switch or electronic command device that enables you to disengage the advance from the shutter-cocking function. And some motorized-advance cameras feature an option that lets you select either **SINGLE** or **CONTINUOUS ADVANCE**; single means one exposure is made each time you press the shutter-release button, while continuous means that exposures are made one after another as long as you hold your finger down on the shutter release.

Many shutter-release buttons have a threaded opening in which you can screw a **CABLE RELEASE**, a long, flexible pin attached to a plunger, which, when pressed, fires the shutter. This comes in handy when you're making long exposures (it prevents potential camera shake) or when you want to fire the shutter while not actually standing near the camera, such as when you're arranging a still life or posing a subject.

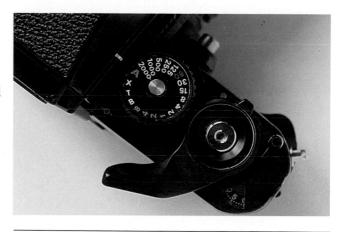

By stroking this lever, you both advance the film to the next frame and cock the shutter in the camera. More and more, the lever is being replaced by pushbutton, motorized film advance.

On this camera, a cable release can be screwed into a threaded opening in the shutter-release button, allowing you to fire the shutter without physically touching the camera. This comes in handy for long time exposures. Electronically controlled cameras have separate cable-release sockets for the same task, although you may be limited to using only the release specially made for your camera.

Radio-remote cable releases, with electronic transmitters that can trip the shutter from as far as 40 feet away, are also available.

Many SLRs have what is known as a "two-stage" shutter-release button. Light pressure on the button may, depending on the model camera, fulfill a number of tasks: it may switch on the metering system, start the search of the autofocusing system, "lock" the focus or the exposure, or even turn on the entire operating system of the camera itself. Applying additional pressure to this button releases the shutter to expose the film.

The **ISO DIAL**—or pushbutton—on top of the camera allows you to input the speed of the film in use. This essential information serves as the basis for the exposure data recommended by the metering system. For example, given identical lighting conditions, an ISO 100 film needs more light for correct exposure than an ISO 400 film. If the camera's operating system cannot tell which film is in the camera, it has no way of making a decision as to what specific aperture and shutter speed should be set for a correct exposure. As mentioned earlier, cameras with DX-code-reading pins make this setting automatically.

The **SHUTTER-SPEED INPUT DIAL**—or pushbuttons—lets you select a specific shutter speed. On most cameras, shutter speeds work in steps that halve the time of each succeeding speed. A typical range of shutter speeds includes: 1, ½, ¼, ⅛, 1/15, 1/30, 1/60, and so forth, up to 1/2000 sec. (You'll notice that fractions of a second are expressed as whole figures on the shutter-speed dial or LCD readout; for example, 1/30 sec. is expressed as "30." Often, numbers below 1 sec. on speed dials are marked in another color; in LCDs, either the fractional value or a coded symbol gives a clear indication of what speed is in use.) Each

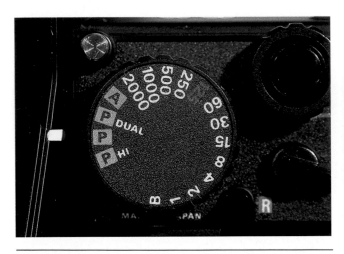

The shutter-speed dial and program-mode selector on this camera are combined. Shutter speeds range from 1 to 1/2000 sec. and Bulb. Synchronization speed (the shutter speed that you set when shooting flash) is 1/125 sec., marked in red. The programmed or autoexposure modes available are: "A" for aperture priority (you choose the aperture and the camera selects the shutter speed); "P-Dual" for dual program—the camera selects both aperture and shutter speed, but when wide-angle lenses are mounted on the camera, it favors a smaller aperture and thus selects slower speeds, and when a telephoto lens is mounted it sets a fast shutter speed and a wider aperture setting, which will prevent blurred exposures due to camera shake; "P" for program—the camera selects both aperture and shutter speed for correct exposure based on a pre-programmed balance of the two; and "P-Hi" for high shutter speed program—the camera selects a high shutter speed re-gardless of the lens on the camera, then aperture is selected. Each of these programs offers you a way to personalize exposures without losing automation.

successively higher speed allows half as much light to enter as the speed that preceded it; or, conversely, a one-stop decrease in the shutter speed allows in twice as much light. The most commonly used shutter speeds range between ⅟30 sec. and ⅟250 sec., although there are many times when faster or slower speeds are used. For example, a 1 sec. exposure time could be used to make a picture at night, while ⅟2000 sec. could be used to freeze an athlete's quick moves.

One other symbol you may see on the shutter-speed dial is a red "X," or one of the numbers in the ⅟60 sec. to ⅟250 sec. range marked in red. This is the FLASH-SYNCHRONIZATION SPEED, which is set whenever you use an electronic flash. This setting is much less common today because DEDICATED flashes automatically set up the camera's operating systems to shoot at "sync" speed. These flash units work in concert with the camera to automatically calculate the amount of flash necessary for correct exposure. All of this is done in the time it takes to push the shutter-release button.

The flat piece of metal with two guides on top of the camera pentaprism is the HOT SHOE, the mount and electrical contact for an auxiliary electronic flash.

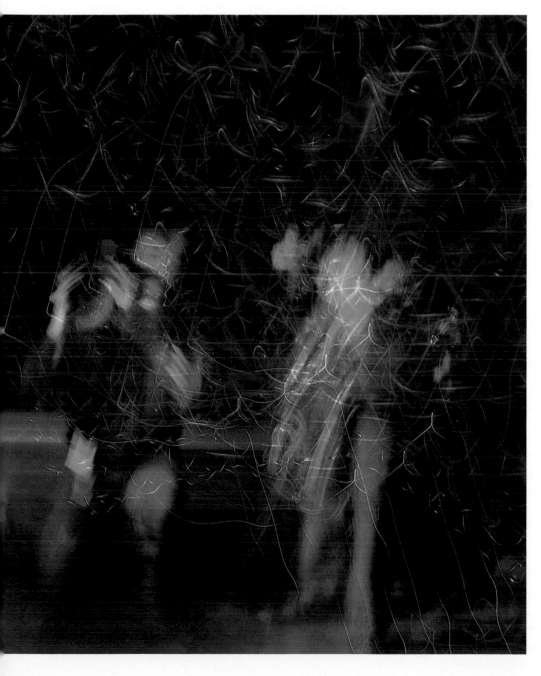

Some interesting effects can be obtained with long exposures, particularly if you have subjects that move while the picture is being made. This picture, shot inside a darkened room around which laser lights were playing, was made in aperture-priority mode set at *f*/5.6; the shutter stayed open for about four seconds.

THE CAMERA COMPONENTS

A metal disc within the guides is the contact point for the pin on the base of the "shoe" of the flash. When the shutter is released, an electrical charge moves through the contact point to the pin to trigger the flash.

Another feature is the **EXPOSURE-COMPENSATION DIAL**. You can use this dial to override the camera's exposure decisions without having to manually input the shutter and aperture settings. When the dial is set at "0," the exposure is made at whatever settings you or the camera have chosen. At +1, you are adding one extra stop to the exposure; when it is set at −1, you are subtracting one stop from the exposure. Although the autoexposure system usually does a good job, you may wish to calculate the exposure yourself. But when the light is "difficult" (very high in contrast, or coming from odd directions), or when you want to make a creative "mistake," or simply think you have a better idea than the camera does, a biasing dial lets you do this with little fuss.

While many cameras still have conventional controls, on some you can select aperture by using pushbuttons located on the camera itself. Your selection is then fed to the lens, which sets the *f*-stops according to the electronic signals it receives from the camera operating system.

The **EXPOSURE-MODE SELECTOR** is located either on the shutter-speed input dial or as part of a pushbutton system that reads out on the display panel. Choosing an exposure mode tells the camera the way you want it to read aperture and shutter speed to obtain a correct exposure, as well as the particular effect you might want in a picture.

Depending on the camera you're working with, mode options may include **APERTURE-PRIORITY** (AV), **SHUTTER-PRIORITY** (TV), **THROUGH-THE-LENS FLASH** (TTL), **PROGRAM** (P), **PROGRAM TELE**, **PROGRAM WIDE**, and **AUTOEXPOSURE** (AE). Even manually setting aperture and shutter speed is now considered a mode.

You may encounter an autofocusing-mode selector switch on the front of the camera (many focus-mode

The exposure-compensation dial is a great asset when you want to automatically override the autoexposure system of the camera. In this portrait, the camera meter read the overall scene, including the dark background and the red shirt, and although good detail is recorded in the scene, the face is overexposed. The larger picture was made with the camera set on −1 exposure compensation; the resulting exposure used the automatic reading as a foundation, then subtracted 1 stop for a better result. As you shoot, you'll learn when exposure compensation is helpful.

selections are made via pushbuttons, with readouts on the LCD). This selector may give you a choice of **SINGLE** or **SERVO-AUTOFOCUS**, which is also known as **CONTINUOUS**, or **ACTION-PRIORITY** (AF). You can also choose a **MANUAL FOCUSING** mode on autofocus cameras. With single AF, the camera's focusing system seeks out one subject and prevents you from shooting if it can't obtain correct focus. With continuous AF, the camera's focusing system continually adjusts for a subject, refocusing the lens if it moves. Here, you can take a picture even if the camera has not locked onto a specific target. With manual focus you turn off the autofocus system and rotate the lens-focusing collar yourself, and focus according to what you see in the camera's viewfinder. All these modes may sound disconcerting, but keep in mind that they are simply program codes that tell the camera how you want its automation to work.

On the front of the camera body there are a number of pushbuttons and switches. One is the **DEPTH-OF-FIELD PREVIEW BUTTON**, usually located on the right-hand side of the body. When you are focusing or composing, you look at the scene through the widest **APERTURE**, or opening, that the lens has. However, when you take a picture, the lens automatically **STOPS DOWN**, or closes, to the aperture you or the camera has selected. For example, you may have a lens with a maximum aperture of $f/1.4$, but when an exposure is made, the lens stops down to $f/8$, a much smaller opening.

When a lens stops down, it changes the amount of light entering the camera and the way that light is focused upon the film, and the visual effect of $f/8$ is quite different than at $f/1.4$. One way to see what effect aperture has on the picture is to use the depth-of-field preview button before the picture is made. This will give you a clear idea of what the **DEPTH OF FIELD**, or zone of sharpness, will be in your final picture (see page 42).

Another control you may encounter on the front of the camera is the **AUTOEXPOSURE-LOCK BUTTON** (sometimes located in the shutter-release button). In effect,

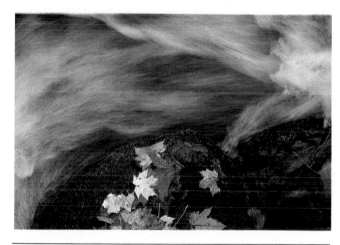

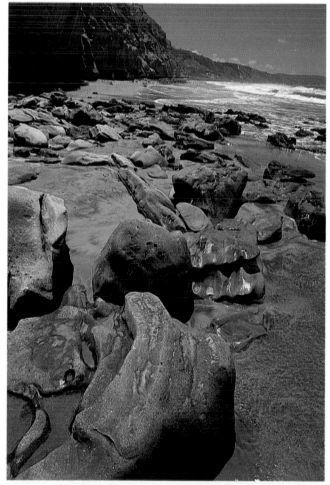

You can use the various autoexposure modes to select the way a scene will be recorded. In aperture- and shutter-priority modes, you select one of the values (aperture or shutter speed, respectively) and the camera automatically sets the other. Shutter-priority mode is useful when you want to choose a certain shutter speed to freeze the action or to shoot at a slow speed to create a sense of motion in a single image. In the picture on the left, shutter-priority mode was chosen and set at a speed of 1/15 sec. This relatively slow speed gave the flowing water a smoother, more continuous sense of motion. Aperture-priority mode is useful when you want to control depth of field, or the zone of sharpness in your picture. You can set the aperture for either a shallow or deep zone of sharpness. In the photo on the right, an aperture of $f/16$ yielded sharpness from near to far.

The autoexposure-lock button comes in handy when you want to override the autoexposure system of the camera but still use the autoexposure function. In this scene, the photo on the left was exposed according to the in-camera meter reading. Though it is a fine rendition of the scene, it lacks the drama of the darker version. To get the second shot, the meter reading was made directly from the bright area and locked in; then the original composition was reframed and shot.

depressing this button freezes the camera on a certain exposure setting and prevents it from altering the setting even if the lighting changes. This comes in handy in contrasty light when you want to expose for the brightest or darkest part of the scene.

An **AUTOFOCUS-LOCK BUTTON** on the camera body or in the shutter-release button works in the same fashion as the autoexposure-lock button, but here you freeze a certain focusing-distance setting, whether or not the camera-to-subject distance changes. When you look into the viewfinder of an autofocus camera, you see a set of brackets in the center of the frame: this is the **AUTOFOCUS-DETECTOR INDICATION**. You must place these brackets "over" the principal subject in order to focus correctly. For occasions when the subject isn't centered, you can still focus on it, lock the focus, and then recompose as you wish.

The base of the camera body has only a few notable features: the rewind button, the tripod socket, and the battery compartment. In addition, some professional cameras have removable plates for motor-drive or power-wind connections. The **REWIND BUTTON** actually releases the forward gear setting in the film advance and allows the film to be pulled backward into the cassette. Motorized rewinds do this

automatically, but in general you still have to engage a rewind switch to get it all going. Some cameras decide all this for you and begin to rewind once the last available frame has been exposed.

The **TRIPOD SOCKET** is a threaded inset that allows you to mount the camera on most tripods and monopods. Tripods come in handy when you want to make exposures longer than 1/30 sec. or to use a long telephoto lens. Without the aid of a steadying device, you will find that shooting at slow shutter speeds—or even moderate speeds with a long lens—can cause camera shake and blurry pictures.

Many SLRs are completely dependent on **BATTERIES**: no power means no pictures. Always keep a fresh set of batteries on hand, and make sure the **CONTACTS**, the metal tabs in the battery compartment, are kept clean. If they become covered with grit, use a soft pencil eraser to remove the deposit. Also, if you don't plan to use your camera for more than a month, remove the batteries to prevent corrosion.

On some cameras, the **BATTERY-CHECK BUTTON** is placed near the on-off switch and should be tested before the camera is used; on others, checking battery power involves turning on the camera and looking through the viewfinder or at the LCD display.

CAMERA MANUFACTURERS' SPECIFICATIONS

When you shop for a camera or read a product report in a photography magazine, you may be confronted with a manufacturer's spec sheet. The following lists common specifications and explains each feature.

Camera Type: *35mm SLR. Electronically controlled systems. Multiple automation.*
This is an SLR that takes 35mm film. "Electronically controlled" means that the shutter, the aperture, and all other control functions are run by microprocessors and battery power. "Multiple automation" means that there are a number of mechanical functions such as film advance, rewind, and exposure modes that are electronically controlled.

Bayonet: *Reflexo-R Type.*
This refers to a specific type of lens-mounting system. Lenses for this type of camera must be compatible or must be adapted.

Lenses: *Over 20 R-Type from 8mm to 800mm.*
This indicates the focal-length range of the various lenses offered by the manufacturer.

Power-Up: *Pressure on the shutter-release button of camera or motor drive; modes selected through push-button; camera shuts down after 12 seconds if not used.*
This explains the process of turning on the camera and selecting operating systems.

Exposure Systems: *TTL ambient and flash. Silicon diode in bottom of lens box. Selective and average metering. Selective field: 8mm. Measured value stored by secondary pressure on release. Average measuring field is center-weighted.*
This spec refers to the way light is measured in the camera system. TTL means through-the-lens metering. The silicon diode is the metering cell, and its location is given. Selective metering means that only a small, central portion of the light entering the lens is measured; average metering means

the light falling over most of the viewfinder screen is measured. The field of selective measurement is a circle with an 8mm diameter, located in the center of the viewfinder screen. This metering system allows more accurate control over difficult-to-read exposures. This measurement is stored during the three-step shutter release: the camera is turned on, the appropriate light value is recorded and kept (even if the light changes), and the picture is taken. A center-weighted measuring field means that, even though light is measured from all parts of the viewfinder screen, the light in the center of the scene is given the greatest consideration when the exposure is calculated.

Measurement Range: *EV 4 to EV 20 in Selective, at ISO 100; EV 1 to EV 20 in Average, at ISO 100.*
This indicates the light meter sensitivity with ISO 100 film for both types of metering patterns. "EV," or exposure value, is a combination of the aperture and the shutter speed.

Exposure Programs: *Aperture-priority, shutter-priority, program-wide, program-tele, program, TTL-flash, manual.*
This lists the ways you can set up the camera to expose automatically (see page 98).

Exposure Overrides: *+/−3 stops in ⅓-stop steps. AE-lock button.*
This means that you can override the camera's automation in two ways. The plus/minus system uses the meter reading as a basis for exposure, but automatically gives more or less light than the meter recommends. The AE-lock allows you to take a meter reading that you can "lock" and shoot at, regardless of what the meter indicates when you move the camera toward another light value.

Film Speed Range: *ISO 12 to 3200.*
This shows the range of film speeds that the in-camera meter can register.

Viewfinder: *Pentaprism, fixed. Five user-interchangeable screens. Con-*

tains LED aperture and shutter-speed settings, override indicators, flash-ready signal.
The top of every 35mm SLR has a pentaprism; a fixed pentaprism means that it cannot be removed from the body. The screen refers to the groundglass, which provides the subject image reflected to the viewfinder; these screens have different patterns and focusing aids that you can choose from. LEDs in the viewfinder indicate the aperture and the shutter-speed settings. The decision to override is also indicated in the viewfinder. Flash-ready signals can be seen in some viewfinder displays when you use a dedicated flash with your camera.

Shutter: *Electronically controlled vertical blade type. Speed from 15 sec. to 1/2000 sec. Mechanical at 1/100 sec.*
This means that the electronically controlled shutter works in the automatic mode from 15 sec. to 1/2000 sec.; if the battery fails, you can activate the shutter to release at 1/100 sec. Of course, you can get longer exposure times in the manual-exposure mode in bulb, or "B," when the shutter stays open as long as you press the shutter-release button.

While all of these buttons, switches, and mode selectors may seem overwhelming, try to think of them as a set of automated options that make your photography easier and more spontaneous. Automation allows you to control what goes on without the bother of manually setting controls each time you make a picture. In time, you'll be using various exposure options with your camera's automation for a number of sophisticated decisions. Keep in mind that automatic cameras do not make great pictures; the photographer does. Automation makes the picture-taking process easier and more fun, but the photographer must understand and master the automation to make effective pictures.

THE LENS

A LENS IS SIMPLY a curved piece of glass that alters the direction of the light passing through it to form an upside-down and backward image of the subject. Lenses used in photography are a combination of single lenses, called **ELEMENTS**, some of which are cemented together into groups that are arranged inside a barrel, or **LENS CASING**. The reason for the complexity of photographic lenses (some are constructed with as many as thirteen elements in eight groups) is that light goes through a number of changes and is distorted as it is collected and passes through glass. Each lens is constructed so that it corrects some of these faults, or **ABERRATIONS**, before the light strikes the film. Lenses are a delicate balance of surfaces, thicknesses, and air spaces designed to eliminate the distortion. When a lens is **FOCUSED**, the curved glasses inside move back and forth to change their distance from the **FILM PLANE**, or the point at which the light rays converge. With the advent of computer-aided lens design, photographic lenses have become more advanced, and lens quality has greatly improved.

Within the lens is a **DIAPHRAGM**, or iris, that forms the aperture setting. The size of this opening is determined by the turning of an aperture ring on the outside of the lens, or, with some fully electronic cameras, by the signals generated by a program via the camera's light meter and central processing unit.

The lens couples, or attaches, to the camera body by a specific mount on the rear of the lens, ensuring a light-tight fit and serving as the junction for all the mechanical and electrical contacts between the lens and camera. The camera and lens continuously exchange signals as exposure and focusing decisions are made.

A lens has a focusing collar for manual focusing control. In autofocusing cameras, lenses are driven by motors that are located in either the camera body or the lens itself; focusing decisions are based on signals received from a detector that sits behind the lens inside the camera body.

The important functions of the lens are the ways in which it focuses the light that strikes the film and controls the amount of light that passes through it to form an image on the film. Focusing is accomplished by increasing or decreasing the distance between the elements of the lens and the film. Light is controlled by changing the size of the aperture built into the

Computer-aided design has done much to create lenses that deliver top optical performance and that are lightweight and compact as well. These are autofocus lenses, but the arrangement of elements is similar to those in the manual-focusing types. The top left diagram shows the interior of a 35–70mm lens. It is extremely compact, thanks to the arrangement of its elements. The 28–135mm zoom lens, illustrated in the diagram on the right, has sixteen glass elements in thirteen groups. The 300mm lens in the bottom diagram weighs five pounds and is a little over nine inches long. It has eleven elements in nine groups, and its angle of view is slightly greater than 8 degrees.

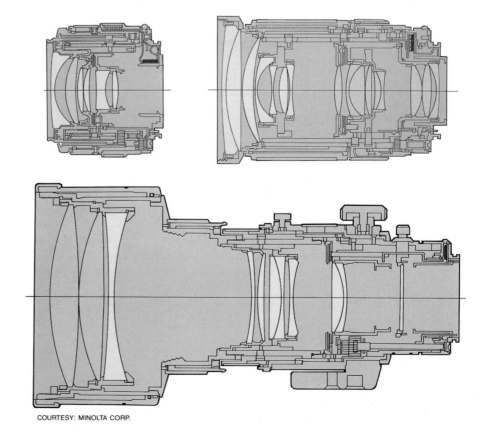

COURTESY: MINOLTA CORP.

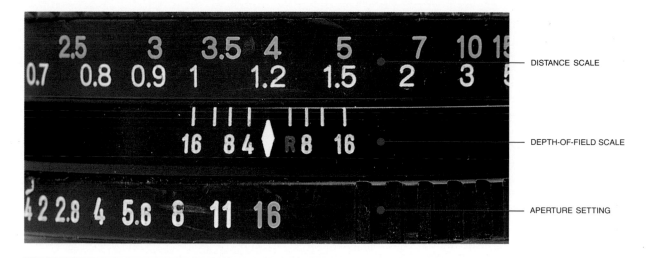

The depth-of-field scale, aperture setting, and distance scale are linked on the lens. They are designed to give you an accurate idea of 1) the distance from the camera to the subject; 2) the f-number at which you are shooting; and 3) the zone of sharpness of your picture. Usually, the f-number will also be shown in the camera viewfinder. The settings here indicate that the aperture is f/16, the distance from camera to the subject on which you've focused is about 4 feet (or 1.2 meters), and the depth of field available is about 3½–5 feet.

lens. Apertures are expressed in f-stops, with the higher numbers, such as f/16, representing narrower openings than the lower numbers, such as f/2. And, of course, the wider the aperture, the more light enters through the lens.

At the base of the lens sits a series of interconnected markers and scales. These are the **DISTANCE MARKER**, the **DEPTH-OF-FIELD SCALE**, and the **APERTURE-SETTING RING**. The latter two are explained in detail on pages 32 and 42. These scales are vital to many focusing and image-control operations, and serve as the information center for many of the creative choices you will make when taking pictures. For example, the place where the **DISTANCE MARKER** falls on the distance scale indicates the actual distance at which the lens is at the point of **CRITICAL**, or sharpest, focus. This marker is a rangefinder: if you focus on a specific point in space, it will tell you exactly how far it is from the camera and lens. It also lets you use the zone of sharpness provided by a given aperture to best effect. The distance marker is also quite useful when you're working with manual electronic flash settings. It gives you one of the main figures in the equation that allows you to get correct flash exposures.

On photographic lenses, **INFINITY** is the distance beyond which any finite number appears on the distance marker scale; on a 50mm lens that might be beyond 20 feet, while a long-range telephoto lens might have an infinity sign (∞) beyond the 150-foot marker. In the dictionary, infinity is defined as a distance so great that rays of light from a source at that distance may be regarded as parallel. This means that, when you are focusing and have reached the infinity mark on your lens, anything beyond that point of actual focus will also be in focus.

THE FOCUSING COLLAR on most lenses is a broad, textured ring that surrounds the lens barrel; on some autofocusing lenses, the ring is smaller and sits more toward the front of the lens. By moving this ring clockwise and counterclockwise, you change the distance between some of the lens elements and the film; as a result, you focus light from different distances in a particular scene onto the film. As you turn the focusing ring, you can see the effects of your actions on the camera's viewfinder screen. However, these changes may actually not correspond to what the film will record because the depth of field of different lens apertures changes the apparent focus of the image on the film (see page 64).

Lenses for autofocus cameras may differ in a number of respects from their manually focusing counterparts. Internally, the optics may be the same for a similar focal-length lens. Externally, many of the autofocus (AF) lenses have much narrower manual-focus rings, and their rings have been moved

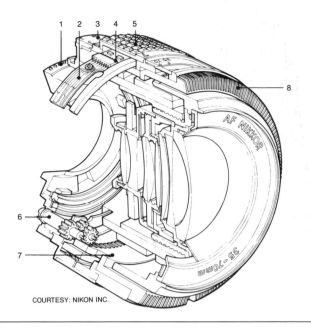

COURTESY: NIKON INC.

This cutaway of an autofocus lens reveals 1) the autofocus-signal contacts, which relay information back and forth between the camera's microcomputer and the lens itself; 2) a zoom encoder, which constantly monitors the focal length in use on the lens; 3) an aperture-control ring, which, when changed, feeds information back to the camera's exposure-control system; 4) a built-in CPU (central processing unit), which is the communications headquarters for the lens; 5) a knurled zooming ring, which, when turned, sends signals back to the camera's exposure and focusing systems; 6) a coupling drive axis, which engages to the autofocus motor in the camera body; 7) a gear train, which turns the lens until it agrees with the distance signaled by the autofocus detector in the camera; and 8) the manual-focus ring, which you turn to achieve focus when you're shooting in manual-focus mode.

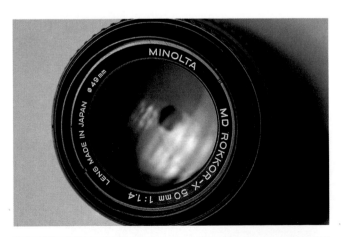

The inscriptions on the lens collar give the specifications of the lens. This Minolta MD Rokkor-X lens has a focal length of 50mm and a maximum aperture of f/1.4. The theta symbol (Θ) followed by 49mm indicates that the diameter of the filter thread is 49mm—only filters with this diameter will fit this lens.

down the barrel so they sit close to the front element of the lens. Because these lenses were designed to be focused without the aid of human hands, some people find AF lenses somewhat difficult to focus manually. But the latest AF lenses have improved—wider—focusing collars.

AF lenses are driven by in-camera, or sometimes even in-lens, motors that receive signals from AF sensors within the camera body itself. On the back of AF lenses, there is a scrics of contacts, which serve as a junction for sending and receiving these signals which guide focus and exposure decisions. Although some AF lenses can be used on manual-focus camera bodies made by the same manufacturer, a lack of connectors on the mounting flange means that some, if not all, of the automated features of the camera and/or lens may not function. And, many manual lenses simply will not fit on the same company's newer AF camera bodies. Some manufacturers, however, offer adaptors that allow you to use an AF lens on a manual camera, or even to turn a manual-focusing lens into an AF lens on an AF camera. Always check camera/lens compatibility before making any purchases.

The glass on the front of the lens is called the **FRONT ELEMENT**. Its surface is coated with a substance, such as magnesium fluoride, to help reduce reflections that can cause a loss of contrast. The multiple layers of this substance can be worn off or scratched by repeated cleaning or abrasion, which is why many photographers cover the front element with a clear glass filter. When a lens is not in use, the front element should always be protected with a lens cap.

When you look at the front of the lens, you'll notice the specifications of the lens you have in hand. For example, an etched code might read: Nikkor 50,1:2, Θ52, Ser. No. 0211665. The last two numbers tell you the filter thread size in millimeters and the serial number of the particular lens. The first set of numbers, 50,1:2, tells you the focal length and maximum aperture of the lens. The focal length—50mm in this case—of a lens is the distance from the back of the lens to the point on the film plane at which rays of light converge to form a sharp image of a subject at infinity. The other half of the lens designation, the numbers 1:2, refer to the lens's maximum aperture. The 2 is the operative number here. You may also see a simple f/2 on the lens. This is the widest opening the lens has to offer,

the aperture setting at which the most light comes through. This and all other numbers that designate lens openings are called **F-STOPS**, or aperture settings.

CONTROLLING THE APERTURE

The aperture, or diaphragm, is a variable opening in the lens that can be adjusted from the narrowness of a pinhole to nearly the width of the lens itself. Aperture settings are designated as $f/22$, $f/8$, $f/5.6$, $f/2$, and so forth.

These openings work much as the pupil of the eye works. In bright light, the pupil contracts, or grows smaller; in darkness it dilates, or expands. In the same way the lens aperture can adjust to different levels of brightness and thus control the amount of light reaching the film.

The **F-STOP** is defined as the proportion of the diameter of the diaphragm opening to the focal length of the lens. This is why **LARGER** numbers represent smaller apertures and vice versa. For example, if the diaphragm opening on a 110mm lens is 10mm wide, the aperture is $f/11$. With any lens, the lower the f-number, the wider the aperture. And, naturally, the wider the opening, the more light that passes through the lens.

The maximum aperture of a lens is important not only in terms of the light level it allows you to shoot in, but also because it affects the ease with which you can compose and focus. When you look through the viewfinder, you're actually viewing a scene at the maximum aperture (because you're viewing through the lens); then, when you press the shutter-release button, the lens **CLOSES DOWN** to the aperture that is appropriate for the light level and the film speed, and then, after the exposure is made, quickly opens up to the maximum aperture again.

Because a wider aperture—such as $f/2$—lets in more light than a narrower aperture—such as $f/5.6$—the wider aperture makes it easier to see subjects in the viewfinder because it's brighter. Also, when the light level is low, a lens with a greater maximum aperture may allow you to shoot without using flash, while a lens with a narrower maximum aperture may not let in enough light for you to shoot handheld in the dim light. For that reason, the lens with the wider maximum aperture is called a **FASTER** lens. The wider you can go in low lighting conditions, the greater your ability to shoot at handheld shutter speeds. This becomes helpful when you don't want to or simply cannot shoot using electronic flash.

For example, if you're taking pictures at a basketball game, you may not want to distract the players by using flash. However, in order to stop the action around the basket, you probably must shoot at a fairly high shutter speed, such as $\frac{1}{250}$ sec. Your lightmeter might tell you that to shoot at that speed you have to set the lens at $f/2.8$. If, however, the lens you're using has a maximum aperture of $f/5.6$ (which is two stops narrower than $f/2.8$), you'll have to reduce the shutter speed by two stops, to $\frac{1}{60}$ sec., to

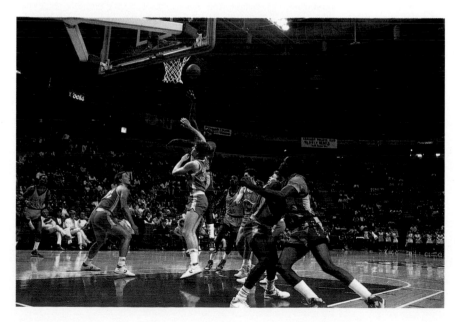

This shot was made at a basketball game where a flash would have been distracting to the players, so it was necessary to use a fast shutter speed to stop the action. Having a "fast" 35mm $f/2.8$ lens on the camera allowed for a shutter speed of $\frac{1}{500}$ sec. at $f/2.8$ with an ISO 200 film. If the maximum aperture of the lens was $f/5.6$, the fastest shutter speed that could have been used with the film would have been $\frac{1}{125}$ sec. The two stops difference might mean the difference between getting or missing the action.

have enough light to make a correct exposure. But this speed is too slow to freeze action. So the "faster" the lens (the one with the greater maximum aperture) the greater your freedom to shoot at handheld shutter speeds in low light conditions.

Today's automatic SLRs have autoexposure systems that set the aperture and shutter speed and respond quickly to changes in light. But many combinations of aperture and shutter speed can give you a "correct" exposure. Once you begin to appreciate the subtle interplay between aperture and shutter speed, you'll have gone a long way toward mastering the technical side of photography and can begin to explore the creative aspects of picture-taking.

Aperture Rings

Next to and behind the depth-of-field scale is the **APERTURE RING**, which you turn to set the appropriate aperture number when making a picture. Aperture rings are inscribed with all the available settings on the lens, from the maximum, or widest, to the minimum, or narrowest lens opening. Typically, aperture numbers read 2, 2.8, 3.5, 4, 5.6, 8, 11, and 16. Some lenses have **CLICK STOPS** both at the aperture numbers and between them; the latter are **HALF-STOPS**. Although not marked, they indicate the precise halfway point between any two aperture numbers.

The best way to see the effects these settings have on the amount of light that enters the camera is to take the lens off the camera, hold it up to a light, and turn the aperture ring, stopping at each click and looking at the size of the diaphragm opening. You'll see that the maximum aperture opens widest. As you click down the scale, you'll see the opening getting smaller. Each stop allows in half as much light as the one preceding it. For example, $f/11$ lets in half as much light as $f/8$, and $f/8$ lets in half as much light as $f/5.6$. These openings also control the zone of sharpness recorded on the film.

On fully or semiautomatic cameras, there may be an "A" or a particular f-number that indicates an automatic setting on the aperture ring. Use this when you want to turn over complete control to the camera's autoexposure system. Lenses that lack an aperture ring altogether are made for fully electronic cameras; aperture selection is made via pushbuttons on the camera.

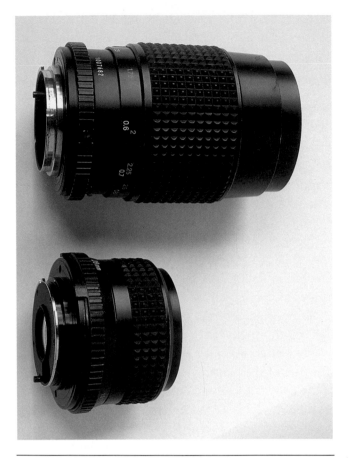

The 100mm and 28mm lenses, shown top and bottom respectively, are but two of many lenses available for your 35mm SLR. In general, the longer the focal length of the lens, the greater its physical size. Notice the texturized ring around the barrels. This is the focusing collar that you turn to shift focus. Note also the coupling pins on the back of the lenses.

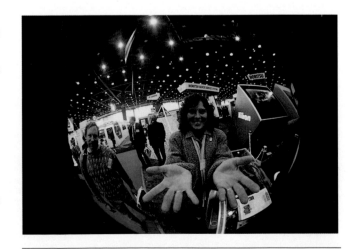

The extreme distortion of fisheye lenses can be used for interesting effects. Their angle of coverage is very wide, and most fisheye lenses also give you incredible depth of field (from inches to infinity) even at moderate apertures. This picture was made with an 8mm fisheye lens.

FOCAL LENGTH

Lenses come in various focal lengths, allowing you to select a particular angle of view for your picture. There are wide-angle, standard, and telephoto lenses, with the angle of view ranging from broad to narrow. Specialty lenses include: zoom lenses, for many angles of view within one lens; fisheye lenses, for a 180-degree, or higher, angle of view; super-wide-angle lenses, for extreme wide-angle effects; macro-lenses, for intimate closeups; and super-telephoto lenses, for bringing distant subjects close.

You can understand what focal length means by putting a magnifying glass up to the sun and seeing where the light converges in a sharp, tight dot on a piece of paper behind the glass. You'll notice that moving the glass, or the paper, to various positions changes the sharpness of the dot. Actually, there is only one distance at which the dot is sharpest, or where the light rays converge; this distance is the focal length of that magnifying lens.

The focal length you choose has a great effect on the visual relationships you establish within a photograph. Although a **WIDE-ANGLE** lens includes more of the scene before you, it can also alter the size relationship of the various subjects within the frame and make them seem farther away from one another than they actually are. A **STANDARD** lens, such as a 50mm lens, echoes your "normal" view of the world, while a **TELEPHOTO LENS** tends to "flatten," or shorten, the perceived distance between objects.

The focal length of a lens tells you the **ANGLE OF VIEW**, or field coverage, of the lens. The lower the focal-length number, the wider the amount of coverage it provides. For example, a wide-angle lens, such as a 24mm lens, encompasses more of a scene than a telephoto lens, such as a 200mm lens, when the same scene is viewed from the same distance. Suppose, for

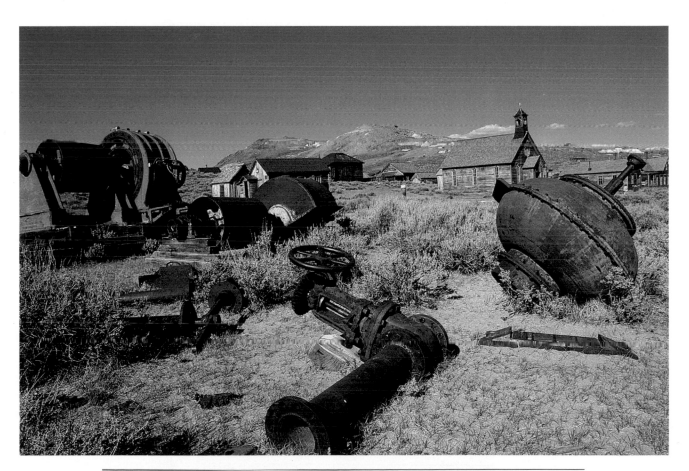

Wide-angle lenses, especially those below 28mm in focal length, let you focus quite close and utilize a very deep zone of sharpness. Hence subjects very close to the camera can be offset by a very distant background, with both the foreground and background staying sharp. Such a visual trick makes the church appear as if it has been miniaturized to fit in with the other artifacts lying in the field of this ghost town.

LENS GROUPINGS AND ANGLES OF VIEW

Though there are no hard and fast boundaries between what makes a lens an ultrawide or merely a wide angle, a telephoto or a super-tele, this chart shows the categories generally accepted by most photographers. Each lens is listed with its approximate angle of view, or the field coverage of the focal length of the lens. The "shorter" the lens is, the greater its angle of view. Zoom lenses are not included here, but to find their minimum and maximum angles of view, just cross reference the minimum and maximum focal length of the zoom with the fixed focal lengths listed here. Also shown is the typical closest-focus setting for each focal length. This distance may vary slightly from brand to brand. Being able to close-focus with a wide-angle lens allows you to exploit the potential for very deep depth of field in your shots. Notice how the close-focusing distance becomes greater as focal length increases.

LENS

20 MM

Ultra Wides

8mm (Fisheye)

16mm (Fisheye)

18mm

20mm

24 MM

35 MM

Wide Angles

24mm

28mm

35mm

50 MM

Normal lenses

50mm

55mm (Macro)

105 MM

135 MM

200 MM

Telephoto lenses

80mm

85mm

105mm

105mm (Macro)

135mm

180mm

200mm

300 MM

600 MM

Super-telephoto

300mm

400mm

600mm

800mm

THE LENS

ANGLE OF VIEW	CLOSEST FOCUSING DISTANCE
180-degrees	0.9 foot
170-degrees	1 foot
100-degrees	0.85 foot
94-degrees	0.85 foot
84-degrees	1 foot
74-degrees	0.7 foot
62-degrees	1 foot
40-degrees	1.7 foot
43-degrees	0.9 foot
30-degrees	3.5 feet
28-degrees	3 feet
23-degrees	3.5 feet
23-degrees	1.3 feet
18-degrees	4.5 feet
13-degrees	6 feet
12-degrees	9 feet
8-degrees	13 feet
6-degrees	15 feet
4-degrees	25 feet
3-degrees	30 feet

example, you're sitting in a sports arena about twenty rows up from court side. Using a wide-angle lens, such as a 28mm lens, you'll probably be able to get a picture of all the action taking place within the frame; by using an ultrawide-angle lens, such as a 16mm lens, you may be able to get the entire court, and even much of the crowd, in the shot. With a telephoto lens, such as a 105mm lens, you may be able to focus in on one section of the court, and with a super-telephoto lens, such as a 300mm lens, you can get pictures of one player in the game.

Focal lengths are divided into general categories, but the borders between them are by no means fixed. Generally, **ULTRAWIDE-ANGLE** lenses are those in the 13–20mm range, while **MODERATE WIDE-ANGLE** lenses include those in the 28–45mm range.

The 50mm lens, which most cameras come with, is referred to as a standard, or normal, lens. Some people claim that a 50mm lens most closely approximates our normal angle of view (actually, our angle of view is closer to 35mm). Any focal length between 50mm and 135mm is called a **MODERATE TELEPHOTO**; beyond 200mm lenses are called **TELEPHOTO** or **SUPER-TELEPHOTO**.

TELEPHOTO lenses are at the other end of the angle-of-view spectrum. In the telephoto range, you may find a 300mm (or higher) focal-length mirror lens, or a lens that does double-duty as a long-range viewing telescope. While these lenses rarely produce the image quality of a more expensive super-telephoto lens, they do offer a cheaper and more compact way for you to be creative in the high-power range.

Although super-telephoto lenses bring distant objects close, they generally provide a very narrow depth of field. This is fine if you want to isolate a subject against a soft-focus, or out-of-focus, background. However, if you want both the foreground and what is behind it to be sharp, you may have to stop down to nearly the smallest aperture.

Fast shutter speeds come in handy when you use a long or bulky telephoto lens. Handholding these lenses at a slow shutter speed may cause a condition called **CAMERA SHAKE**, resulting in pictures that look as if you or your camera were bouncing when the picture was made. A good rule to keep in mind is: **USE A SHUTTER SPEED AT LEAST AS FAST AS THE RECIPROCAL OF THE FOCAL LENGTH OF THE LENS IN USE.** For example, if you're handholding your camera with a 200mm lens, try to always shoot at a minimum of $\frac{1}{250}$ sec.

The focal length of the lens you choose determines both the angle of coverage of a scene and the apparent distance from the camera to the subject. This series of shots was made from the same vantage point with a variety of focal lengths ranging from 17mm to 300mm. Though the widest angle certainly provides the broadest field of view, a 17mm lens is of little use if the purpose is to cover the basketball game; however, it might be the right lens if all you want to do is show the architecture of the arena.

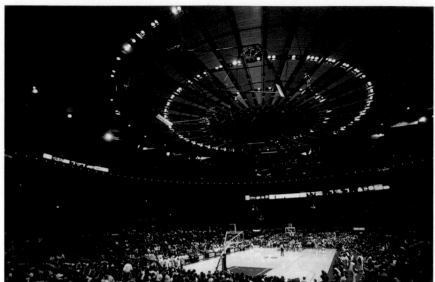

17MM

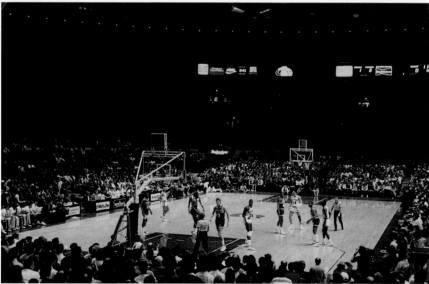

35MM

50MM

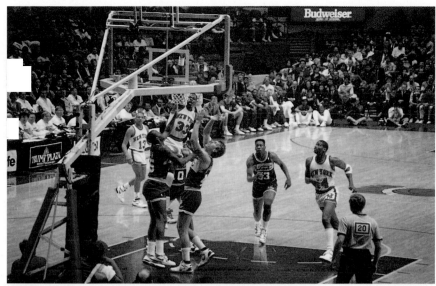

100MM

200MM

300MM

Macro Lenses

Another term you may see applied to a lens is **MACRO**. This means that the lens can be used for extreme closeup photography, although most of them work for general photography as well, because they focus to infinity. In the past, **MACRO** referred to lenses that could focus close enough to give a life-size image or a half-life-size image. For example, with a 1:1 ratio, a subject would be recorded life-size on the film; with a 1:2 ratio, half-life-size. While lenses that can provide only, for example, a 1:6 ratio are sometimes referred to as macro lenses, they are more properly called **CLOSE-FOCUSING** lenses. Both zoom and fixed-focal-length lenses (see "Zoom Lenses") come with macro capability.

Generally, as the focal-length gap between lenses widens, the differences can be dramatic. For example, a 24mm lens may let you focus as close as 6

Macro lenses allow you to shoot at very close focusing distances to your subject. These shots were made at increasingly closer distances. When you shoot this close, depth of field becomes very shallow; if you want sharpness throughout, use as high an aperture as possible (given the light and the film) and keep the camera very steady while shooting.

inches from your subject, while you may have to stand at a distance of 10 feet to focus on the same subject with a 300mm lens. But a 24mm lens at a distance of 5 feet provides the same image size as a 100mm lens 20 feet away. As a result, the spatial relationships between the subject and background can be manipulated.

Zoom Lenses

Lenses that offer a single focal length, or angle of view, are known as **FIXED-FOCAL-LENGTH** (FFL) lenses. However, the most popular type of 35mm lens sold is the **ZOOM** lens, which offers a range of focal lengths in one lens. A zoom lens enables you to compose and crop or to change the angle of view without altering your shooting position. A zoom lens is great for traveling because it reduces the number of lenses in your camera bag. A 70–210mm zoom lets you shoot at every focal length within those parameters.

When you use a zoom lens, you may have two textured rings to manipulate; one is the **FOCUSING RING**, the other is the **FOCAL-LENGTH**, or **ZOOM-CONTROL RING**. Rotating the zoom-control ring increases or decreases the focal length of the lens, changing the angle of view. On many lenses, zooming rings are coupled with the focusing collar, so you push and pull the ring to compose, and turn it clockwise and counterclockwise to focus. When a zoom lens is constructed this way, it's called a **ONE-TOUCH ZOOM**; **TWO-TOUCH ZOOMS** have separate collars for composing and focusing.

By their very nature, two-touch zoom lenses are slower to work with, but they also may allow you to focus more accurately, which is especially important at wider apertures. Focus is critical with all lenses, but becomes even more important with long-range zoom lenses. In general, the best way to achieve proper focus with these lenses is to first focus at the longest focal length, then pull back and compose at the shooting focal length without altering focus. This process may cause a problem with a one-touch zoom lens: when you pull back the coupled ring from the longest focal-length setting, you may inadvertently nudge the lens out of focus. However, good quality one-touch zoom lenses hold focus well, even when the zooming ring is pushed and pulled.

A zoom lens allows you to make compositional decisions right in the camera viewfinder without moving from your shooting position. This series of shots was made from the same spot with a wide-to-telephoto zoom lens. With the advent of computer-aided design, quality zoom lenses are becoming readily available in dramatic focal-length ranges. These zoom lenses make excellent traveling companions because they cut down on the number of lenses in your camera bag.

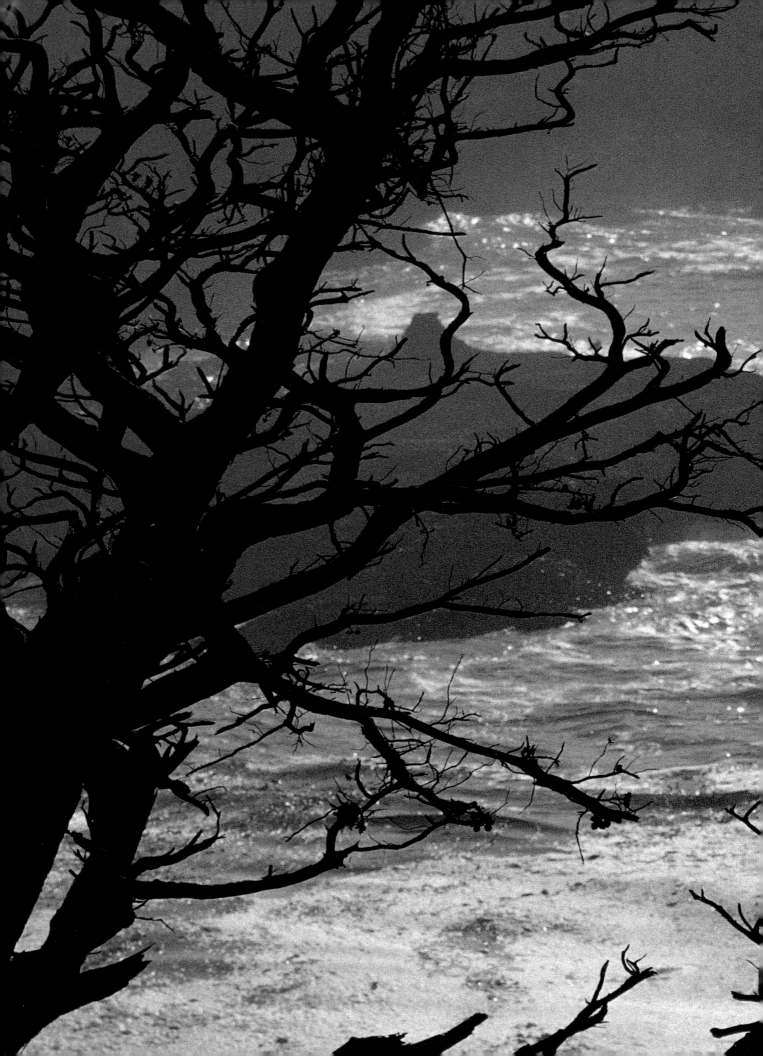

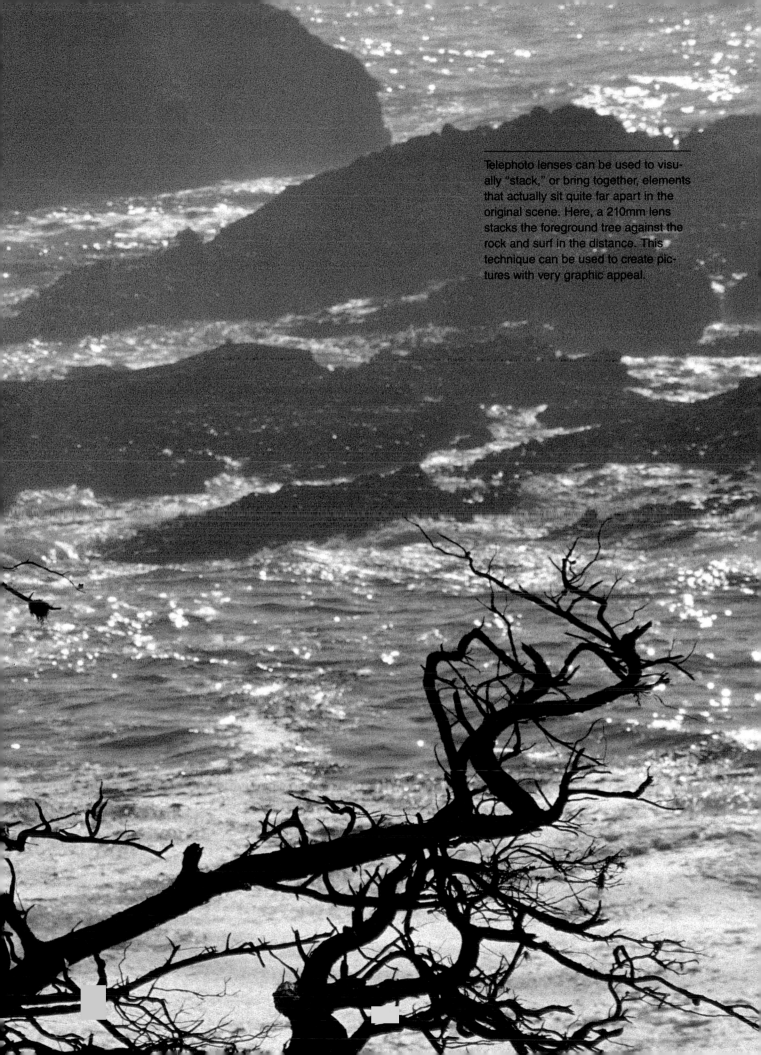

Telephoto lenses can be used to visu-ally "stack," or bring together, elements that actually sit quite far apart in the original scene. Here, a 210mm lens stacks the foreground tree against the rock and surf in the distance. This technique can be used to create pic-tures with very graphic appeal.

DEPTH OF FIELD

Adjacent to the distance scale on the lens is the depth-of-field scale. **DEPTH OF FIELD** is the zone in front of and behind the point of actual, or critical, focus where the eye perceives the image to be in focus. The depth of this zone is dependent, in part, upon what lens aperture you use to make the picture. The narrower the aperture (the higher the f-number), the greater the depth of field with the same lens. A general rule of thumb is that **DEPTH OF FIELD EXTENDS FROM ABOUT ONE-THIRD IN FRONT OF TO ABOUT TWO-THIRDS BEHIND THE ACTUAL POINT OF FOCUS**.

The depth-of-field scale has two sets of like numbers or color-coded marks going in opposite directions around the lens barrel. To find the depth of field at a particular f-stop, all you need do is focus, and then match the f-number with the two like numbers on the depth-of-field scale. The distances on the distance scale that fall between the two like

A narrow zone of sharpness comes in handy when you want to minimize a distracting background. Of course, there are degrees of unsharpness. How "soft" your background goes depends on how close you are to your foreground subject, the focal length of the lens you're using, and the aperture setting on the lens itself. The top photo was made with a 100mm lens set at f/11; even though the distant background has begun to go out of focus, it is still distracting. This problem was solved in the bottom photo by switching to f/4, which causes the background to become more of a color blur than detailed form.

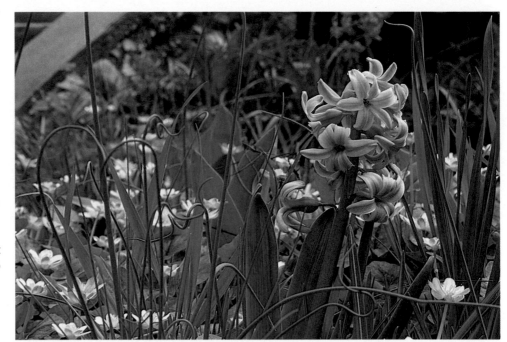

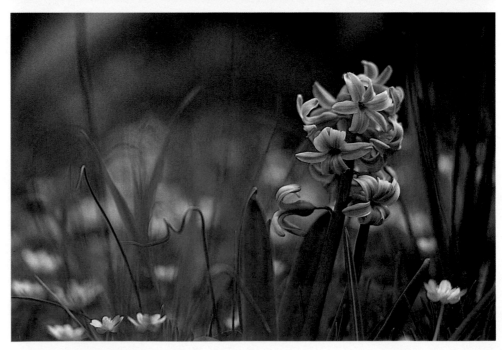

f-numbers or marks on the depth-of-field scale show how deep the zone of sharpness for that particular shot will be. For example, suppose you're shooting at *f*/16 with a 28mm lens, and your focused distance is 8 feet. You then note the distances that lie within the two "16" marks on the depth-of-field scale, and you see that your actual zone of sharpness is 3 feet to infinity. This optical marvel allows photographers to make pictures in which subjects from near to far are in focus.

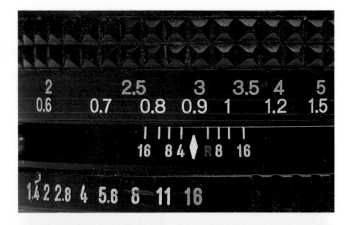

The depth of field you see in the viewfinder, however, doesn't necessarily match what will finally end up on film. Cameras are designed so that you can compose and focus with the lens at its maximum aperture. This makes focusing and composing easier by allowing the greatest amount of light to enter. But it also means that what you see in the viewfinder indicates a shallow depth of field. This is when the scale's usefulness becomes apparent. When you take a picture, the lens automatically stops down to your selected aperture, then opens wide again to be ready for the next compose-focus-shoot sequence. Having to compose and focus at small apertures would make 35mm photography difficult, and might even preclude proper focusing in low light.

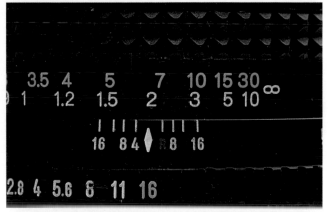

Using wide-angle lenses at small apertures offers a potential for great depth of field. Telephoto lenses, on the other hand, offer a more shallow depth of field throughout their *f*-stop ranges. However, because telephoto lenses are more often used for long-distance shooting of a single subject—such as a wild animal—this lack of a deep zone of focus becomes less of a problem. In fact, shallow depth of field can be as creative a tool as a deep zone of sharpness.

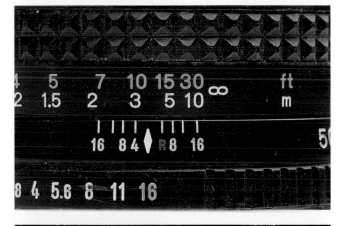

The distance at which you focus coordinates with the aperture setting to produce a certain depth of field. The 50mm lens shown here is set at an aperture of *f*/16, with the distance setting indicated by the numbers opposite the white diamond. You can see the depth of field by looking at the distance settings that lie within the two "16" marks on the depth-of-field scale. At close-focusing distances, the depth of field is shallow: for example, when the lens is focused at about 3 feet, the depth of field is only about 1 foot. However, the depth of field becomes greater as the distance from the camera to the subject increases. Consider these examples: at 6 feet, the depth of field is about 4½–10 feet; at 12 feet, it is 7–30 feet; and at 18 feet, it is 8 feet to infinity.

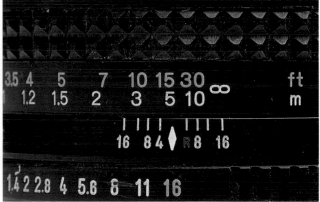

One factor that affects the zone of sharpness is the camera-to-subject distance. Here, all shots were made with a 28mm lens set at ƒ/8. As you move closer to the subject and maintain focus on the headlight, the background becomes less sharp. There are two ways I could have changed the relationship of background-to-foreground sharpness using a 28mm lens in this scene. One would have been to maximize the zone of sharpness by manipulating the focusing-distance marker on the lens within the depth-of-field scale; the other would have been to shift to a narrower aperture, thus increasing the potential for greater depth of field. Being able to perform these manipulations and knowing when to apply them can make the difference between making creative decisions or just going along with what the automatic camera system determines with almost every shot you make.

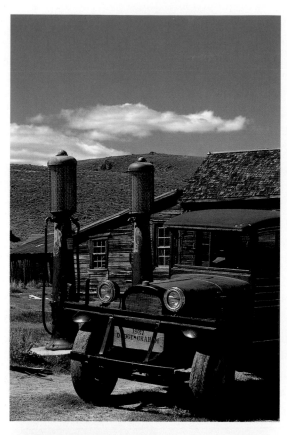

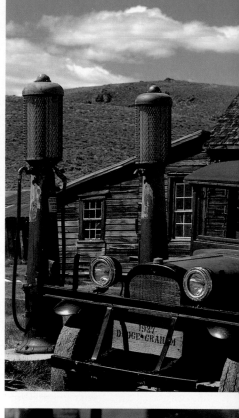

Depth-of-field scales on zoom lenses can be complex, with the zone of sharpness changing with every focal-length selection you make. On lenses with large ranges, such as a 28mm to 300mm zoom, these scales can be unreadable. In order for these markers to be precise, every available focal length would have to be inscribed on the lens, resulting in a jumble of numbers on even short-ratio zoom lenses. Some zooms have curved lines down the barrel that lead to reference numbers at the bottom, but these can be confusing. With zooms or any lenses, set a high aperture for deep depth of field and a low one for shallow. The depth-of-field preview button on your camera comes in handy when you're working with a zoom lens. With cameras lacking such a feature, all you can do is to set a small aperture, such as $f/11$ or $f/16$, for more depth of field, and a wide aperture, such as $f/2$ or $f/4$, for less. Keep in mind that your choices may be limited by light levels and/or shutter-speed requirements.

MOUNTING THE LENS ON THE CAMERA

On the back of every lens is a coupling ring that physically and "mentally" links the lens to the camera. Along with ensuring a proper, light-tight fit, this ring contains mechanical and electrical linkages that unite the "brains" of the camera with the lens. It is the contact point for the signals that may drive the aperture ring through its changes, or for focusing signals that turn a lens to the point of sharpest focus.

The coupling ring aligns with the mounting flange on the camera body. Every lens manufacturer has a distinct mounting system, so different mounting systems cannot be mixed and matched. The flange may contain many junction points for coupling the lens to the SLR. These might include: a lens attachment indicator mark, which you align with a similar mark on the lens itself to ensure proper coupling; contacts for interchanging electrical information on exposure control; a groove for attaching a non-autofocus lens on an autofocus camera; an autofocus locking pin, which inserts into the AF lens upon mounting; an automatic aperture-control ring, which changes the size of the diaphragm in the lens according to signals from the camera's exposure-control system; and an autofocus coupler, which coordinates the signals from the autofocus detector in the camera with the motions of the lens. The placement of these contacts and mounting pins is different on every make of SLR cameras and lenses; this is why lens compatibility is a must.

When mounting a lens to a body, make sure that you have a proper fit. If it doesn't seem to work right away, don't force it, as you may damage some sensitive parts. Generally, a red or white dot on the lens should be aligned to a similar marking on the camera body. Once these are snug, press in slightly and couple the lens and body together by turning left (on some systems it may be to the right, so check your instruction book) until you hear a "click." To ensure that the lens and body are properly fit, run the aperture ring back and forth a few times. A smooth motion will tell you you're ready to shoot.

Adaptors allow you to use one lens on many different camera bodies, but, for the most part, you'll be using one type of lens mount because you have a camera body that only takes one type of lens mount.

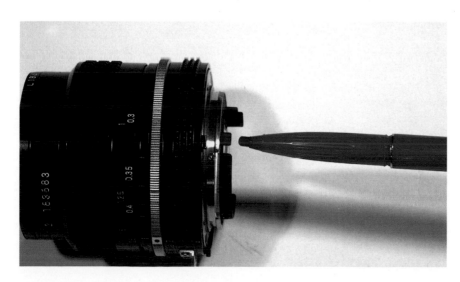

A lens couples to a camera via a set of pins located on the ring surrounding its rear element. These pins ensure proper communication between the camera body and lens. Every lens you buy must be compatible with the specific brand of camera that you own.

FILM: PHOTOGRAPHY'S SOFTWARE

FILM IS THE MEDIUM on which the image formed by the lens is recorded. Film has characteristics that can be measured, compared, and described, but none of these quite touches its miraculous ability to capture time, light, mood, and emotions in a unique way. Beyond its ability to capture light, film adds expressiveness to the image by converting it to black and white, or by revealing the world in rich, bold colors.

Choosing one film over another can be as creative a decision as selecting a particular combination of aperture and shutter speed over another. Although film choice may be limited by lighting conditions, the variety of films available offers a wide-ranging palette. Learning to discriminate between the qualities and capacities of different films under various lighting conditions is a fundamental part of becoming a photographer. Understanding a film's latitude brings another dimension to the creative choices involved in picture-taking.

There are three basic types of film: **COLOR-NEGATIVE** for color prints; **BLACK-AND-WHITE-NEGATIVE** for black-and-white prints; and **COLOR-POSITIVE** for color slides, or transparencies. Regardless of the type of film, images are recorded through the action of light upon silver halides, which are silver crystals (grains) embedded in the film's layered emulsion coating. When light strikes these crystals, they change and form a latent image. When films are developed, the latent image is amplified and the silver halides that were exposed to light are converted to metallic silver. The silver halides not exposed to light are dissolved out of the film by chemicals; this prevents the film from reacting further when it is exposed to light after processing.

The amount of silver altered in development depends upon just how much exposure to light the film received: those areas that were exposed to more light turn darker, while those that received less, or none, are lighter, or clear. This is why a piece of film for prints is called a **NEGATIVE**—its **TONES**, or **DENSITIES**, are the opposite of what appeared in the original scene. When prints are made, however, the densities are reversed to create a positive print. Slide films work in essentially the same way, except that the flip from negative to positive is done in the processing steps of the film itself, and a positive image is formed on the original film emulsion.

Each kind of film has certain characteristics of sharpness, grain, color saturation, and contrast, plus a subjective "feel" that makes it unique. Although film speed is a major factor in defining these characteristics, subtle distinctions separate one brand from another, even among films with the same speed. As you shoot, you'll discover the film that best suits your needs, and as you begin to gain experience, you'll be able to match a particular film to the subject matter and mood of each series of pictures you take. With color-print films of the same speed, these distinguishing characteristics are less apparent; the printing step tends to make prints from one film look much like those from another. However, with slide films there is more differentiation: some films are more contrasty, accentuate different colors, or are more **SATURATED**, or color rich, than their counterparts (see page 52).

Color film differs from black-and-white film in one very basic way. A processed black-and-white negative contains a **SILVER** image; the metallic silver formed in development remains in essentially that same state on the finished film. When color films are processed, color dyes replace the silver image that is the record of the subject. These dyes, however, mirror the densities of the original silver and re-create the lights and darks and colors of the recorded scene on the film.

BLACK-AND-WHITE FILM

Black-and-white film "sees" the world in shades of gray, from white through varying degrees of gray to pitch black. While this may sound bleak, black-and-white film often can offer a more sensuous, evocative rendition of a subject than color film. The subtlety of black-and-white tonality has attracted master photographers to it for years.

Another attractive quality about black-and-white film is its versatility: it can be abstract or starkly real. It can also be effective in nearly every type of photography. Compare the inspiring, majestic beauty of an Ansel Adams landscape with the gritty photograph of an airline disaster that appears on the front page of a tabloid. You will see that both "work," that each has a quality that color film rarely matches. Even if you aren't bitten by the black-and-white bug, try using a roll of black-and-white film every so often as a way of opening your eyes to its special power.

When you take a photograph, you are actually recording a negative image; this means that tones are reversed, and that black records as white. When prints are made, the film is projected onto a sheet of light-sensitive paper, which reverses the tones so that they re-create what you saw in the original scene. Black-and-white film sees the world in shades of gray. Notice how all the tones and shades of gray in the negative reverse when the final print is made.

Color-print film begins with a negative, but here the reverse of light and dark tones as well as the color complements of the colors in the original scene form the negative image. When a print is made, both the tones and color values are reversed to form a positive picture. The orange mask over the color negative makes it easier for the printers to get correct color balance; however, this masking also makes it very difficult to "read" a color negative.

FILM: PHOTOGRAPHY'S SOFTWARE

COLOR FILM

Color films expand on the miracle of capturing light by allowing you to make pictures in vibrant color. The color layers built into the film emulsion—each of which contains light-sensitive silver halides—pass or absorb the light of different colors when they strike the film.

In a sense, films are a sandwich of three basic colors that, when combined, form all the colors in the spectrum. Color is recorded through the use of a complementary color-building scheme; when color-negative film is printed, these colors reverse again and blend to form the color of the original scene in the positive print. With color-slide film, the layers form a positive image that accurately represents a scene. This complex yet elegantly simple arrangement is what makes color photography possible.

If you hold a color-negative film—which is more commonly referred to as color-print film—up to the light, you will see a strong orange cast. This "mask" compensates for some of the color deficiencies in the film and is essential to obtaining true colors in a print. However, it also makes a negative difficult to "read" in terms of what colors will reproduce in the print. In general, only trained photo-lab technicians can analyze a color negative by eye.

Color-print films are among the easiest to shoot with; they forgive slight errors in exposure and, to a certain extent, color imbalances that may be caused by **MIXED LIGHTING**, such as daylight and artificial light sources in the same scene. Also, many problems can be solved in printing: the film can be printed darker if you overexposed the negative, or lighter if you underexposed it. The printer can even change the overall color of the film by switching the color-printing filter pack in the printing machine.

Because color-printing techniques are so advanced and color-print film compensates for mistakes, this type of film should be your first choice when you want color prints and enlargements. Although prints can be made from color slides, they rarely match the

Color films are composed of three or more color layers—magenta, cyan, and yellow are the main foundation—that transmit and absorb light. In various combinations, these filter layers form all the colors in the spectrum. In these pictures of a yellow flower, filters were used to illustrate how different colors combine to form other colors, or to block or transmit colored light. The top left picture was shot with an orange filter over the lens; the top right photo was shot with a green filter. The bottom picture is actually an in-camera double exposure using one of the two filters for each shot. The camera was shifted slightly after the first exposure so that the filter effects overlap in the middle of the frame, leaving the individual filter's effect on the edges. Yellow emerges when these two colors are combined.

quality of those from color-print film and are usually quite a bit more expensive.

With color-positive film—which is more commonly referred to as **COLOR-SLIDE FILM**—what you see when you project or hold the slide up to the light is the actual processed film. No orange mask blocks your view. As a result, color slides are much easier to read than color negatives are. Also, anyone who views a 35mm color slide projected on a screen or wall may be disappointed in the color print of the same scene. However, unlike color-negative film, almost nothing can be done to correct any serious exposure errors when color-slide film is developed.

FILM SPEED

As mentioned, the light-sensitive components in film are crystals of silver compounds. The larger the surface area of these individual crystals, the more light they are able to absorb. The more absorptive power they have, the more sensitive the film is to light, or the faster its speed. Films are broadly defined as **SLOW-**, **MEDIUM-**, and **HIGH-SPEED**. Slow films are called **FINE-GRAIN FILMS**. The rest are assigned **GRAIN RATINGS**, or **GRANULARITY**, accordingly.

Grain usually becomes apparent in the final image when it is enlarged; the process magnifies the grain. This explains why some pictures taken with slow, fine-grain films have a smooth appearance when enlarged, while those shot with **FASTER FILMS** appear as if they have been produced with gritty sand. As you become more familiar with different types of film, you'll be able to identify the speed of the film used simply by examining the grain in the picture.

A film's speed tells you how sensitive it is to light, and **ISO** (International Standards Organization) **NUMBERS** indicate how one film speed relates to another. These numbers, or speed ratings, enable you to determine how much or how little light is needed for proper exposure. Obviously, this number is important because it is programmed into the camera when you load film, whether you do it yourself manually or the camera does it automatically through a DX-code-reading system.

Today's films come in a variety of speeds: ISO 25, 40, 50, 64, 100, 125, 160, 200, 320, 400, 640, 1000, 1250, 1600, and 3200. When the ISO rating doubles, there is a one-stop doubling of light sensitivity. For example, an ISO 100 film is two stops faster than a

film with a rating of ISO 25, one stop faster than an ISO 50 film, one stop slower than an ISO 200 film, two stops slower than an ISO 400 film, and four stops slower than an ISO 1600 film. The ISO scale is calibrated in one-third-stop increments as are most exposure-compensation dials. ISO 3200 is currently the fastest film available, and it permits shooting in very low light without flash. How fast films become seems limited only by the imagination of research scientists and the demands of the marketplace.

Although you should always try to match your film with the subject and the light at hand, two color-print film speeds are considered "universal"; that is, they can handle a variety of shooting conditions with good results. These are ISO 200 and ISO 400. Modern film technology has done much to improve all film types, but the chief beneficiaries seem to be these two. Both deliver enough speed to allow you to select a range of apertures and shutter speeds for most shots, are quite sharp, and have relatively fine grain.

BRIGHTNESS VALUES AND FILM LATITUDE

Films differ in their ability to record a range of brightnesses. This means that some films can render detail in both bright and dark parts of a scene (such as in the chrome bumpers as well as the tire tread on a car), while others may make you sacrifice one or the other of these extremes. The human eye can bridge a fairly wide gap in brightness values and see detail in both light and shadow; however, to compensate for a film's narrower recording range, you may have to adjust the way you see so you will know what you can record on film. It is like the difference between being at a concert and hearing it on tape; both experiences may be satisfying, but tape simply can't re-create the total resonance of the experience, no matter how much digital processing it may receive.

As a general guideline, the ratios between brightness values can be thought of in terms of contrast. On an overcast day, for example, the ratio of dark to light tones is less extreme than on a sunny day. This contrast range can be determined with actual light readings of the brightest and darkest portions of a scene. For example, an overcast scene may have areas that read in a narrow range of $f/5.6$ to $f/8$; the same scene on a sunny day may produce light readings ranging from $f/16$ to $f/2.8$.

FILM: PHOTOGRAPHY'S SOFTWARE

The incredible flexibility of ISO 400 color-print film can be seen in this group of shots taken on the same roll of film. The shooting started out in a shaded bazaar in a theme park; even though the light was quite contrasty, the film bridged the gap and yielded detail in the shadows of the stalls. Moving clockwise, the next picture was taken without flash inside one of the stores in the arcade; this exposure was handheld at f/2.8 at 1/30 sec. Later, at poolside, a narrow aperture was used for a deep zone of focus. A few nights later at a fair I got this available-light shot at f/2.8 at 1/30 sec. Although not all night shots can be made handheld with an ISO 400 film, it definitely allows photographers both a certain amount of shooting freedom and candid work after the sun has set.

When you record any scene, you must take into consideration the type of film you're using and its ability to record a particular brightness range. Most color- and black-and-white-negative films are able to record a greater range of brightness values than color-slide films. This is because the former have a greater exposure latitude. Color-negative films with ISO ratings of 100, 200, and 400 have almost as much exposure latitude as black-and-white ISO 400 film. These films usually give you a three-to-five stop range (from 1½ to 2½ stops above and below an average reading) and can handle just about the same brightness range as black-and-white film. Color-slide film is less able to handle high contrast, although some films are better able to do this than others. While slide film can be slightly underexposed, the biggest problem with slide film is **OVEREXPOSURE**. An overexposed slide looks "washed out," with weak colors and a general loss of quality.

When film receives less light than it needs for correct exposure, it will be **UNDEREXPOSED**. With negative film, this results in prints that have a muddy, grainy look and lack detail in the darker areas of the scene. In color-negative film, underexposure may also yield greenish-yellow colors and hazy blacks. An underexposed slide can range from dark to totally black. Conversely, when a film receives too much light, it becomes overexposed. As a result, black-and-white prints show excessive grain, color prints may be affected by color shifts, and slides have burnt-out highlights or, in extreme cases, have no detail at all.

Some films "forgive" exposure mistakes better than others do. Both color-print and black and white film can still produce pictures with relatively good quality with about a one-to-two stop overall exposure error. Color-slide film is more precise and, although there may be exceptions, any exposure error beyond plus or minus one stop results in poor picture quality. Naturally, correct exposure is always best because miscalculations adversely affect picture quality, but you do have some leeway.

In fact, today's color-negative films are designed with a certain amount of exposure "forgiveness" in mind; this trend came about largely because of the proliferation of 35mm cameras that have no manual exposure systems, which can lead to a relatively high number of exposure mistakes on each roll. But, by working with film that can handle more exposure

One of the main challenges in photography is calculating the right amount of exposure for any given scene. Failure to get enough light onto the film produced the top underexposed image—it is too dark, has poor color, and loses important details in the darker portions of the scene, or shadow areas. Too much light hitting the film overexposed the center photo, causing a loss of detail in the brighter areas of the scene, or highlight areas, a weakening of colors, and a general loss of quality. The bottom photo was correctly exposed and records the balance of colors and tones as they appeared in the original scene.

errors, you can use these compact 35mm cameras to make acceptable pictures in most lighting conditions.

Along with a grain structure, speed, and exposure-error tolerance, every brand and type of film has a particular look. This look may include a certain way of rendering colors and tones, a lower or higher inherent contrast, or a palette of colors that is more reminiscent of pastel than acrylic paint. As you gain experience, you'll be able to mix and match films with different lighting conditions, subjects, and moods.

SELECTING THE RIGHT FILMS

Film brands and types change continually, so having a thorough understanding of their characteristics will help you select film wisely. With color film, one of the main differences between brands is the degree of **COLOR SATURATION**, or the level of intensity in which different colors are rendered on film. Today, the trend among film manufacturers is toward producing films with "higher" saturation.

Another way in which color films differ is their overall **RENDITION**, or **TONE**. Of course, most films strive to be neutral, but many are either **COOL** or **WARM**. In photography, cool means that the film has a slightly blue cast to it; warm means that it has a yellowish cast. These differences in saturation and tone are most apparent with slide films, because the transparency is the actual, "original" film. Conversely, color-negative films reveal fewer variations because, when prints are made, many subtle differences are **BALANCED**, or **NORMALIZED**, by the printing process.

An even more subtle distinction can be seen in the way each film records individual colors. With some films, reds are quite intense and blues are muted. Other films may record bright yellows and near-electric blues, but add a touch of purple to reds.

Though all colors reproduce with greater or lesser degrees of intensity, there is something about reds that really "pop," even to the point in some slide films of looking "dripping wet."

Similarly, skin tones may be warm in one type of film and cool in another. Again, many of these minor variations may be accentuated or eliminated during processing, but they do exist.

Films also differ in their inherent **CONTRAST**, which refers to the way they record brightness relationships. Some films are more contrasty than others; this can either help when the scene is **FLAT**, or lacks contrast, or it can pose a problem when the scene itself is contrasty. (However, sometimes you may want to increase the contrast in an already contrasty scene by using a film with a higher inherent contrast.)

Film choice is a case of luxury balanced by necessity, which is described more fully in Part III under "Matching Film Speed with Lighting Conditions" (see page 110). The luxury comes when you can choose any film for any subject; the wide range of film brands and types offers you many ways to interpret a subject. Necessity becomes a factor when shooting and lighting conditions are difficult. This usually happens in low light, when higher shutter speeds are needed, or in artificial light. Keep in mind this important rule: **IT'S ALWAYS BEST TO SHOOT WITH THE SLOWEST FILM SPEED POSSIBLE.** But you can ignore this rule whenever necessary to get the shots you want.

Don't give up making pictures just because you can't use the slowest film in your camera bag. Because most photographers usually don't carry ten different types of film, gauge your needs before you go out—whether for a day, a week, or an extended trip. Also, always pack one or two rolls of film you don't think you will need; you never know when something will come up. Experiment with new films as much as possible. As you work with different films, you'll begin to see how each one has some special way of rendering color, contrast, and tone. Learn to exploit these differences in your work, and make film choice another creative option.

The film you carry with you often determines how you will shoot pictures, as well as the way they will turn out. The ISO 1000 film used to make the above picture allowed for a fast enough shutter speed for a handheld exposure. The picture on the right, made by Carl Santoro, was shot on a slower ISO 64 slide film; because the shutter speed was ⅛ sec., a tripod had to be used to ensure a blur-free shot. However, the slower shutter speed was used to its best advantage: it recorded both a multiple burst of fireworks and the flowing stream of colors during the longer exposure time.

BUYING ACCESSORIES

WHEN YOU PURCHASE an SLR, you generally get a camera body, a 50mm lens, and perhaps a flash. While this basic kit can take you through many happy months of shooting at first, you may soon find that you want to explore and experiment with the various accessories available. While you can take superb pictures with a single camera and lens, there are zoom, super-wide, and telephoto lenses; special flash units; fancy filters; focusing screens; and numerous other accessories to tempt you.

Let your interests—and your budget—guide you. For example, if you find that you like to photograph sports, your first addition might be a telephoto lens; if you find that you like to take closeups of flowers, the most useful item to buy is either a macro lens or a set of closeup filters. Before you purchase any accessories, make sure they will increase your shooting freedom, flexibility, and creativity.

LENSES

When, and if, you decide to purchase additional lenses, keep in mind that only one type of lens mount will fit on your camera body. Always check compatibility before you buy a lens: selecting a lens made by the company that manufactured your camera does not guarantee that the lens will fit or operate properly.

If you can try out a lens before you buy it, do so. Bring your camera body with you and mount the lens, making sure it fits correctly. Make sure that all the modes work and that all the exposure information shows up in the viewfinder. As cameras become more electronic, proper coupling between camera and lens becomes more critical. Also, if you can, shoot a roll of film or two and look at the finished prints. Take and inspect pictures at all f-stops, paying particular attention to the edges and corners of picture frames to be sure they are sharp. Shoot pictures with strong backlighting to check for **FLARE**. These internal reflections of light within the lens cause geometrically shaped patterns of light to form on film (in some cases, flare can be eliminated by using a lens shade). Make sure that the pictures taken with the lens are distortion-free and have good contrast and sharpness. If you're thinking of buying a zoom lens, move the zooming and/or focusing rings. If either one is a bit tight, it may loosen up with use, but if it's already loose, you might have trouble when you try to maintain focus as you zoom.

Many people feel a zoom is the first additional lens they should own, and some even substitute a moderate zoom, such as a 35–70mm lens, for the standard 50mm lens when they buy a camera. Although a zoom lens offers great flexibility, a fast fixed-focal-length lens should also be considered. In time, the lenses you choose to add to your equipment will be a natural outgrowth of your work.

Don't forget super-telephoto and super-wide lenses, among others, as you add to your lens collection. Each lens you mount on your camera offers you a new way of seeing and almost forces you to confront new subject matter and experiment with composition. A macro lens brings you into contact with a previously unseen world. Also, a super-telephoto lens brings you into contact with graphic compositions that can further inspire you.

Arbitrarily changing lenses every so often is a good way to reawaken a sense of visual play. For example, with a 16mm super-wide fisheye lens, you'll have to fight to keep the extreme distortion from overwhelming your pictures, but you'll probably get a real thrill from the visual possibilities it presents. Most photographers eventually find one or two focal lengths that are perfect for expressing their own personal vision.

A final suggestion about buying lenses—be sure to shop at a reputable store that will allow you to exchange or to return your purchases for a full refund, and that has a knowledgeable owner or manager who can advise you. Be sure to jot down the serial number of any lens you buy, and keep this information with your insurance papers in case of damage or loss. Because no two lenses have the same serial number, this identifies a unique piece of equipment.

LIGHTING EQUIPMENT

Investing in an **ELECTRONIC FLASH UNIT** is a smart idea. **DEDICATED AUTOMATIC FLASH UNITS** link into a camera's exposure and focusing systems and often come with **TILT HEADS** for bouncing the light and **DIFFUSERS** for softening the mood. Also, some electronic flash units have automatic fill-flash capabilities that can open up many picture possibilities outdoors in sunlight.

For indoor still lifes, a set of **PHOTOFLOOD LAMPS**, **REFLECTOR HOUSINGS**, and **FILL BOARDS** can start you on the way to building a home studio. Photofloods are

inexpensive; of course, you can buy more elaborate lighting equipment, but this setup is adequate in the beginning.

FILTERS

There is a time and a place for every filter available, but the ones you'll be using most often are yellow, green, and perhaps, red for black-and-white contrast control, an **ULTRAVIOLET** (UV) filter or **SKYLIGHT** 1A filter for protecting your lenses, and a **POLARIZING FILTER**, or polarizer, for controlling reflections and deepening the sky (in either color or black and white).

Placing a colorless skylight or UV filter over a lens protects the delicate front elements from scratches and abrasions. Many photographers always leave one of these filters on the lens and clean off any dust or fingerprints that may get on it—rather than on the lens glass—during normal shooting. Unlike most filters, skylight and UV filters don't reduce the amount of incoming light.

The second set of filters to buy might be a **SOFT-FOCUS FILTER** for floral images and romantic portraits and **COLOR-CORRECTING FILTERS**, an 81A light yellow, for example, for adding a touch of warmth to a scene. The third set of filters includes special-effects filters

Although overuse of filters can become tiresome, there are times when they add a bit of fun to your shots. In the top left picture, an orange filter was placed over the lens to add a surrealistic touch to this already strange scene. Another odd effect was achieved by using a magenta filter for the scene of a thatched cottage in the top right picture. A blue filter gave the sunset beach scene in the bottom shot an extra moody quality.

that make lines bend, colors look wild, or break up light into thousands of small cross-hatched stars. These filters may seem attractive at first and, in some cases, may actually make a shot work. But many photographers buy them impulsively, only to find that the effect soon wears thin.

Filters screw into a threaded collar, which is found just inside the front rim of the lens barrel. Each filter has a threaded front collar, so you can screw other filters on top of it to increase the number of light-altering effects, or screw on a **LENS SHADE** to reduce flare. If you use one brand of camera, the filter thread size should be consistent for many of the fixed-focal-length lenses in the 24–100mm range. As a result, you will probably have to buy only one set of special filters for a whole group of lenses. However, lenses with focal lengths outside this range, as well as certain zooms, might require filters with wider or narrower diameters.

HANDHELD LIGHTMETERS

You might have noticed that professional photographers often make exposure readings with a handheld lightmeter. Although you'll probably rely on your in-camera meter for most readings, a handheld meter can come in handy in certain situations. There are basically three categories of handheld meters; however, some types offer the advantage of combining several functions in one unit or take accessories that allow for numerous functions.

A handheld meter takes ambient light readings, but unlike the in-camera meter, is used to read incident rather than reflected light. **INCIDENT LIGHT** is light that falls on the subject; reflected light is reflected from the subject. When you use a handheld incident lightmeter, you take a reading of the light falling on the subject from the subject position, or in an area that has the same brightness level as where your subject sits. For example, suppose you're photographing a subject standing under the shade of a tree with strong backlighting behind it. A reflected, or in-camera, lightmeter, reads the total light from the scene, which means the main subject may possibly be underexposed. However, by taking an incident light-meter under the tree and pointing it back toward the camera, the light measured is based upon the brightness level of the shaded area. This results in correct

Warming and cooling filters add a dash of yellow or blue bias, respectively. The picture on the left was made using a bluish filter. The filter used in the picture on the right had a slight yellowish tinge.

A polarizing filter is useful for cutting down on reflections or simply for deepening the color of a blue sky without adversely affecting the other colors in the scene. In this riverside scene, a polarizing filter was used to cut down on the glare of the white boat and to deepen the blue in the scene. Polarizers are often considered essential companions for slide photographers, especially when light is bright and contrasty. You can vary a polarizer's effect by rotating one element of the filter and watching the changes this creates right in the camera viewfinder.

Though you may never need to stack this many filters on the same lens, a filter can be screwed into the threaded collar of another as long as each has the same diameter designation. Also, the diameter of the filter must be the same as that of the thread on the prime lens.

exposure for the main subject. You could also move the incident meter into the bright area around the tree and take a reading—this would give you a sense of what the ratio of bright to dark area is in the total scene, and you could calculate a compromise setting accordingly. In practice, incident readings are most useful with slide films and give very accurate readings when highlight control is necessary.

Another type of handheld meter used by professionals is a **FLASHMETER**. It measures the brief "pops" of light emitted by an electronic flash unit. If you're shooting with a dedicated electronic flash or with an autothyristor model, the exposure and flash duration are determined in-camera or by a sensor in the flash unit that measures the light reflected back from the subject. However, with a handheld flashmeter, you measure light at the subject position, not from the camera position. As a result, you often get a more accurate reading. This happens because the reflectivity of the subject is not taken into account, just the amount of light reaching your subject. A flashmeter is essential if you're using more than one flash unit or if you expose with more than one pop from your main flash. Multiple flash comes in handy for still lifes and portraits, or when more illumination than a single burst of flash is required.

A **SPOTMETER** is a third special type of handheld lightmeter that measures a very selective portion of the scene; some spotmeters can measure as critically as a one-degree circle within a scene. Spotmeters are useful to photographers who make multiple readings within a scene and to those who want very critical readings for highlight or shadow exposure of distant or inaccessible subjects. Many cameras have selective, or spot-reading, metering patterns built in, but they rarely provide the pinpoint-reading capability of a spotmeter. Although a spotmeter is actually a type of reflective meter (from camera position it reads light reflected from the subject), its ability to isolate selective brightnesses makes it a very handy tool for critical-exposure calculations.

TRIPODS

Another accessory you might want to buy is a **TRIPOD**, which is useful for closeup photography, shooting with a super-telephoto lens, and preventing camera shake when you use relatively slow shutter speeds.

In this picture of New York's Grand Central Station, the exposure was ⅛ sec. at *f*/4 on ISO 100 film. Because the available light was dim, the camera had to be mounted on a tripod to eliminate the possibility of image-degrading camera shake that results from handholding a slow shutter speed.

A tripod also forces you to take some time while composing, which can inspire contemplative photography.

If you decide to buy a tripod, don't skimp. There's nothing worse than a wobbly tripod. Look for a tripod whose legs extend easily and lock securely. Also, be sure to investigate the various interchangeable heads, or tripod/camera connecting platforms. **TILTING** and **PANNING HEADS** allow a good deal of level flexibility; **BALL HEADS** let you tilt and turn the camera to any angle you wish.

One small accessory that goes hand-in-hand with a tripod is a **CABLE RELEASE**. Available in lengths ranging from 6 inches to a few feet, it allows you to fire the shutter without touching the shutter-release button with your finger. This capability is invaluable for long exposures when accidental camera shake would ruin the picture or for when you can't be near your camera.

Another support option is a **MONOPOD**, which as its name implies, is a one-legged camera support. Monopods are favored by sports photographers, who require more mobility than a tripod provides.

CARRYING CASES

Once you purchase a few extra lenses, a tripod, a variety of filters, and a batch of film, you have to think about carrying all of this with you. Remember: cameras and lenses are delicate instruments, and tossing and banging them may cause them to malfunction or deliver unsharp images. So it is essential that you get a well-padded, water-resistant carrying case, with wide shoulder straps.

I suggest buying two cases, a large case for storing equipment at home and a smaller one to carry with you. This case can be a backpack, a shoulder pack, or a fanny pack, which straps around your waist. If you travel frequently, you might want to look into a hard metal or plastic case.

Photography magazines and store catalogs are filled with gadgets that offer interesting ways to make pictures. But all you really need is a camera, lens, film, and your eyes. However, toys can be fun; if they help you play better, use them. Now that the hardware and software of 35mm SLR photography have been discussed, it's time for you to learn how to operate your camera and begin shooting.

PART II

OPERATING
THE CAMERA

LOADING AND REWINDING FILM

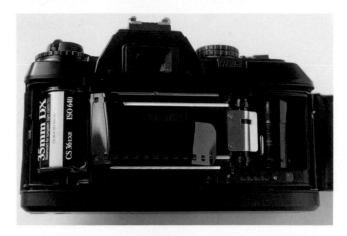

LOADING A ROLL of film, which sits in a light-tight cassette, is done in a series of steps. First, place the roll of film into the camera by turning the film cassette upside down (the plastic nib should point downward) and fitting it snugly into the **FILM CHAMBER** on the left side of the camera's interior. Make sure that the **REWIND SPINDLE** at the top of the film chamber extends into the spool. If the **REWIND CRANK** on the top of a manual-loading camera protrudes into this chamber, lift it from the outside, put in the film, and then reinsert the crank shaft into the opening on top of the film cassette. Cameras with motorized advance and rewind mechanisms don't have rewind cranks; here, you simply fit the film snugly into the chamber. If the film is properly positioned, its shiny side will be facing you.

Next, pull the **FILM LEADER**, or **TONGUE**, the narrow strip at the beginning of the film, until it is long enough to insert into the grooves of the **TAKEUP SPOOL**, which sits in the chamber on the right side of the camera's interior; with the autoload cameras, pull the leader over to a marked position on the right side. Then, with manual-loading cameras, push the **FILM-ADVANCE LEVER** once or twice, or until you are certain the **SPROCKET HOLES** on the film are engaged in the **SPROCKET GEARS**, and that the film winds firmly on the takeup spool. With autowind cameras, closing the camera back engages the film and advances it to the first frame.

Loading film is one of the most common problems for new SLR owners. For example, you may not line up the sprocket holes and the gears on the takeup spool properly, which causes the film to fail to advance when you're taking pictures. You'll know this has happened when you keep shooting and shooting beyond the designated number of exposures on the film, or when the tension on the rewind crank eases after only one or two turns.

You can confirm that the film is advancing properly several ways. With manual-advance cameras, follow this procedure: load the film normally; advance it a frame or two, checking that the film is both snug on the takeup spool and that the sprocket holes align with the sprocket gears; then close the camera back and advance the film one more frame. Next, turn the rewind crank counterclockwise until you feel a slight

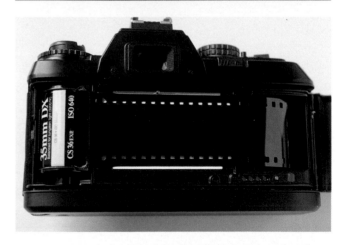

Here is a common loading sequence for cameras with motorized advances. When you first place the film in the film chamber on the left (notice the position of the film cassette's nib, or lip, and the way the film is cut), the film's leader only reaches about halfway across the film guides. In order to thread the film correctly, grasp the film leader and pull the film out of the cassette until the edge of the leader reaches the colored mark on the right side of the camera. You can then close the camera and push the advance/shutter-release button; the film will advance automatically to the first frame (shown here with an open camera back).

tension. Advance the film again, and, as you do, watch the rewind crank: it should respond by turning slightly in a clockwise direction. Once it does, you can be assured that the film is firmly in place and will advance correctly.

Some cameras come equipped with an advance-confirmation indicator. This is either a porthole-like window with a patterned spinning disc or, on cameras with an LCD, a signal or symbol.

When you finish a roll of film, your camera will not advance any longer, and your advance lever won't budge. Don't force the film-advance lever, even if you have just come upon a great picture, for doing so may ruin all of the earlier exposures. Applying pressure to the lever will, more than likely, rip the film from its fastener in the light-tight cassette. If this happens, you won't be able to rewind the film into the cassette or be able to remove the film from the camera—unless you're in a completely dark room.

The next step is to rewind the film. First, push the **REWIND BUTTON**, which is usually located on the base of the camera, and then extend the rewind crank (but don't lift it yet—that would open the back and expose the film!) and wind the film back into its cassette. The rewind button releases the "forward" gear setting in the film-advance mechanism, and allows the film to be pulled backward into the cassette. You know the rewind is complete when you feel a release of tension on the crank and/or hear a definitive "click" as the film comes off the takeup spool. Turn the rewind crank one more time for good measure, and then pull it up (or open the camera back, depending on your model camera) and remove the film. Motorized rewinds complete all of these steps automatically, but usually you still have to engage a rewind switch to begin the process. Some cameras even start to rewind the film once the last available frame has been exposed.

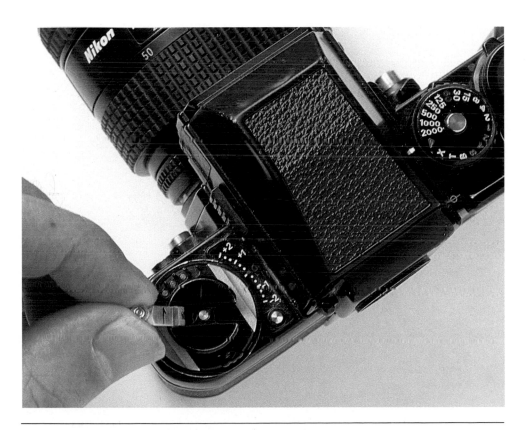

Is your film properly threaded? When you have loaded your film, you can confirm that it is firmly on the takeup spool by first turning the rewind crank clockwise until you feel a slight tension, then firing the shutter and advancing the film to the next frame. If the rewind crank spins as the film advances, you can be sure it is loaded correctly.

FOCUSING

GETTING AN IMAGE into sharp focus involves more than immediately meets the eye. At first glance, it seems to be a simple matter: you bring the camera viewfinder to your eye, turn the focusing collar on the lens until the image seems clear, and shoot. You can also just activate the autofocusing mechanism, and let the camera do the rest. This would be all you need to know about focusing if the various elements in a scene were the same distance from the camera, but this rarely happens. Although having all the subjects in a scene sharp from near to far is often the goal, there may be times when you will want specific parts of a scene to be "soft," or out of focus. We live in a three-dimensional world, and focusing is more complex because it must bring subjects located at various distances from the lens into focus on a two-dimensional plane: the film.

First, watch what happens when you move the focusing collar. Put your camera up to your eye, pick out a subject that is about 10 feet away from you and, starting at the closest focusing distance, slowly turn the collar until you see the subject come into focus in the finder. What you're actually doing is bending and shaping light rays from the subject as they pass through the lens and are reflected up into the viewing screen. At the closest setting, when the subject is out of focus in the viewfinder, the rays converge behind

the film plane. When the subject is sharp—when the 10-foot distance setting on the scale is aligned with the distance marker on the lens barrel—the rays converge at the film plane. When you focus behind the subject, the rays converge in front of the film plane, and the scene goes out of focus.

But what you see in the viewfinder is not always what your pictures will look like. While it is true that the viewfinder gives you an indication of your composition, it doesn't necessarily tell you just how sharp subjects that are at varying distances from the camera will be. To overcome this, keep in mind that the focusing and composing aperture is always the maximum aperture of the lens. The system is designed to keep the lens wide open until the shutter is fired in order to give you the most light in which to focus and compose. However, while there may be times when the maximum aperture and the aperture at which you expose is the same, you probably will take most of your pictures at an aperture narrower than the maximum. For example, suppose you have an $f/1.4$ lens on your camera, but use an aperture of $f/8$ for a picture. When you press the shutter-release button, the lens automatically closes down to the taking aperture ($f/8$), and then immediately opens back up to $f/1.4$ after the exposure is made. Thus, even though part of a picture may seem out of focus when

Being "in focus" means that rays of light from the subject have come together on the film plane to form a sharp image or, in more technical terms, have formed the minimum diameter of a "circle of confusion." These diagrams show how light coming through a lens converges on a plane to form a point, then diverges again. In diagram A the convergence of the light at the plane gives us sharp focus. Diagram B shows how an unfocused image can result from light converging, then splitting again in front of the film plane; the lens is focused in front of the subject. The length of the line defined by the two rays of diverging light is the diameter of the circle of confusion. Diagram C illustrates a similar problem when light rays converge behind the film plane; here the lens is focused behind the subject.

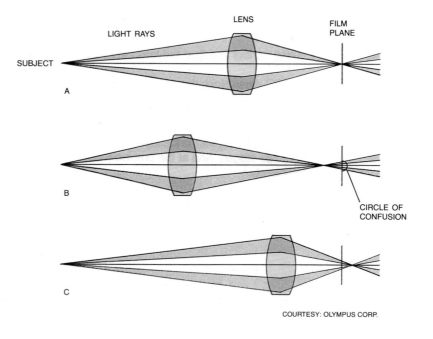

COURTESY: OLYMPUS CORP.

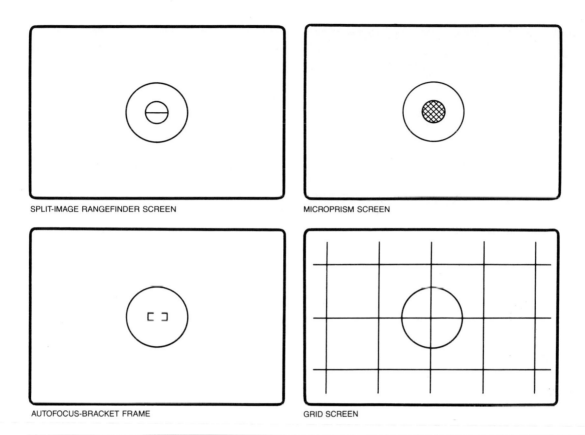

SPLIT-IMAGE RANGEFINDER SCREEN

MICROPRISM SCREEN

AUTOFOCUS-BRACKET FRAME

GRID SCREEN

The most common type of focusing screen in a manual-focus SLR camera has a microprism focusing aid in the center of the viewfinder. The split-image rangefinder-type screen actually halves a portion of the image; joining these halves makes for perfect focus. This works best if you focus on an edge or vertical line in the picture. Some screens combine the microprism and split-image type surrounded by a ground glass. The matte screen including an autofocus-bracket frame is found in autofocusing SLRs. You use these brackets to point to the subject or area you want in focus. A grid screen is useful as a compositional tool and is an excellent way to place elements within a frame or to make sure that lines are plumb and square in your pictures. Grid screens are very popular with architectural photographers.

you view it through the finder, it may well be in focus on the film.

But having all this leeway shouldn't lull you into careless focusing. The actual distance from the camera to the subject is important for critical work. In general, manual focusing of a lens is a two-step process: the first step brings you close to the point of best visual sharpness; the second step is fine-tuning that range. Practice focusing without film in the camera, as endless searching may result in the loss of a good photograph.

Viewing subjects and making focusing decisions can be a problem for even the keenest eye. Luckily, 35mm SLRs come with a number of focusing aids, the most common being a **MICROPRISM CENTER SPOT** that clarifies focusing in the center of the image field. When doing critical focusing, put this center spot on your main area of interest and turn the focusing collar. As the subject area comes into focus, you will see it become progressively sharper. If your main subject is difficult to bring into focus because it lacks contrast or has extreme patterns, switch to another subject at the same distance; if this is any easier on the eye, get the subject in focus, recompose, and then shoot.

Some viewfinders also contain a split-image rangefinder. To use it, find a part of your subject that contains a vertical line. As you turn the focusing collar, the two sides of the split picture in the viewfinder will begin to line up; when they form one picture, or a cohesive whole, the subject is in proper focus. Although split-screen rangefinders are excellent tools for critical focus, they take some getting used to. Also, when you're using lenses with a

Wide-angle lenses are able to focus close and, at the narrower apertures, can render a very deep zone of sharpness. This came in handy here, where both the rocks that literally sit at your feet and the mountains in the far distance are rendered sharp. This shot was exposed with a 24mm lens set at f/16 for 1/60 sec.

recompose, and shoot with a reasonable assurance of a sharp image. If you're photographing a group of people in low light with flash, ask a member of the group to light a match; this becomes the point of light on which you can focus. And, if all else fails, simply estimate the distance, align it with the focusing mark, and stop your lens down as far as conditions permit, in the hope that the depth of field will cover any focusing errors.

In general, focusing with a moderate telephoto lens is easier than focusing with a wide-angle lens. Because the long lens magnifies the scene, proper focus is readily apparent. A wide-angle lens, however, can make subjects appear to be farther away from the camera than they actually are, making them more difficult as focusing subjects. (However, wide-angle lenses more than make up for this difficulty by permitting deep zones of sharpness.)

Zoom lenses offer many advantages in terms of focusing. Suppose you're working with a 35mm to 105mm zoom and taking a picture at the shortest focal length (35mm). One way to do this is to zoom down to the longest setting (105mm), use its magnification power to obtain sharp focus, and then zoom back to your wide-angle setting for the shot. The only problem with focusing zoom lenses in this fashion is the danger of jarring the critical focus setting when you make the shift. To prevent this, some manufacturers developed a focus-lock switch. Today's zooms hold focus well as the focal length is adjusted, but be aware that they might slip.

relatively small maximum aperture (f/3.5 and higher), one side of the split screen may actually blank out. Luckily, the split screen usually comes in combination with a microprism, so you get the best of both worlds. There are many other types of interchangeable focusing screens available. These two are the most common and, I think, are also the most useful.

There are times when focusing, even with the help of special screens, can be difficult. Low light levels mean that less light comes through the viewfinder, especially when you use a lens with a narrow maximum aperture. When the light is low, you might be able to focus on the brightest part of a scene,

SELECTIVE FOCUSING

As soon as you are able to consistently get your pictures in sharp focus, you can begin to make **SELECTIVE-FOCUSING** decisions. By changing one or a number of variables, you can decide whether you want all or only certain parts of the scene to be sharp, and just how out of focus you want other areas to be.

As you continue to make pictures, you'll begin to see how critical a role creative focusing plays in composing and in the emphasis of important subjects. Often, these decisions make a picture succeed—or fail. You'll also come to recognize when sharpness from near to far is effective, as well as how a shallow zone of sharpness can minimize distracting backgrounds and emphasize the subject.

Selective focus can be used to make shots that pick a face out of a crowd by turning what might have been a distracting background into more of a color than a form. This shot was made with a 180mm lens set at f/4, an aperture and focal-length combination that yields an extremely shallow depth of field. The lens was focused on the tip of the bagpiper's nose; as a result, the bagpipe went slightly out of focus, and the band members in the background went "soft."

Selective focus means making focusing decisions that are both practical and visually enhancing. In this scene, I was caught with a 50mm lens, fairly slow film, no tripod, and dim lighting conditions. Rather than forget about the shot, I composed so that the line of statues stretched from one edge to a vanishing point in the center of the frame. The smallest aperture I could get with a handheld shutter speed of $\frac{1}{30}$ sec. was f/8, so I focused on a statue about a quarter of the way down the line and shot.

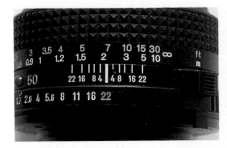

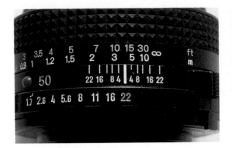

You can maximize your zone of sharpness by using hyperfocal distance settings. The top picture was shot with a 50mm lens set at $f/22$; the focus was set on the bush that stood about 7 feet away. As you can see from the lens itself, the depth of field at that distance setting is from about 4½–15 feet, and the trees and hills in the distance are not sharp. In the bottom picture the focusing-distance scale was moved to the left so that the infinity marker sits within the $f/22$ mark on the right; notice that the actual focus setting is now about 13 feet, and that the 7-foot distance setting has been moved to the left and sits well within the $f/22$ mark on that side. This means that the zone of sharpness is now about 6½ feet to infinity. This pickup in depth of field comes without sacrificing stops in shutter speed or changing the lens or the camera-to-subject distance; however, the foreground subject will not appear sharp in the camera viewfinder.

Selective focusing is implemented in a number of ways: changing the aperture setting on the lens, manipulating the depth of field, changing to a lens with a different focal length, and altering the camera-to-subject distance. Although each method can be used individually, you can achieve radically different focusing effects in the same scene by combining methods. One of the major influences on the zone of sharpness in your pictures is the aperture setting. The rule is: **IF YOU'RE SHOOTING WITH THE SAME FOCAL-LENGTH LENS AND FROM THE SAME CAMERA-TO-SUBJECT DISTANCE, THE WIDER THE APERTURE, THE SHALLOWER THE DEPTH OF FIELD.** Conversely, with the same conditions, the narrower the aperture setting, the greater the depth of field. A one-stop difference can result in subtle changes; a two- or three-stop change can have a dramatic impact on the depth of field in a picture. Just remember that each time you change the aperture to alter the zone of sharpness, you must make a corresponding change in the shutter speed to keep your exposure constant. When you work in any of the autoexposure modes, these shifts will be made automatically; if you work in manual mode, the in-camera meter will tell you when counterbalancing changes should be made.

One way to see exactly how the aperture setting affects the zone of sharpness is to consult the depth-of-field scale on your lens. To determine the depth of field for any given distance and aperture, check the two appropriate aperture indicators on opposite sides of the depth-of-field scale. The distance markers within this spread indicate the zone of sharpness. Subjects that are just outside this range will be slightly out of focus; those well beyond this range will be quite out of focus.

Hyperfocal Distance

You can optimize the zone of sharpness by using the **HYPERFOCAL DISTANCE** setting. For example, with a 50mm lens, focus on an object very far away and look at the distance scale on the lens; you might see that the distance setting is beyond the last numerical value on the scale (this is usually 30 feet on a 50mm lens) and is at the infinity (∞) symbol. Next, check the two lines marked $f/16$ on the depth-of-field scale: this indicates that the zone of sharpness ranges from about 15 feet to infinity. Although this is fine for distance subjects, you might want to gain extra depth of field in the foreground.

To do this align the infinity marker with the right-hand $f/16$ mark on the depth-of-field scale, and then take note of the distance with which the left-hand $f/16$ marker is aligned. That is the minimum distance at which objects will be sharp. This setting is called

The photo above was shot with a 50mm lens, set at $f/8$ and focused on the brick wall seven feet away. Even with the hyperfocal distance set on the lens, there is little change in sharpness. To get enough depth of field to cover the background in the photo on the right required a hyperfocal setting with an aperture of $f/22$.

There are times when setting the focus may interfere with getting a quick, candid shot. That is when presetting a zone of sharpness comes in handy. A wide-angle lens does this best, as it offers you a fairly deep depth of field even at "medium" apertures, such as ƒ/8 or ƒ/11. This shot was made with a 28mm lens set at ƒ/11 with the depth-of-field scale set so that whatever sat in the eight-feet-to-infinity range would be in focus. The camera was set on aperture-priority, so shutter speed was automatically calculated by the automatic exposure system. When using this technique, always make sure your shutter speed is fast enough for a handheld exposure.

the hyperfocal distance, and on this 50mm lens is about 8 feet to infinity. This is a gain of 7 feet (on the near side) over the previous setting. You don't lose anything by setting hyperfocal distance; you simply gain a bit more foreground sharpness.

Zone Focusing

You can use a similar technique to maximize depth of field when the farthest object you want sharp is at a distance less than infinity. With this method, called

ZONE FOCUSING, you adjust the focus so that the distance range is enclosed by the index marks of the aperture in use. For example, if the farthest subject is 10 feet away, you would set the number 10 next to the ƒ/16 mark on the right side of the depth-of-field scale. The zone of sharpness should range from about 4½ to 10 feet with the aperture set at ƒ/16.

Presetting the zone of sharpness can be quite a help when you shoot candids or when you don't have time to focus each image. For example, suppose you're

shooting in a foreign marketplace and want to make pictures of people without being noticed. By presetting the zone of sharpness so that you can shoot from 4 to 15 feet, you can photograph in this distance range quickly without stopping to focus. Before using the technique, however, take a reading to be sure that the aperture you set doesn't require too low a shutter speed; if this happens, switch to a faster film or shift apertures.

At other times, you can be more deliberate about what you want to bring into focus. With the depth-of-field scale, you can use fairly precise settings to get the most out of the available zone of sharpness. For example, for a shot of a statue in front of a building, you might want to have both the statue and building in focus. Without using or being aware of the possibility of depth-of-field manipulations, you might not get the effect you want. But with them, you can play some visual tricks. You can take a picture in which both the statue and background are in focus, as well as shots in which the background is slightly out of focus or where it's nothing but a blur.

The depth-of-field preview button is an important part of exploring various possibilities because it stops the lens down to its selected aperture, allowing you to see the effect the aperture setting has on focus before you shoot. At some apertures, such as $f/16$, the viewing screen is quite dark—so dark, in fact, that you may have trouble seeing what's going on if you're shooting in dim light. If this happens, open up another stop to better see what's in focus in the viewfinder, and then stop down to your selected aperture when you shoot. This won't give you an exact idea of the depth of field at the taking aperture, but it will certainly give you a clearer idea of the final picture focus than will looking through the lens at maximum aperture. Overall, the depth-of-field scale is still the best guide to determine what will be sharp and what will be fuzzy in your picture. Keep in mind that hyperfocal distance and zone focusing can be set up with any aperture: just check the depth-of-field scale using the aperture you set.

AUTOFOCUSING

In some ways, autofocusing lenses are a breed apart, even though all can be focused manually as well. **AUTOFOCUSING** in SLR cameras is controlled by a **PHASE-DETECTION SYSTEM**. As light rays enter the

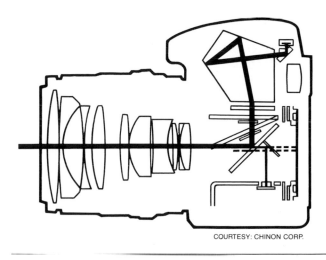

COURTESY: CHINON CORP.

In this autofocus SLR you see how the light entering the lens is split; one beam travels up to the metering cell in the pentaprism housing, while the other travels down to the autofocus detector located in the base of the camera.

camera, they split into pairs that are then projected onto a focus-detector module, which is an array of light-sensing cells. If the system detects an out-of-focus condition, it directs a motor located in either the camera or the lens to change the relationship of the lens to the film plane until the best focus has been achieved, or when the signals are "in phase." This system works well under most lighting conditions with most subjects. However, subjects with low contrast, such as a uniformly toned wall, or those with a fixed, repeated pattern, such as bars on a cage, will give the detector trouble.

You know the system is confused when the lens moves back and forth in a seemingly aimless search for a suitable subject to focus on. When this happens, simply switch the system over to manual-focus mode and focus as you would with a manual-focusing lens. However, never attempt to focus manually when the camera is set for autofocusing. Doing so with extreme force may strip the gears.

The autofocusing function is usually activated by slight pressure on the shutter-release button. You may have a choice of two autofocusing modes, or styles of operation: single or continuous focusing. With **SINGLE**, or **FOCUS-PRIORITY, MODE**, the system locks onto a focus setting and remains there; it is designed so that you can't take a picture until the camera confirms that the image is in focus. If you want to refocus, you have to stop applying pressure to the shutter-release button and then depress it again. In contrast, **CONTINUOUS MODE** means that the camera is continually tracking a

subject to focus on, or changing the focus setting in response to subject or camera movement. Unlike single mode, this mode allows you to take a picture whether or not the subject is in focus.

Single mode is an excellent choice for shooting stationary subjects, such as landscapes, still lifes, or portraits. Continuous mode is useful for active subjects, or when you're scanning or moving around during shooting—but it doesn't always guarantee sharp pictures. Recent developments in autofocus include a third **PREDICTIVE** mode, in which the system assumes that the subject is moving in a certain direction and adjusts focus accordingly. All of the new autofocus systems point the way to the future when autofocusing will probably be as reliable as autoexposure, and all you'll have to do is know when to make certain creative overrides.

All autofocusing SLRs focus on the subject that's covered, at least in part, by the rectangular brackets in the center of the camera's viewfinder. These brackets indicate the range of the detector, so you must make sure these marks fall properly on your main subject. Failure to do so will result in the camera focusing on some subject other than your main point of interest.

When you use non-autofocusing lenses with an autofocus SLR, or when you shoot in the manual-focus mode, you may be directed to correct focus by a set of arrows in the viewfinder. The direction of the arrows indicates the way you should turn the lens to get the subject into focus. Generally, once you achieve focus (according to the camera), a focus-confirmation indicator lights up. This same signal serves as a confirmation of focus when you use autofocus lenses, informing you that focus is locked onto a subject. Some cameras also indicate proper focus by beeping.

Autofocus Problems and Solutions

Although autofocus systems might seem to be the last step toward a completely responsive, decision-free picture-taking machine, they have a number of inherent problems. You will have to give autofocus a hand, or bypass it, by switching to manual mode and focusing with your hand and eye in a variety of situations. For example, when you work in the continuous mode, you may think that the motion of

the lens means that it is sticking to a moving subject like glue. This may be true for some subjects, but not all: most autofocus cameras can't follow anyone moving in an erratic fashion. Some autofocus cameras, however, have predictive programs that can **TRACK** a fast-moving subject; although they can't give you pinpoint focus every time, these programs can produce results that come close to matching those obtained by a very experienced photographer using manual focusing.

There are a number of reasons why autofocus cameras may not always give sharp pictures. First, photographers sometimes fail to place the autofocus brackets on the main subject, wrongly assuming that the camera will focus automatically on whatever subject they have in mind. Fast focusing subjects may be just too quick for the mechanism to track. This problem also occurs with manual focusing but is less noticeable because photographers know that they must anticipate the changes in a subject's position when focusing manually; they don't expect the camera to do it for them.

You might try anticipating the action of your subject by presetting focus on a spot and depressing the shutter-release button right before your subject hits this mark. In most autofocusing cameras, you preselect focus by using the focus-lock function, which allows selective choice of a focus setting at a chosen distance. Focus lock also comes in handy when the main subject sits at the side of the frame, outside the autofocus brackets in the viewfinder. If the subject is 10 feet away from the camera, the nearest background is 30 feet away, and you fail to lock focus on the foreground subject, the autofocus mechanism will, in a sense, bypass the closer subject and focus on the one more distant. In such cases, you have to tell the detector where you want it to focus by moving the camera so that the brackets in the viewfinder fall on the closer subject. Once the viewfinder snaps into focus, lock the focus, swing back to your original framing, and shoot.

Perhaps the greatest sacrifice you make when using an autofocusing system is the loss of critical control over depth of field. The ability to set a hyperfocal distance or optimize the zone of sharpness is eliminated. Most fixed-focal-length autofocusing lenses have a depth-of-field scale on their barrels. But

Placing the main subject in a corner or side of the frame may cause problems if you're shooting with an autofocusing camera. Recording such a scene is possible, however, if you first place the focusing brackets in your viewfinder over your main subject, "lock" focus by activating the autofocus-lock button, then recompose and shoot.

when you use your camera in an autofocusing mode, you can only consult these distance settings; you can't manually change them to get the optimum depth of field. If you try, you may, in fact, damage the gears on the lens.

Also, only a few autofocus SLRs have a depth-of-field preview button. Probably the easiest way around this problem is to switch over to the manual-focus mode when a specific zone of focus is important, and to go about making calculations as you normally would. (This is one of the reasons why manufacturers include a manual mode on an autofocusing camera;

they recognize the camera's autofocusing limitations.)

You can also use focus lock to set up an approximate zone of sharpness. For example, if you focus on a subject about 10 feet away using an aperture of f/16 on a 50mm lens, the zone of sharpness will be from about 5 to 20 feet. If this will achieve the effect you want, focus on a subject 10 feet away, lock the focus, and shoot; however, this seems like a fairly awkward solution.

Autofocusing cameras made by one manufacturer have an automatic depth-of-field program that allows you to lock focus on the foreground subject and then

When a dedicated flash unit with a focus-assist beam is mounted on an autofocus camera, as shown on the right, you can get automatic focusing even in total darkness. The focusing and metering systems coordinate to give both correct focus and light output. In low light, you activate the AF illuminator in the flash by pressing lightly on the camera's shutter-release button (illuminators built in to the camera body come on automatically in low light). This sends out a beam of near-infrared light that strikes and then reflects back from the subject (diagram A). In this unit, a second beam (diagram B) confirms that the focus is correct; if needed, further adjustments are made before the flash fires. When the flash fires (diagram C), the metering system in the camera controls the flash duration for accurate exposure. In many units, focusing and exposure in total darkness is possible up to about 16 feet away.

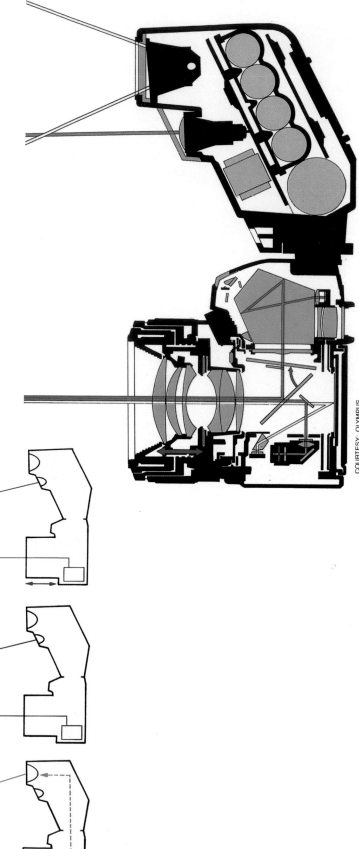

COURTESY: OLYMPUS

A

B

C

do the same for a background subject. The camera calculates the aperture necessary for this zone of sharpness and sets it and the shutter speed accordingly. This program offers a high-tech solution to the depth-of-field problem; others may follow.

In normal lighting conditions, an autofocus lens will allow you to focus faster than any manual-focus operation will. Most autofocus systems are very responsive, and seeing a subject pop into sharp focus in the viewfinder without your even touching the lens is remarkable.

But one of the most fascinating aspects of autofocus is the way it performs in low or dim light, which is usually a problem with manual focusing. With some autofocus cameras—and almost all autofocus flash systems—comes a focus-aid beam system. These near-infrared beams are emitted by the camera or flash unit and bounce back into a focus-setting detector. With this high-tech tool, you can photograph in virtual darkness, although more practical uses are shooting in dimly lit rooms and reception halls, and on streets at night.

Autofocusing is also helpful when you use wide angle lenses, admittedly the most difficult focal lengths to focus manually. If you shoot a distant subject with a 24mm lens, for example, the subject will look quite small in the viewfinder and may present some focusing difficulty. As long as the main subject is placed within the autofocusing brackets in the viewfinder, an autofocus lens will have no problem. Autofocusing becomes even more beneficial when you shoot with wide-angle lenses at wide apertures: there is less of a chance that a high aperture setting will compensate for any slight focusing errors with a deep zone of sharpness. Also, when you want to shoot spontaneously, or to make "grab" shots when you travel or even at home, autofocusing is an ideal option. Quite simply, autofocus means that you don't always have to bring the camera up to your eye or to spend precious moments focusing when a fleeting image presents itself.

The combination of autofocus and autoexposure can make photography spontaneous. However, keep in mind that both of these automatic operating systems are options—and that they're preprogrammed. Neither can think, feel, anticipate, or even make creative changes for you. Use them to handle the mundane tasks of picture-taking. Keep them in proper perspective: they are simply tools that may help you.

When you use an autofocus SLR, be aware of the position of the AF brackets in the center of the viewfinder because they indicate the area that the AF detector reads. In the photo above, the AF system "snagged" on the blades of grass in the foreground; shifting the camera slightly to the left resulted in proper focus.

METERING LIGHT LEVELS

WHILE THERE IS NO NEED to understand the actual mechanics of your camera's exposure system, it is a good idea to familiarize yourself with the way its parts—the meter, aperture, and shutter—work individually and collectively. Having this knowledge will give you more creative control of your photography. Before you can start choosing apertures and shutter speeds, you have to know just how much light will reach the film. Without this information, you have no way to make sure that you're getting a correct exposure. This evaluation of light, and its eventual translation into aperture and shutter-speed values, is the job of the camera's exposure metering system.

All modern 35mm cameras have built-in **EXPOSURE METERS**. The actual light-reading metering cell is located near the mirror at the base of the camera or in the pentaprism head. Metering systems are designed to react to light, but first they have to be told what level of sensitivity to use as a foundation for measurement. This is done when you (or a camera with a DX-code-reading system) set the ISO number of the film in use. This number tells the meter your film's sensitivity to light. Once this foundation is established, the meter reading can be further refined through the use of various metering patterns.

A **METERING PATTERN** indicates the area of coverage in the viewfinder in which light is read. An overall measurement is generally **CENTER-WEIGHTED**; this means that, although the light is read from nearly all parts of the viewfinder, or the scene taken in by the angle of view of the lens in use, the meter assigns more importance to the information from the center portion of the viewfinder. Most standard metering patterns in SLRs are center-weighted averaging systems. A **SELECTIVE**, or **CENTER-SPOT**, **METER PATTERN** excludes nearly all light information from anywhere but the center portion of the frame. A **SPOTMETERING PATTERN** reduces the size of this central light-reading area even further, usually making it smaller than the focusing aid in the exact center of the viewfinder. An **EVALUATIVE** metering pattern, available in the newer "smart" cameras, means that light is read from several areas in the frame and then evaluated by the camera's microcomputer to come up with the correct exposure.

These metering patterns have a tremendous influence on the settings the camera indicates and, when

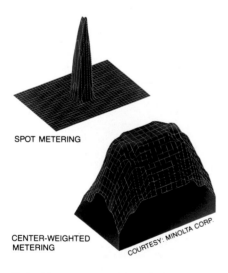

SPOT METERING

CENTER-WEIGHTED METERING

COURTESY: MINOLTA CORP.

These graphic representations of a spotmetering and a center-weighted metering pattern show a heightened response to information from a particular area or the center portion of the viewfinder frame, respectively.

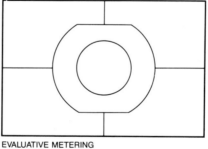

EVALUATIVE METERING

CENTER-WEIGHTED METERING

PARTIAL METERING

SPOT METERING

COURTESY: CANON USA

A number of SLRs offer more than one metering pattern. Choose center-weighted for normally lit scenes, and spot metering for making selective readings. Whatever metering pattern your camera has, learn to use it along with your exposure lock or manual-exposure controls, and you'll be guaranteed exact exposures time after time.

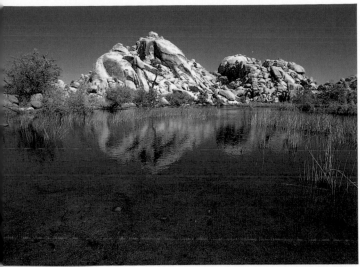

Achieving correct exposure often depends on metering the right portion of a scene. The dark body of water in this composition caused the autoexposure system to give a reading that overexposed the rocks. To avoid this and similar problems, you can either: 1) stay in the autoexposure mode but override it with a −1- to 1½-stop compensation, thereby correcting the meter's tendency to overexpose a predominantly deep-toned scene; 2) take an exposure reading that includes more of the bright rocks in the center of the viewfinder, with a center-weighted in-camera meter, then locking in that reading and returning to your original composition; or 3) take a spot reading directly off the rocks—the highlight in the scene—then open up the lens from ½ to one full stop. The final shot was made using the second option.

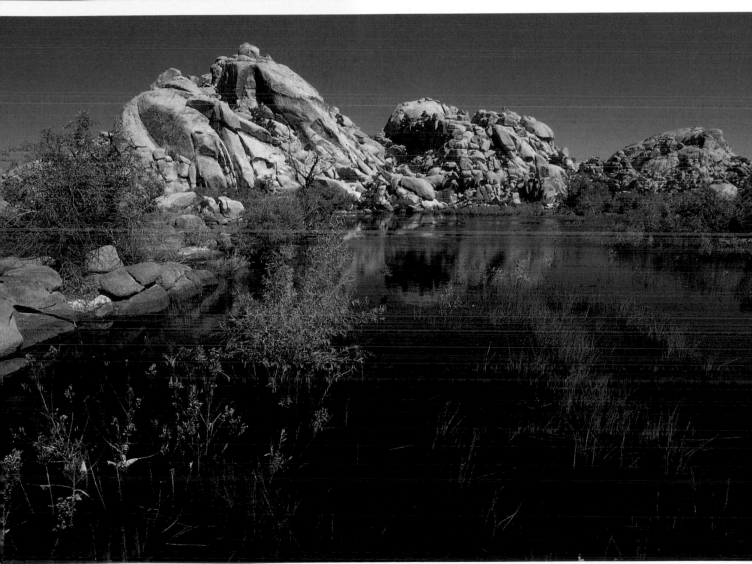

used properly, can make a problematic exposure easy. Suppose, for example, you're taking pictures on a bright day. The subject stands between you and the sun, creating a classic backlit, high-contrast situation. If you take a light reading from more than a few feet away with an averaging-meter pattern, the face in the shadows will probably be underexposed. This happens because the bright light in the background tells the meter that there is plenty of light in the scene; as a result, the meter signals the camera to set an aperture and a shutter speed that are usually inadequate to properly expose the face.

You can overcome this problem a number of ways. If your meter takes only center-weighted readings, go up to the subject, take a reading by pointing the camera toward the shadowed face, set these exposure values on your camera, return to your original shooting position, and shoot. If you can't get close to your subject, try to locate one lit in a similar fashion, take a reading from it, set the exposure values, and then shoot.

But a built-in spotmetering pattern eliminates the need for such steps. All you have to do is set the spot in the viewfinder on the shadowed face, take a reading, and shoot. The meter will exclude the rest of the light in the scene from its calculations and give you an exposure value for the face alone. Also, some advanced SLRs have a built-in program that recognizes such potential lighting problems and enables you to avoid taking additional readings.

Don't think, however, that the averaging center-weighted meter found in most SLRs is without merit. In general, it works well when the lighting is normal and contrast is neither extremely high nor low. In other situations, when the lighting is difficult, this metering pattern can help you find the correct exposure, even though it may need some modification. This slight failing comes from the way the meter is designed to read light.

All in-camera meters read light reflected from the subject and seek to normalize that reading within certain limits. Meters "see" the world in terms of illumination levels, or in shades of gray. They read light so that the subject's varied brightnesses, when averaged together, will produce a **MIDDLE GRAY**, which reflects 18 percent of the light. This is why low and high contrast can produce a false reading. If you're taking a meter reading off a white wall on a bright

A critical aspect of making indoor exposures is knowing how to make a light reading. If the lighting is fairly even (or not contrasty), such as in this poolroom scene in which north light came through a side window, you can usually rely on averaging metering to get the correct exposure.

day, the meter recommends an exposure that will render that wall as a middle gray, although you see the wall as bright white. This shift causes the whiteness of the wall and all the other light values to record on film as relatively darker than they are.

Next, imagine that you're making a portrait with a subject against this same bright white wall, and that you're far enough away so that the values of your subject have little or no influence on the meter reading. Here, the meter reading will be skewed by the brightness of the wall and give you a photograph with a very underexposed subject. But if the wall was black, the in-camera meter would still want to read it as 18-percent gray—and will read the wall's values that way. Any considerably lighter subject standing in front of this wall will be overexposed. In this situation, the meter pushes the values of the darker tones higher, and all the brighter tones become even brighter. This problem frequently occurs with pictures taken around water, where the meter reads a large body of water as a very deep, dark tone; consequently everything around or in it is overexposed. Conversely, underexposure is often caused by the dominance of very bright tones in pictures taken at the beach or in the snow. Clearly, not all subjects conform to the in-camera meter's tendency to turn everything a middle gray.

This discrepancy is present in all in-camera light meters, and some manufacturers have come up with sophisticated metering patterns to try to overcome it. A spot-metering pattern, which allows you to meter specific areas in a scene, can compensate for this problem, but even this system requires practice. Just be aware that no in-camera meter is infallible and that you'll have to put some thought into getting the correct exposure in difficult lighting situations. Test your camera under these conditions to see how it performs, then make future adjustments.

As soon as the meter reads the light levels, it transmits this information to the camera, where it is translated into aperture and shutter-speed settings. Although you can shoot in the automatic mode without being aware of what these settings actually are, knowing what they are will allow you to make fully informed decisions about what the picture will look like. Each change you make in settings can have a profound effect on the final image.

First, it is important to be familiar with the exposure information appearing in the viewfinder. Viewfinders come in various designs that provide different amounts of information. Pre-microchip SLRs often have a match-needle system, in which the signals from the meter cause two needles to bob up and down a scale. To get the correct exposure you align the needles with each other, or one needle with a central site, by turning the aperture ring or shutter-speed dial. Modern SLRs use LEDs or other displays that indicate the aperture or shutter-speed in use. As the light entering the camera activates the meter, tiny lights come on next to the scales. As you spin the aperture ring or change the shutter speed, you can watch as these lights and numbers dance up and down around the edge of the viewfinder.

Some viewfinders may also flash a plus or minus sign, or have red and green lights or some other way to indicate that lighting conditions will lead to correct exposure, underexposure, or overexposure. Generally, matching these lights or getting a green "go" signal means that you manipulated the exposure controls adequately or that conditions are "A-OK" to snap the shutter.

Once the exposure meter indicates the amount of light necessary for correct exposure on a particular speed film, you can: let the camera determine both the aperture and shutter-speed setting; choose the aperture and shutter-speed settings yourself, using the meter readings as a guide to make the picture the way you want to, or take the information the meter gives you and change it to custom design your own exposure settings.

Making the right exposure sometimes means being able to choose the tone within a scene that most represents the "middle" value, the one that will anchor the rest of the tones around it. This is generally done by the meter itself, with its tendency to average the brightness levels it reads to an 18-percent gray. Other times, such as in this shot made in a church interior, you'll have to choose the middle-value tone for the camera.

When a very bright area, or highlight, dominates a scene, your in-camera autoexposure system might yield an exposure reading that will both underexpose anything less bright and record the dominant highlight darker than it actually appears. This commonly occurs in pictures with snow in bright daylight. Here I have used a white wall on a sunny day as the background. When I took a reading directly off the white wall for the top left shot, the exposure system rendered the wall a neutral gray and underexposed the subject. Because the wall is very bright, you might think that closing down the lens or using a −1 stop exposure compensation in automatic mode will help, but both ap-

proaches simply result in a darker wall and a severely underexposed subject, as in the top right photograph. At the other extreme, opening up two stops to compensate caused the white background to lose detail and produced a harsh, overexposed subject; this effect is seen in the shot on the bottom left. However, by opening up one stop (or compensating with a +1 exposure compensation in automatic mode) as in the bottom right shot, I was able to solve the problem of the bright background. Depending on both the subject and the amount of contrast present, you might need to open up between +½ and +1½ stops in similar shooting situations to achieve the best results.

This sequence, shot at the Vietnam Veterans' Memorial in Washington, DC, illustrates a potential failing of in-camera light meters: overexposure of pictures dominated by large areas of black or deep tones. In the top photo, the camera (and therefore the meter) was pointed directly from the Wall; although many details in the reflection are preserved, the rest of the scene is highly overexposed. In the middle photo, made by reading straight ahead, the meter averages the values, and neither the Wall nor the overall scene is pleasingly exposed. The bottom photo was made by giving −1-stop exposure compensation from the middle exposure. When using your in-camera meter, you'll find that using your exposure-compensation dial can help when a scene is dominated by very dark or light tones.

In these pictures, the bright reflective surface of the sculpture is so dominant that it must be considered essential to the exposure calculations. The trick is to record the reflections without losing the balance in the rest of the scene. Although you may think that a shot like this requires fancy footwork to get right, you'll see how just a slight modification of the camera's autoexposure system yields the best results. To make the top left picture, I took a reading from the lawn and opened the lens one stop; the reflective object then became very overexposed. At the other extreme in the top right photo, when I took a reading directly from the bright reflections on the metal (and even stopped down one more stop for good measure), the entire scene went too dark. The bottom left shot is close; this was made by using the camera's recommended exposure. The bottom right shot, which captures both the reflections and the true colors and tones of the surrounding area, was made by setting the exposure-compensation dial to − ½ stop. Although dramatic leaps from what the camera recommends can sometimes produce dramatic results, sometimes only a slight change will give the best results.

Approach the autoexposure system in your camera as a light-measuring instrument that suggests, but does not dictate, proper exposure. Take the time to analyze its suggestions, and then make up your own mind as to what's best for the picture at hand. As you gain experience, this will become second nature and won't interrupt the flow of your work. When you begin, however, take the time to make careful light readings. You may also want to take notes that you can later compare with your results.

What you meter in a scene—specifically, the tones and brightness values you use as the touchstones of your exposure—depends in large part on the type of film you have in the camera. Color-slide film has a fairly narrow exposure latitude, so you should pay attention to the highlights, or brighter portions, of the scene to avoid overexposure.

For example, if you're shooting a white building in an autumn landscape, be sure to include some portion of the bright white in your exposure calculations. You can do this by "placing" the white in some part of the viewfinder. Exactly where you place the white depends on the metering pattern of your particular camera. If it's center-weighted, move the camera until the white is included in the center of the viewfinder, and then meter, note or lock the exposure, recompose, and shoot. If you have a spot-metering system, switch it on, place a portion of the white in the spot indicator in your viewfinder, meter, lock, recompose, and shoot. If the sky is very bright, you may have to use a polarizing filter to bring contrast under control; in fact, this filter "saves" many slides.

Color- and black-and-white-print films are able to accommodate a wide range of subject brightnesses in a scene. When the light is dim or of normal contrast, an averaged automatic exposure will deliver most of the tones in the scene onto these films. However, the increased latitude of these types of film doesn't allow you to point the camera anywhere to make a reading; you still have to give a thought to what you're doing

with the light. As with color-slide film, you should take careful readings with print films.

Suppose you're photographing some buildings in a city, with shadows falling in different areas in the scene. With color-slide film, you must meter for the bright spots; failure to do this will produce washed-out areas with no details in the brighter parts of the scene. With black-and-white and color-print film, however, you should take meter readings of the areas where the shadows fall. If the light is very contrasty, you should also include brighter parts of the picture in your reading. Keep in mind that the key to successful exposure lies in knowing where to point the camera to make the most effective light readings. If you follow the rule, **METER HIGHLIGHTS FOR SLIDE FILM, SHADOW-AREAS FOR PRINT FILM**, you can't go too wrong.

The solution is to recognize potential problems and then bypass the meter to get a correct reading. If you use a straight meter reading of, for example, white snow, expose 1 to 1½ stops more than what the in-camera meter recommends; with very dark backgrounds, decrease exposure by the same number of stops. You can also preprogram the meter by setting the exposure-compensation dial accordingly. In this case you would again add 1½ stops for snowy scenes or for subjects with bright backgrounds, and subtract 1½ stops for scenes with dark backgrounds. If you have the time, you can also individually meter the more significant parts of the picture, and then calculate exposures. However, using the compensation dial is a valuable shortcut.

The in-camera meter provides a solid foundation for most exposure readings, but keep in mind that it isn't infallible. Learn how to recognize potential problems—and how to overcome them. You will soon master how to control and manipulate light to achieve the most effective exposures. In many cases, all you need to know is where to point the camera and how to match the brightness levels you read to the type of film you're using.

PART III

UNDERSTANDING EXPOSURE

LIGHT AND F-STOPS

EXPOSURE CONTROL is a critical part of photography. A film's sensitivity requires a specific amount of light to properly record a subject. If excess light reaches the film, an overexposed negative or slide will result. This will lead to a loss of detail in the brighter areas of the scene and an overall washing out of colors or tones in the film. If the film receives too little light, it becomes underexposed, and the resulting picture can be dark, show a loss of detail, or have poor color quality.

When film emulsions were slower, exposure control was fairly rudimentary. The first "shutter," for example, was a simple lens cap. When photographers wanted to make a picture, they removed the cap, allowed enough light in for a few seconds or minutes to expose the film, and then simply recovered the lens. Today, lens caps are used only to protect the lens when the camera is not in use. As film became faster, the need for precise ways to control exposure became obvious. This is done with the lens aperture and the shutter speed.

Aperture and shutter speed are joined in a logical system of light control based on the concept of **STOPS** and, as previously mentioned, both are indicated by sets of numbers. Aperture settings are designated by f-numbers, while the shutter speeds are indicated by units of time, either seconds or fractions of a second. A typical aperture scale might read: 1.4, 2, 2.8, 4, 5.6, 8, 11, and 16. Each number indicates the ratio of the actual diaphragm opening to the focal length of the lens in use. Because these are actually fractions, the smaller numbers signify larger openings.

Each f-stop always admits the same amount of light because, with a larger lens, the diameter is proportionately larger. This compensates for the extra distance the light must travel. For example, $f/2$ on a 35mm lens allows the same amount of light to enter the lens as $f/2$ on a 200mm lens. Each subsequent higher number represents half the amount of light, and each subsequent lower number doubles the amount of light. For example, $f/4$ lets in twice as much light as $f/5.6$ and four times as much as $f/8$. To look at this another way, $f/8$ allows half as much light in as $f/5.6$ does, and one-quarter the amount of light $f/4$ lets in.

Shutter-speed values usually read: 30, 60, 125, 250, 500, 1000, and 2000. These numbers actually refer to fractions of a second; whole numbers are used on these dials solely for clarity. Slow speeds, such as one or two seconds, typically sit at the opposite end of the dial from the higher shutter speeds (such as $1/1000$ sec. and $1/2000$ sec.) and may be color-coded to differentiate them from fractions of a second. In cameras without shutter-speed dials, these values read out on the LCD panel and/or in the viewfinder.

Each subsequent higher stop in the shutter-speed sequence represents a halving of the light reaching the film. For example, $1/500$ sec. lets in half as much light as $1/250$ sec., and $1/1000$ sec. lets in half as much light as $1/500$ sec. To put it another way, $1/500$ sec. is one stop less than $1/250$ sec., and $1/1000$ sec. is one stop less than $1/500$ sec. Figuring out stops with shutter speeds seems easier than determining aperture settings because the numbers, which relate to time, make more sense. But both give you ways to control the amount of light reaching the film.

All of this exposure information ties together if you think of a film's sensitivity, its ISO rating, in terms of stops. An ISO 100 film is one stop faster—that is, more sensitive to light—than an ISO 50 film. This means that ISO 100 film needs one stop less light than ISO 50 film to get correct exposure in the same lighting conditions. Similarly, ISO 200 film is one stop faster than ISO 100 film, and two stops faster than ISO 50 film. For example, if you have a roll of ISO 200 film in your camera, you may get correct exposure at $f/16$ for $1/125$ sec. for a particular scene; to use the same shutter speed with ISO 50 film under the same lighting conditions, you must expose at $f/8$ because the slower film is less sensitive to light.

Thinking in terms of stops can enable you to manipulate aperture and shutter speed for various effects. For instance, you gain a stop by changing the shutter speed from $1/125$ sec. to $1/60$ sec., moving the aperture setting from $f/8$ to $f/5.6$, or switching from an ISO 50 film to an ISO 100 film. You lose a stop by changing the shutter speed from $1/60$ sec. to $1/125$ sec., moving the aperture setting from $f/5.6$ to $f/8$, or changing from an ISO 100 to an ISO 50 film.

As you work with your camera's exposure-control system, all this will become much clearer. Just keep in mind that the higher its ISO, the more sensitive a film is to light; the higher the aperture number, the narrower the opening; and the faster the shutter-speed number, the less light enters the camera.

When you alter exposure, you can make subtle or great changes in a picture's color and tonal relationships and, therefore, on the entire emotional feeling an image conveys. With slide film, even slight changes can have a profound effect. This sunset was photographed on slide film; each darker picture indicates a − ⅓-stop exposure change. With print film, some of these changes can be made by having the processing lab print the picture darker or lighter.

RELATING APERTURE TO SHUTTER SPEED

By NOW YOU MAY have realized that many aperture and shutter-speed combinations can result in the same exposure. The film speed and level of illumination within a given scene are constants, while the aperture and shutter speed can be used in tandem to control the amount of light to get correct exposure. For example, you get the same exposure when the settings are $f/8$ at $\frac{1}{125}$ sec. or $f/11$ at $\frac{1}{60}$ sec. The second set of numbers represents a one-stop decrease in aperture combined with a one-stop increase in shutter speed. A more radical example is changing from $f/2$ at $\frac{1}{500}$ sec. to $f/11$ at $\frac{1}{15}$ sec.; this shift represents a five-stop decrease in aperture balanced by a five-stop increase in shutter speed. This may seem like game-playing until you realize how the choices you make affect your pictures.

As you know, the shutter speed controls the length of time allowed for light to strike the film—in a sense, "grabbing" moments in time. When a subject is in motion, these moments become part of a continuum of action; however, with a fast shutter speed, you can grab a briefer part of the action than you can with a slower speed. For example, using a shutter speed of $\frac{1}{500}$ sec. may allow you to "freeze" motion, while using a speed of $\frac{1}{30}$ sec. may result in a blur of the same action.

Consider another situation. Suppose you're at a diving event and want to freeze the diver coming off the board. The fastest shutter speed available on your camera is $\frac{1}{1000}$ sec., you're using ISO 100 film, and an average exposure reading indicates $f/11$ and $\frac{1}{125}$ sec. How would you set the aperture to get a shutter speed of $\frac{1}{1000}$ sec.? The calculations are as follows: Going from $\frac{1}{125}$ sec. to $\frac{1}{1000}$ sec. means a three-stop increase in shutter speed. So, because an increase in shutter speed requires a corresponding increase, or opening, of the aperture to get an equivalent exposure, you must make the lens opening three stops wider. The equivalent exposure, then, would be $f/4$ at $\frac{1}{1000}$ sec.

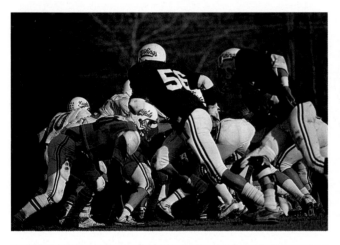

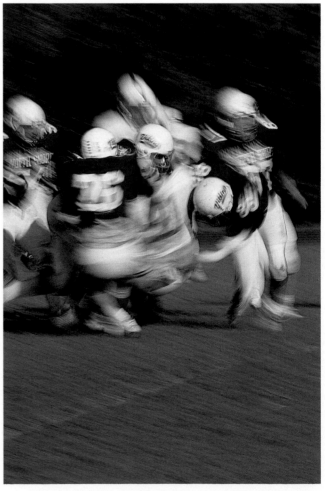

Though the total exposure—or amount of light falling upon the film—is the same in both these shots, what has changed is the relationship between the aperture and shutter speed. Shooting at $\frac{1}{250}$ sec. stops the football players in the photo above in their tracks. But by lowering the shutter speed in the photo on the right to $\frac{1}{15}$ sec., the bodies begin to blur. In some cases you might want to freeze the action; in others you might want to interpret the scene more emotionally. However, when you change the shutter speed, you have to shift the aperture correspondingly to maintain the same exposure. In the shot above, the aperture was $f/4$; in the shot on the right, it was $f/16$.

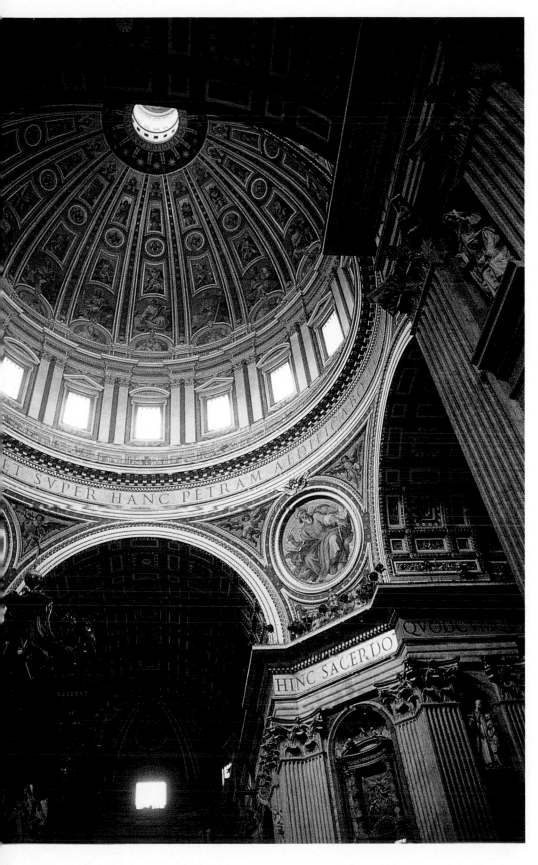

Very slow shutter speeds are sometimes the only solution to shooting in dim light. Even with the lens wide open (at maximum aperture), there wasn't enough light in this church interior to allow for a correct exposure with a handholdable shutter speed. I propped the lens on a pew (to eliminate the possibility of camera shake), and exposed at ⅛ sec. In such scenes there is little use of exposing with an electronic flash (even if it's allowed), as the single burst of light would never illuminate all the details this sweeping angle of view takes in. Even though outdoor light (as seen in the windows) is highly overexposed, the overall feeling is not ruined.

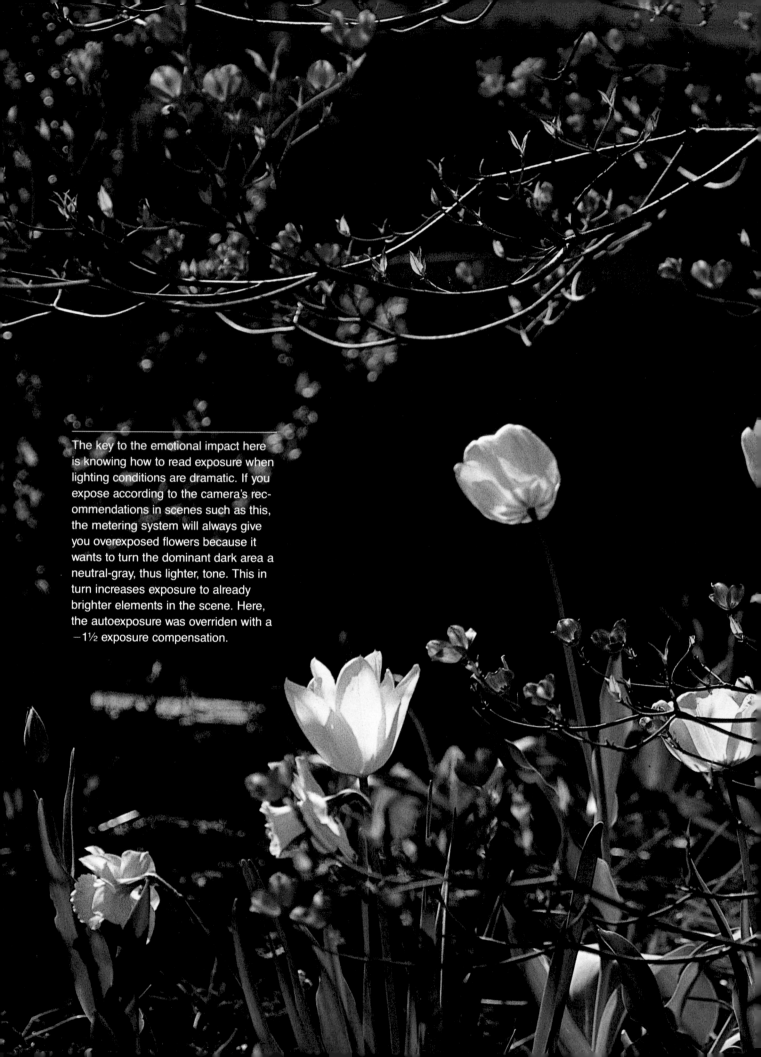

The key to the emotional impact here is knowing how to read exposure when lighting conditions are dramatic. If you expose according to the camera's recommendations in scenes such as this, the metering system will always give you overexposed flowers because it wants to turn the dominant dark area a neutral-gray, thus lighter, tone. This in turn increases exposure to already brighter elements in the scene. Here, the autoexposure was overriden with a −1½ exposure compensation.

Slow shutter speeds, on the other hand, are usually needed when you shoot in dim light using slow to moderate speed film but no flash. You may find that even with the lens set at its maximum aperture, the shutter speeds required to obtain correct exposure are too slow to permit handheld photography.

Relatively slow shutter speeds are also used in brighter lighting situations, when you want to set a small aperture to optimize depth of field. For example, suppose your camera is loaded with ISO 50 film, and you're shooting a landscape in the late afternoon. You want to set the aperture at $f/16$ so that your 28mm lens will yield a zone of sharpness from 4 feet to infinity. But when you take a light reading, the meter indicates an exposure of $f/5.6$ at $\frac{1}{60}$ sec. Changing the aperture three stops to $f/16$ means that you have to change shutter speed by three stops, to $\frac{1}{8}$ sec. Naturally, working with speeds in this range means that you need to use a tripod or some other steadying device.

A slow shutter speed is also necessary to achieve an intentional blur. This is not the blur indicative of camera shake, but one in which the subject's motion creates a sense of fluidity. You may, for example, want to convey the energy and churning motion of a group of marathon runners. By setting the shutter-speed dial to $\frac{1}{15}$ sec., $\frac{1}{8}$ sec., or even $\frac{1}{4}$ sec., you'll get different effects from the moving bodies. Of course, you must compensate for these slow shutter speeds by setting higher apertures and using a tripod.

There are two special shutter speeds on the dial or readout display of an SLR: "B," for bulb, and "X." When you set the camera on **BULB**, the shutter stays open for as long as you keep pressure on the shutter-release button with either your finger or a cable release. (Although somewhat out of style, some shutter-speed dials also have a "T," for **TIME SETTING**. "T" is similar to "B," except that the shutter stays open after its first release until you press or release the shutter a second time.) "B" is used for very

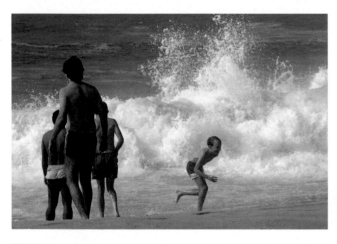

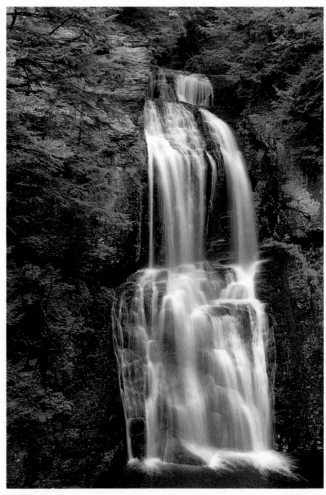

Changing shutter speed has a profound effect on the way you record motion on film. Landscape photographers often take advantage of this when they shoot streams and waterfalls. By mounting a camera on a tripod (or even on a rock) to steady it and using a cable release to further guarantee a shake-free picture, you can make waterfalls become sheets of flowing water by using a shutter speed of $\frac{1}{15}$ sec. or slower as in the shot on the right. On the other hand, you may want to freeze action. In the shot above, a shutter speed of $\frac{1}{2000}$ sec. catches this boy escaping a big wave and suspends the water and foam in midair.

There may be times when a little blur goes a long way toward bringing extra emotion to a scene. Such was the case in this picture made at the Chicago Mercantile Exchange, where a handheld exposure of ⅟₁₅ sec. with a telephoto lens communicated the frenzy of activity.

long exposures, those not available on the camera's shutter-speed dial, and is most often set for nighttime cityscapes, capturing lightning, and even photographing multiple fireworks bursts. The "X" is the **FLASH-SYNCHRONIZATION SHUTTER-SPEED SETTING**. If a specific "X" marking doesn't appear on the dial, this synchronization, or **SYNC**, speed is usually marked in red. In many cases, setting the "X" speed is unnecessary because dedicated flash units set the speed as soon as you mount them on the camera and turn them on. The shutter is actually a set of curtains or blades that move across the lens opening when an exposure is made. The sync speed is the fastest speed at which the first curtain completes its motion—before the second one covers the film.

Shooting at speeds faster than the sync speed with flash will black out a portion of the film frame. In your pictures this appears as if a sharp-edged board on one side of the frame is blocking your point-of-view. However, shooting at below sync speed is no problem, although you should keep in mind that when you shoot below a certain speed—such as ⅟₁₅ sec.—you might in effect be using both your flash and available light for exposure. This "shutter dragging," as pros call it, can be used to record candle flames in wedding shots or portraits. Remember, though, that when shooting at such slow speeds, you should use a tripod, even if you're using flash. Sync speed on most SLRs is ⅟₆₀ sec. or ⅟₉₀ sec., although some cameras have a sync speed of ⅟₁₂₅ sec. or even ⅟₂₅₀ sec.

Not all shutter speeds are **STEPPED**, like those discussed earlier. While a stepped shutter speed works in whole-stop intervals, a stepless shutter speed means that the shutter can work at or between any of the designated speeds. This system is found only in fully automatic, electronically controlled cameras. Also, when you switch to manual, this system usually reverts to a standard stepped approach.

CONTROLLING CONTRAST

WHEN YOU SHOOT, the in-camera lightmeter will help you determine how much contrast exists in a particular scene. You have to take two readings to determine this. Make an actual reading of both the highlight (the area in which the brightest light falls) and the shadow (the darkest area in which you want detail). Any image in which there is more than a three-to-four-stop difference can be thought of as contrasty. Again, your eyes may not see this degree of contrast as very dramatic, but it will be recorded as such on film.

The second approach to reading contrast relationships is to use a gray card, or the palm of your hand, placing the card or your open hand in both the area of highest illumination and of shadow. Take the reading off the card or your open hand with the camera focused at infinity. Again, the differences between the highlight and the shadow reading will indicate how contrasty the scene will be recorded.

Suppose you have a highlight reading of $f/11$ and a shadow reading of $f/4$. In this quite contrasty scene, setting the camera to either of these apertures will cause a problem. If you set the aperture at $f/4$, the bright area of the scene will be three stops overexposed, and will lack detail in a print and be impossibly overexposed on a slide. On the other hand, if you expose for the highlight side, $f/11$, the shadow portion will lose all detail and become a dark

Taking light readings of a high-contrast scene such as this one poses real problems. If an averaged reading with a center-weighted meter is made, the dominance of the blank, dark area in the center of the frame will invariably result in a poor exposure. However, the subjects themselves are so bright that taking a reading off the extremely bright highlight on the mannequin's skull would make all the other tones in the scene go completely dark. The best you can do is compromise—find a tonal value in the scene that you would like to be the "neutral," or average, tone. The top left picture was exposed according to what the program mode called for, and the results—overexposed highlight areas—were as predicted. In the top right picture, the exposure reading was made directly off the neck mantle of the foreground mannequin; this tone then became our neutral, or average, tone in the scene. For insurance, the bottom picture was made at one-half stop less exposure. Although its highlights are still "hot," they are more in tune with those in the original scene.

mass in a print. How you confront this problem largely depends on the type of film you're using.

Both color-print and black-and-white film offer a wider exposure latitude and, as such, can resolve greater degrees of contrast in a scene. If you were using either type of film in the above situation, you could average the readings from the highlight and shadow portions of the scene. This means that you would split the difference in the readings and expose at either $f/5.6$ or $f/8$. While this does not completely solve the problem, it goes a long way to bringing the contrast under control. Some adjustments may have to be made in printing, but detail will be recorded.

Color-slide film, however, poses a different dilem-

ma because it cannot bridge high degrees of contrast; in fact, you usually have to favor the highlights in slide-film exposures, which usually results in the loss of most of the shadow detail, or darker tones in a scene. You might be able to solve the above problem by exposing at $f/8$—one stop more than a highlight reading would indicate— hoping that the highlight area won't be too overexposed. However, even at this setting, the shadow area will go quite dark—not as dark as it would if you shot at $f/11$, but certainly dark enough to cause a loss of detail. If you'll be shooting color-slide film most of your photographic life, learn to adjust to this peculiarity.

When contrast is high, reading for the highlights against very deep black shadows can yield very dramatic results. In this scene, an averaged reading yielded $f/8$ at $\frac{1}{125}$ sec. However, the contrast was such that this would yield a hotspot where the sun hit the wet sand, as well as a fairly bland rendition overall. A selective reading off the brightest region in the scene yielded $f/16$ at the same shutter speed. By exposing for the highlights, I was able to increase the overall drama of the scene, albeit at the cost of some details.

AUTOEXPOSURE MODES

IF PHOTOGRAPHERS had to make light readings and adjust exposure settings on their camera and lenses every time they took photographs, picture-taking would hardly be a spontaneous affair. Luckily, the process of determining exposure has been greatly simplified in the 35mm SLR through the introduction of autoexposure controls and "modes." When you choose a particular mode, you are preselecting the way a picture is to be made. In a sense, you are programming the camera to analyze a scene the same way you might; however, aperture and shutter speed are set automatically.

For example, you can choose a program mode that is biased toward a higher shutter speed; this means that it will shift the exposure for a faster shutter speed at the expense of a narrower aperture. Conversely, you can choose a program mode that is biased toward a narrower aperture, which results in a slower shutter speed, when you want greater depth of field.

Think of exposure modes as styles, or approaches, that give you many programming options. Although you may want to override the autoexposure modes for more creative control, they are able to make the bulk of the exposure decisions and, when used at the right time and with the right subject, are quite convenient. They fulfill a function by making picture-taking more spontaneous.

Although almost every camera manufacturer has its own names for its autoexposure modes, as well as different ways to set them, there are actually just a few basic modes. Also, modes are usually set on the shutter-speed dial or via a group of programming pushbuttons. The mode you choose is then indicated on a panel display on the top of the camera and/or in the viewfinder.

PROGRAM MODES

One of the most common modes is known by a number of names, including **PROGRAM MODE** and **AUTO MODE**. This mode allows the camera to have total exposure control. "Program" means that both the aperture and the shutter speed are chosen by the camera. This mode comes in handy when you want to use your SLR as a basic point-and-shoot 35mm camera, such as at parties and weddings.

The problem with any program mode is that it doesn't always think the way you do; it can only determine exposure based on the way it believes you would like to make a picture. But, if program mode gives you what you want in your photography, then by all means use it. If it doesn't, try different modes until you find the one that complements your picture-making practices.

Many program modes can be "biased," which gives you some creative control over how the picture will turn out. These biases are also geared toward the focal length of the lens in use. Many modern SLRs are capable of automatically choosing a program for you; this multi-program selection process can be exploited to make your picture-taking even easier. This chart shows sample program-mode selections over a wide range of focal lengths in a multi-programming system. When a 24mm lens is mounted, the program is set up to give preference to a narrower, or minimum, aperture over a higher shutter speed in any given lighting condition. When a telephoto 300mm is in use, the program gives priority to a higher shutter speed over a narrower aperture.

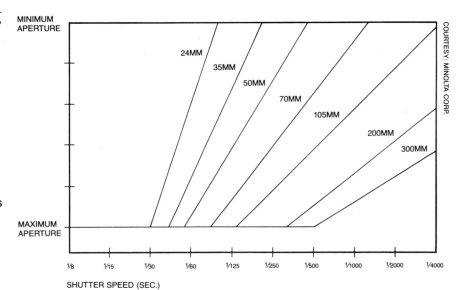

MINIMUM APERTURE

MAXIMUM APERTURE

24MM
35MM
50MM
70MM
105MM
200MM
300MM

SHUTTER SPEED (SEC.)

1/8 1/15 1/30 1/60 1/125 1/250 1/500 1/1000 1/2000 1/4000

COURTESY: MINOLTA CORP.

You can, however, "personalize" the program mode: many camera systems allow for adjustments, or biasing systems. These biasing modes are usually called **PROGRAM-WIDE**, or **PROGRAM-DEPTH**, and **PROGRAM-TELE**, or **PROGRAM-ACTION**. These fully automatic modes shift the weight of the exposure equation toward the aperture or the shutter-speed setting, respectively. With program-wide, whatever setting the autoexposure system chooses will be weighted toward a higher f-stop. Suppose you're shooting in normal daylight and the program-mode reading is $f/5.6$ for $\frac{1}{125}$ sec. If you switch to the program-depth mode, the setting will probably be $f/8$ for $\frac{1}{60}$ sec. or, perhaps, even $f/11$ at $\frac{1}{30}$ sec. With program-tele, the autoexposure system will be weighted toward a higher shutter speed; in this case, the exposure might be $f/4$ for $\frac{1}{250}$ sec.

On some fully electronic cameras, these modes are set automatically when you mount a lens with a particular focal length. For example, if you place a 28mm lens on the camera, the program mode will switch to the equivalent of program-wide; if you add a 200mm lens, the mode may automatically shift to a program-tele bias. While this may be logical—for example, by always setting program-action when a telephoto lens is in use—it may not create the look you want to achieve in a given photograph. This is the reason why these programs are options on most SLRs. If, however, your camera doesn't allow for an optional program-mode selection, you'll just have to override it when you can.

Remember that these modes, and all other autoexposure setups, are built into the camera to help you get proper exposures. In most cases, they do. Be aware, however, that most modes are simply high-tech frills for the same camera controls used for manual readings and exposure settings. Manufacturers try to convince photographers that the more modes available to them, the better their pictures will be. But this increase in the number of modes has resulted in confusion. You, too, may find that it's easier to grasp some of the fundamentals of picture-taking and make some simple adjustments yourself, rather than having to continually reprogram your camera's exposure system every time you want to make a different type of shot.

If you want to understand how your particular camera's autoexposure system chooses exposure val-

Though the lighting conditions and film used to record this scene were the same, changing the shutter speed altered the way the figures look moving through the frame. You can alter shutter speed by 1) shooting in shutter-priority mode and setting the shutter speed as you wish; the autoexposure system will then choose an appropriate aperture to maintain the same overall exposure; 2) metering in manual mode and making the shifts yourself; or 3) shooting in aperture-priority mode and opening or closing the aperture, which forces the metering system to compensate by a corresponding increase or decrease in shutter speed. These runners were shot with settings of $\frac{1}{125}$, $\frac{1}{60}$, and $\frac{1}{15}$ secs., the last creating the most blurred action.

These shots, made in shutter-priority mode, illustrate how a change in shutter speed affects the recording of subjects in motion. The top picture of the carnival ride was shot at 1/60 sec. at f/2.8, the middle photo at 1/15 sec. at f/5.6, and the bottom photo at 1 sec. at f/22. Note that as the exposure time increases, the lights become more and more of a blur.

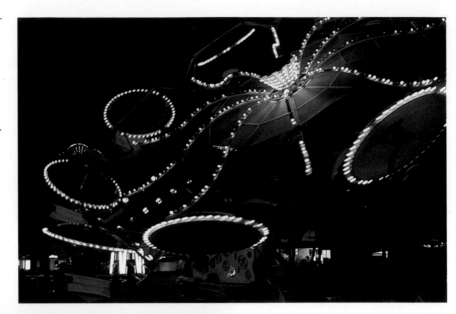

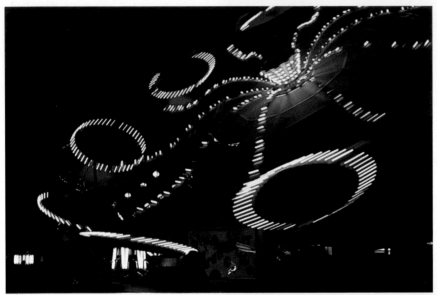

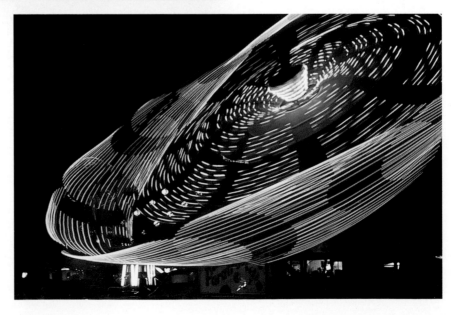

ues in a particular mode, check the graphs supplied in the camera manual. Within these graphs you'll see combinations of settings referred to as "EVs," or exposure values. These numbers represent a combination of the aperture and the shutter speed. For example, EV 10 equals f/5.6 at $\frac{1}{250}$ sec., or f/4 at $\frac{1}{500}$ sec. When a program is biased toward depth or action, it reads the exposure based on EVs, which are constant, and decides on the aperture and shutter-speed combination that will satisfy the program's bias. So, for EV 10, program-tele mode would be biased toward a faster shutter speed to freeze action, and the exposure would be f/4 at $\frac{1}{500}$ sec. Conversely, program-wide mode would be biased toward a narrower aperture for greater depth of field; here, then, for EV 10, the exposure would be f/5.6 at $\frac{1}{250}$ sec. Clearly, as previously mentioned, a change in shutter speed means that you have to balance this with a change in aperture—and vice versa—in order to maintain correct exposure.

This arrangement is the logic behind two of the primary modes in autoexposure systems: aperture-priority, which is sometimes called "AV," and shutter-priority, which is called "Tv" (for Time value) in some cameras.

APERTURE- AND SHUTTER-PRIORITY MODES

Choose aperture-priority mode when you want to give the aperture, or f-number, more importance in your exposure equation. With this mode, once you set the aperture, the camera's exposure system chooses an appropriate shutter speed to make a correct exposure. Aperture-priority is most commonly used when you want to achieve a particular depth of field.

Aperture-priority mode may pose some problems in very bright or dim lighting conditions, such as when you want to set f/16 to take a picture in a dimly lit railroad terminal and have a deep zone of sharpness. When you set the camera to f/16, the camera informs you that a very slow shutter speed will be set. Unless you heed this warning, camera shake may result—and ruin your picture. Under these

conditions, you have to either steady the camera on a tripod or change the aperture until you reach a shutter speed that can be used for a handheld exposure. This minimum shutter speed may become quite high when you're using a long telephoto lens without the benefit of a tripod to steady the camera.

Similar problems may occur if you set too wide an aperture in very bright light. If you're taking a portrait at the beach and want to set a very low aperture so that the background will go out of focus, using f/4 may result in an overexposure warning. This means that even at the highest shutter speed available, such as $\frac{1}{1000}$ sec., the film will be overexposed. In order to get proper exposure, you must change to a lower speed film or a higher aperture, or you could place a neutral-density filter over the lens. Despite these problems, aperture-priority remains one of the most useful autoexposure modes and comes in quite handy when you're making pictures in normal lighting conditions.

With shutter-priority mode, first you select a shutter speed and then the camera automatically chooses the f-stop needed for correct exposure. This mode is useful when you're photographing subjects that are moving or when you want to guarantee a minimum shutter speed to eliminate camera shake. But the cautions that apply to aperture-priority mode also apply to shutter-priority mode: Keep your eye on the viewfinder and pay attention to over- and underexposure warnings. This is essential because, although the aperture and the shutter speed are variable, the speed of the film in the camera and the overall brightness of the scene you are shooting are constants. For example, if you shoot at a slow shutter speed of $\frac{1}{8}$ sec. and use ISO 100 film, a daylight exposure may require an aperture of f/32. But this f-stop may be beyond the minimum aperture on your lens and, if you push the shutter-release button, the picture will be overexposed. Conversely, if you shoot at a very high shutter speed, such as $\frac{1}{2000}$ sec., and your lens's maximum aperture is f/4.5, you may underexpose a daylight scene. In most cases, simply using a faster or slower shutter speed will solve any problems.

EXPOSURE OVERRIDES

AUTOMATION BENEFITS photographers, offering them speed, accuracy, and convenience. However, you may want to override the automation at times either to help the system in difficult lighting conditions or to change the combination of aperture and shutter speed chosen by the camera's autoexposure system. Overrides allow you to customize exposures and have both corrective and creative uses.

You can also bypass the autoexposure system if your camera allows you to manually input the film's speed, its ISO rating. Slight changes in ISO settings can improve the results you get with certain types of slide film. For example, suppose you shoot a number of rolls of slide film and the results simply don't have the deep, rich colors you're looking for in your pictures. It's a common practice to deliberately underexpose slide film by setting the ISO on the camera about one-third stop above the film's speed rating; this actually increases the vibrancy, or saturation, of the colors. To underexpose slide film, you can either use the pushbutton controls to enter the next highest speed on the ISO scale, or shift the ISO dial to the next highest setting. For example, if you want to shoot ISO 64 slide film, you can improve color saturation by setting and exposing the film at ISO 80. In essence, you "fool" the camera into thinking it contains faster film, which would call for slightly less light for correct exposure.

Making small alterations like this will enable you to fine-tune your pictures as you become familiar with your camera and its unique metering system. Not every meter is calibrated the same way, and some may deviate from the standard by as much as half a stop; you'll find out when you get your pictures. You might want to run a few test rolls to see exactly how reliable your camera's meter is in different types of light. To see how film colors change when you underexpose slide film, take a roll of ISO 64 and shoot scenes containing reflective objects, such as leaves on a sunny fall afternoon. Start by shooting a few frames at ISO 64, then change the ISO setting to 80, then to 100, and finally to 125. Keep a careful record of the speed used for each frame. When you compare results, you'll see the amazing power you have over color and light by making small changes in the ISO setting.

USING THE EXPOSURE-COMPENSATION DIAL

Another way to override the automatic exposure system on your SLR is to use the exposure-compensation dial (or pushbuttons that allow you to program changes). This dial allows you to alter the exposure by as much as plus or minus three stops, in ⅓-stop (or sometimes ½-stop) increments. You can make these changes on either individual frames or on a group of frames. This feature comes in handy when you're shooting under changing lighting conditions.

When you move the exposure-compensation dial to the plus settings (+), you are actually adding exposure to what the camera's exposure meter chose; conversely, the minus settings (−) decrease exposure. Most cameras provide a viewfinder signal when you use the exposure-compensation dial. Some cameras display the exact change in exposure; others simply tell you that you have altered the camera's exposure in some fashion and you have to read the dial or LCD to determine the exact amount.

Exposure compensation can be used to help the meter in difficult lighting situations, as well as to give you creative options regarding the way you want to record light on the film. For example, it is usually considered a good idea to add exposure when you shoot in an autoexposure mode with strong **BACKLIGHTING**, which occurs when the sun or a bright light source is behind your subject. As discussed earlier, most metering systems read light from almost all parts of the scene. So, if your subjects are seated with their backs to the window or in the shade of a tree with bright light on a field behind them, the camera's metering system will probably be thrown off by one or two stops and the subjects' faces will be underexposed. But, with a + 1-stop or + 1 ⅓-stop compensation, you will be able to correctly expose your principal subjects.

You should also increase exposure when shooting in the snow or whenever the subjects are highly reflective. Because the camera's built-in meter wants to turn the tones it sees an 18-percent gray, there is a very good chance that the meter will read the snow or the reflective subjects as darker than they actually are. By setting a + 1-stop you won't get "gray," or underexposed, snow or subjects in the final picture.

There are times when a backlit scene—one in which the brightest light comes from behind the foreground or main subject—requires less exposure to be effective. The important elements in such pictures are the mood, shapes, and light, not the details in the shadows. In most such scenes, an averaging meter in an SLR camera will yield a reading that takes the values of the foreground subject into account, possibly diminishing the effectiveness of the overall picture. Reducing the exposure by ½ to 1½ stops will create a moodier, more effective photo. Each of the pictures shown here was given this exposure compensation.

EXPOSURE OVERRIDES

A good deal of glare in a scene can also throw off the lightmeter, resulting in a reading that underexposes all the other values in the picture. While it's true that adding exposure to such a scene may result in even brighter glare, it's also true that without any exposure compensation, the rest of the picture may go unnaturally dark.

Overexposure can also be used creatively: you can use the exposure-compensation dial to make colors seem lighter, or washed-out. Suppose you're using slide film for a portrait of someone holding a flower. A "correct" exposure would result in normal skin-tones and normal colors for the clothing and flower. However, if you intentionally overexposed by half a stop to one full stop, you might bleach certain colors, lighten the tones of the picture overall, and, if the light is right, add a wistful, romantic touch to the scene. This is called a **HIGH-KEY EFFECT**.

Decreasing exposure through the use of the exposure-compensation dial can also correct certain failings of the meter and can help you achieve creative effects. When you shoot something in front of a dark wall and the foreground subject covers only a small portion of the frame, the meter will "see" a dark mass. The meter will then want to turn the wall an 18 percent gray. When it increases exposure to do so, two problems can result. First, the wall may now record more gray than black (or may be recorded lighter than you might like). Also, the subject will certainly be overexposed because when a dark tone is metered as a lighter one, all the other tones in the scene are made even lighter. To correct this type of problem, you have to "fool" the meter by setting a -1-stop or $-1\frac{1}{3}$-stop compensation. Practice will tell you when you might need to underexpose even more.

When you overexpose color-slide film, you are in danger of losing many of the highlight (or brighter tone) details in the scene, ones that cannot be retrieved in the printing step the way they can with color-and black-and-white-print film. The picture above was overexposed by two stops—the sky is "burnt up" and many areas of the white house have lost details. The picture on the right is also overexposed about two stops, but the touch of blue saves it and turns it into a high-key interpretation of a scene.

The minus compensation settings can also be used to manipulate the way film records light. Suppose, for example, you're shooting in a cathedral with shafts of light coming through the stained-glass windows and striking the floor. When you take a general reading of this scene, the meter takes into consideration both the overall dim light of the church interior and the bright shafts of colored light. If you're lucky, you'll get the effect you want, but you may just get a picture with washed-out shafts and dull interior lighting. By intentionally underexposing one or two stops, you will be able to preserve detail and color in the shafts of light.

But you don't have to count on luck in such situations. In fact, you can tilt the odds in your favor by learning to manipulate the exposure-compensation dial. Just keep in mind that slight underexposure adds to the intensity of colors, while slight overexposure lightens them. As a result, you can use the compensation dial to create images any way you wish.

LOCKING EXPOSURE

Another convenient exposure-override feature found on most SLRs is an exposure-lock button. When depressed, this "holds," or remembers, the reading the meter makes. As a result, you can make a reading off a specific tonal area or bright spot, and then shift and recompose without the camera's autoexposure system adjusting the reading in response to the new composition.

You might, for example, use the exposure-lock button when you photograph a sunset and want to record—or even accentuate—the rich colors in the sky. Pointing the camera directly at the sky may give you an exposure reading of $f/16$ for $\frac{1}{250}$ sec., while pointing the camera at the ground may indicate $f/5.6$ for $\frac{1}{60}$ sec., and pointing it at the horizon line and including equal amounts of sky and ground in the frame may call for $f/11$ for $\frac{1}{125}$ sec. After you take these three readings, you decide that you want to include both the sky and the ground in your composition. But, you know that if you shoot in an auto-exposure mode pointing straight ahead, you may overexpose the sky: the foreground throws off the exposure meter and lightens the colors of the sunset. With an exposure-lock button, you simply read for the sky, lock in the exposure, recompose, and shoot.

The exposure-lock button comes in handy when you take a reading from a specific part of a scene and want to hold that reading when you shoot, whether or not the composition or the light changes. It is also helpful for highlight control when shooting slides. In the top picture, exposure was made as recommended by the center-weighted meter in the camera; all the tones were averaged, and an acceptable picture results. However, recognizing that dark tones in the center of the image might throw off the reading and that some parts of the rock were "hot," I took a reading off the brighter rock surface, locked it in, and used it for the bottom picture. The result: richer colors and less tonal washout.

EXPOSURE OVERRIDES

On the other hand, you may sometimes want to lock in darker values. For example, you see a potential picture in an outdoor cafe, but the light shining on the umbrella tops is quite bright and the people sitting at the tables are in shadow. Here you should find a nearby spot that is similarly illuminated to the area underneath the umbrellas (perhaps a shaded section of the sidewalk), read it, lock in the exposure, recompose, and shoot.

Although your camera's manual-exposure systems are just as effective in controlling exposure, overrides allow for a much quicker and, when you've mastered them, more convenient form of adjusting exposures. But, whichever way you decide to change exposure, keep in mind that what's important is the ability to determine when the in-camera meter might not be able to give you the best results. Helping it along, or adding a personal touch, will give your pictures a more dramatic flair.

Sometimes slightly adjusting exposure in slide film or having color prints made slightly darker by the lab can have a subtly pleasing effect. In this scene, made on a medium-speed slide film, the exposure is certainly acceptable. However, because of the various levels of light in the scene, I bracketed down by ⅓-stop increments and chose the −⅔-stop slide on the right. Knowing when to shift exposure levels, even slightly, can make the difference between a good and an excellent exposure. Similarly, working with a custom-printing lab—or one that will at least print to your liking—can give many prints a professional edge.

BRACKETING EXPOSURES

MAKING ACCURATE EXPOSURES time after time, even in the most difficult lighting situations, may result from years of shooting experience. But on-target exposures are more often the result of BRACKETING. In this procedure, a number of exposures of the same scene are made: at the indicated exposure and at exposures both slightly above and below this value. With bracketing, you are basically guaranteed an excellent—not just correct—exposure. Because variations in exposure subtly alter color and tonal renditions, each exposure has a nuance—a slightly different interpretation of the light—and a series of bracketed shots contain the "perfect" variation.

A typical bracketing sequence begins with a correct reading for a scene, made with any of the autoexposure modes on your SLR. You would then begin to slightly under- and overexpose. For example, suppose the initial reading is $f/5.6$ for $\frac{1}{60}$ sec. A one-stop plus/minus bracket series would give a total of three exposures: $f/4$ for $\frac{1}{60}$ sec. (or $f/5.6$ for $\frac{1}{30}$ sec.) for a one-stop overexposure, $f/5.6$ for $\frac{1}{60}$ sec. (the initial reading), and $f/8$ for $\frac{1}{60}$ sec. (or $f/5.6$ for $\frac{1}{125}$ sec.) for a one-stop underexposure. With slide film, for which a one-stop exposure shift may be profound, you'll more than likely be bracketing in one-half or one-third stops. The exposure-compensation dial certainly comes in handy here. The sequence might be: $-\frac{2}{3}$ stop, $-\frac{1}{3}$ stop, initial exposure, $+\frac{1}{3}$ stop, and $+\frac{2}{3}$ stop.

Bracketing can be done manually by changing the aperture or shutter-speed settings as you shoot or by changing the ISO setting or manipulating the exposure-compensation dial. Some cameras with micro-computers and built-in motor drives have an auto-bracketing program, which you preset; when you depress the shutter-release button, the camera automatically takes a rapid sequence of exposures according to your specifications. This is, by far, the smoothest way to bracket and guarantees that you'll capture virtually the same scene throughout the bracketing sequence.

Obviously, you can go through a great deal of film quickly, and bracketing should only be used when lighting conditions are so extreme that you think that the light meter may be off, such as with very contrasty light, and when the shot is special enough. Don't bracket when you're shooting casually, except when you first begin photographing and bracket to see how it affects your results.

Bracketing also shows you that there is rarely one perfect, or correct, exposure for any picture. In general, a correct exposure is one that accurately records most of the tones in a scene. But you'll soon see that this isn't always necessary, such as when you decide to alter exposure in order to interpret reality, not just to record it. When you see all the possibilities of bracketed exposures, you may begin to realize that photography has less to do with meters and scientifically correct results than with the nuances of tone, shadow, and light. In a sense, an exposure that differs somewhat from an objectively correct reading of light can be subjectively right. As long as you get on film what you want to show or say about a particular moment or a scene, you will arrive at your "correct" exposure, regardless of what the meter reads.

This subject is perfect for a bracketing sequence. Although nearly every exposure in the bracket might yield an acceptable exposure, there will probably be only one that gives you exactly what you had in mind. In addition the lighting conditions are such that making a reading for that "perfect" exposure might be a problem. The top left picture was made with a +1-stop exposure compensation, the top right picture with a −1-stop exposure compensation, and the bottom picture with a −⅓-stop exposure compensation. Choosing the "right" exposure here is a matter of taste. Bracketing slide film gives you the freedom to choose from among a number of variations after you have made the shots.

MATCHING FILM SPEED TO THE LIGHT

ALTHOUGH YOU CAN EXPERIMENT and use any film you want under any lighting condition, some general guidelines for coordinating film speed and lighting will help you get the best results in terms of color, contrast, sharpness, and grain, and give you the most shooting freedom. Here are some typical lighting situations paired with the film speeds that will deliver optimum results.

DAYLIGHT, FULL SUN

As a general rule, always use the slowest film speed you possibly can when shooting color film. The slower the film (the lower the ISO number), the finer the grain, the better the sharpness, and the more vivid the color. So, when the light is full and bright, use an ISO 25, 100, or 200 color-print film, and an ISO 25, 50, 64, or 100 color-slide film.

Daylight exposures can often be calculated using the **SUNNY 16 RULE**. According to this time-honored guideline, **THE CORRECT EXPOSURE FOR ANY FILM IN FULL DAYLIGHT CAN BE FOUND BY USING THE RECIPROCAL OF THE FILM'S ISO AS THE SHUTTER SPEED AND f/16 AS THE APERTURE.** So, for an ISO 100 film, an exposure of $\frac{1}{125}$ sec. (there's no $\frac{1}{100}$ on the shutter-speed dial) at f/16 will give you a good exposure on a sunny day. Similarly, for ISO 50 film an exposure of $\frac{1}{60}$ sec. at f/16 follows the "sunny 16" rule. Although this guideline was most useful when exposure calculation was difficult, it can still come in handy as a way of making sure that your in-camera meter is relatively accurate when it reads out exposure information.

Of course, you don't always have to use a slow-speed film, but you may sacrifice some picture quality. For example, both ISO 100 and ISO 1000 films can be exposed in full daylight, but the ISO 1000 photograph will look much grainier than the ISO 100 photograph. Also, the faster film will probably be more contrasty and harsh overall. Of course, you may sometimes want the particular look of a fast film in daylight; this is when it helps to know what happens when the rules are broken creatively.

For outdoor shots using color-slide film, there are four slow speeds you can choose from: ISO 25, 50, 64, and 100. Which one is best? When deciding, keep two points in mind: first, the slower the film speed, the finer the grain; second, the film speed determines the range of apertures and shutter speeds that can be used with the film.

ISO 25 film has the finest grain of any camera film made. Its color and sharpness make it outstanding. However, ISO 100 film is two stops faster than ISO 25 film. So, if the exposure with the ISO 25 film is f/8 for $\frac{1}{125}$ sec. on a sunny day, the exposure with the ISO 100 film will be f/16 for $\frac{1}{125}$ sec., f/8 for $\frac{1}{500}$ sec., or f/11 for $\frac{1}{250}$ sec. If the subjects are moving fast or if you want a greater zone of sharpness for your shots (and you're shooting handheld), then you should choose the faster film.

Aside from these considerations, film choice often comes down to personal taste. Each film has a certain personality, or the way it renders colors and tones. As you work with different types of film, you'll discover favorites that you'll use time after time. The real quality differences exist only when there are large differences in film speed.

DAYLIGHT/DULL OR OVERCAST SKY/SHADE

While it may seem surprising, daylight conditions other than bright and sunny are ideal for color photography. One main reason for this is that such light helps to eliminate the problems of excessive contrast. In fact, studio photographers have discovered the benefits of a softer light source and often cover their electronic flash units with a translucent, light-diffusing material to minimize the quality of strong, direct light.

Unfortunately, many people don't shoot when the sun hides behind the clouds, when fog covers the ground, or when rain threatens. But these lighting conditions can provide a special illumination that brings out all subtle tones and shades of color.

Low light levels mean that you may not be able to use the slower speed films: the ISO 25, 50, and perhaps 64, as well as ISO 100 color-slide and color- and black-and-white-print films when photographing handheld. Of course, you can shoot with wide apertures, but this limits flexibility. Luckily, the next group of films, the medium to medium-fast films, provide more speed with only a slight decrease in grain and sharpness. The two main color-print films you should pack on an overcast day are ISO 200 and 400. In some ways, these films are nearly universal in application: they can be used successfully in the

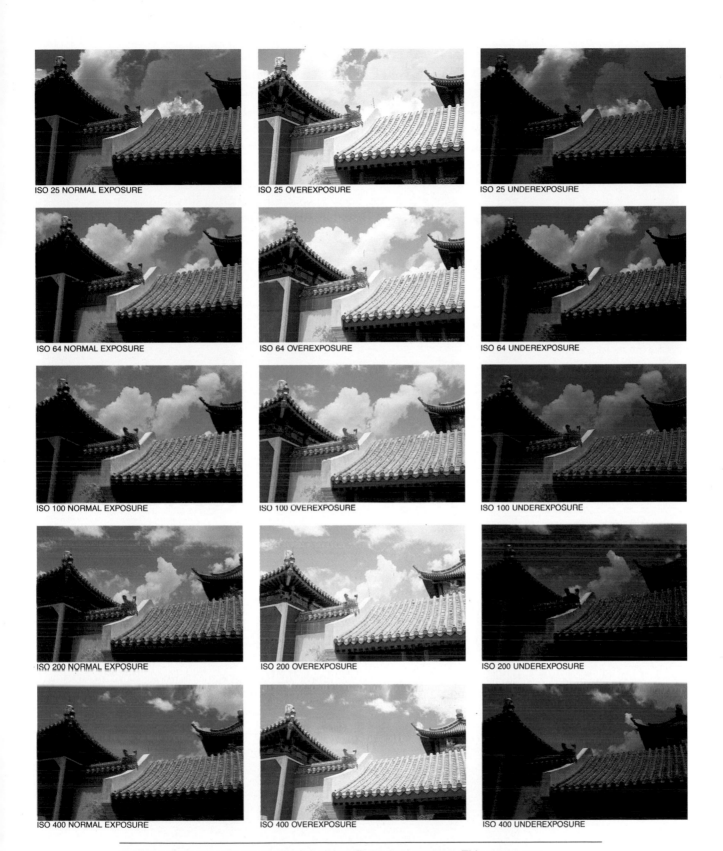

ISO 25 NORMAL EXPOSURE

ISO 25 OVEREXPOSURE

ISO 25 UNDEREXPOSURE

ISO 64 NORMAL EXPOSURE

ISO 64 OVEREXPOSURE

ISO 64 UNDEREXPOSURE

ISO 100 NORMAL EXPOSURE

ISO 100 OVEREXPOSURE

ISO 100 UNDEREXPOSURE

ISO 200 NORMAL EXPOSURE

ISO 200 OVEREXPOSURE

ISO 200 UNDEREXPOSURE

ISO 400 NORMAL EXPOSURE

ISO 400 OVEREXPOSURE

ISO 400 UNDEREXPOSURE

Part of a film's "personality" is the way it handles scene contrast. This scene was photographed on a bright sunny day with a number of different slide films, ranging in speeds from ISO 25 to 400. In each case the scene was shot at the correct exposure and was bracketed for an over- and an underexposure. As you can see, the personality of each film renders the shadow and highlight relationship somewhat differently, with the differences becoming most apparent when exposure deviates from the norm.

brightest to the dimmest light. While it's true that ISO 100 film is best in many ways, ISO 200 and 400 films are faster, giving you a bit more shooting freedom with only a slight sacrifice in quality.

Suppose you're traveling and as you tour the sights, you shoot street scenes and museum interiors. You even carry your camera with you to dinner at an outdoor cafe. Naturally, you'll want to bring a number of rolls of film with you—and might feel that you need a variety of film speeds to cover all possible lighting situations. But if you're shooting color-print or black-and-white film, you can usually stick to one film speed, such as ISO 200 or 400, and take pictures in nearly every lighting condition you encounter, from bright street scenes to interiors of houses and museums. In fact, you can even get some nighttime shots, but only if you can steady the camera on a table edge or a railing. One of the reasons these films are so versatile is their ability to deliver good images even when they are slightly over- or underexposed; of

Sometimes you have to wait for the light to be right. In fact, some photographers simply won't shoot in normal, or midday, light and wait for the more dramatic hours of the day to pick up their cameras. On top is a normal contrast scene of a fisherman. Two hours later, when the sun lowered and the light became more dramatic and contrasty, the bottom picture was exposed by making the highlight, or brightest value in the scene, the most important. This turned the fisherman into a silhouette, and a straightforward scene into an image with graphic appeal.

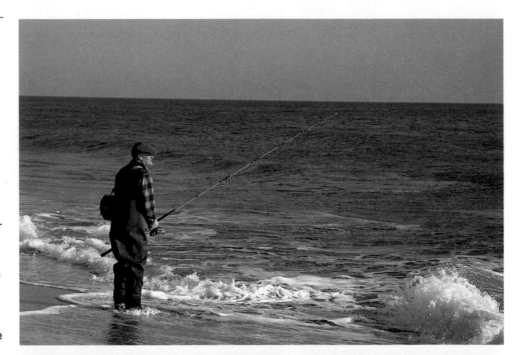

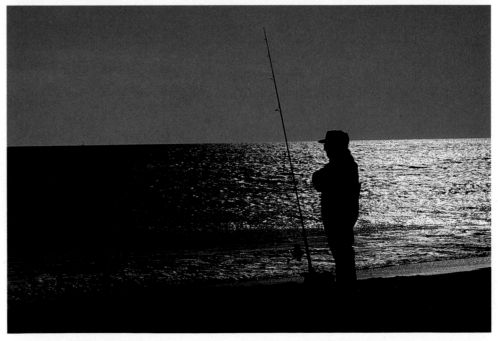

When you're shooting action subjects, a medium-to-fast film often comes in handy. In this shot, a fairly slow 180mm lens was used (the maximum aperture on the lens was $f/4$). To get the shutter speed required to "stop" motion in the lighting conditions, an ISO 200 film was needed. The final exposure of 1/500 sec. at $f/4$ stopped the action but yielded a fairly shallow depth of field. However, if an ISO 100 film had been used, the loss of one stop would have required a shutter speed of 1/250 sec.; this might not have been fast enough to freeze the moving runner in his tracks.

course, it is best to shoot the films at the optimum exposure for their speed, but you can always shoot them at one stop higher or lower and still get quite acceptable results. Color-slide films, however, are not as flexible in terms of exposure; in fact, they are quite exacting. So when you're shooting handheld on an overcast day, you might need an ISO 200 or 400 color-print film.

The primary reason for using a medium- or high-speed film in overcast or dim lighting conditions is that it provides the greatest shooting freedom, allowing you to use a wide range of apertures and shutter speeds. Of course, if you use a tripod or some other camera-steadying device, you can use a slow film in low light by shooting with longer shutter speeds. Unfortunately, a gain in film speed corresponds to a slight loss in picture quality, especially in terms of graininess and slightly less sharpness. You will have to decide whether or not the sacrifice is worth it. For example, if you're shooting ISO 50 film in the late afternoon as a heavy cloud cover moves in, you may get a reading of $f/5.6$ for 1/60 sec. While this is a reasonable exposure, it limits how you can manipulate depth of field. To increase depth of field by shooting at $f/16$, you will have to expose for 1/8

sec. to compensate for the three-stop change in aperture. Keep in mind, however, that this shutter speed is much too slow for a handheld shot and will not stop any sort of movement. In order to use $f/16$ for 1/60 sec., you would need to switch to ISO 400 film, which is three stops faster than ISO 50.

You will also need a faster film to capture motion, such as when you want to photograph a marathon on a cool, dismal day. With an ISO 64 film, you may get a reading of $f/8$ for 1/60 sec. While this may give you the depth of field you want, the shutter speed may not be fast enough to keep the runners from becoming a blur. Remember, each increase in film speed gives you a corresponding ability to use either faster shutter speeds or narrower apertures.

Keep in mind, too, that, whenever possible, shoot with the slowest speed film you can, whatever the lighting conditions. This guarantees the best grain, contrast, sharpness, and color rendition overall and explains why photographers don't use only the fastest film they can find. Although they would have more leeway in terms of speed, they would sacrifice overall picture quality. But there are times when film choice is dictated by the light or when the effect you want cannot be achieved with a slower speed film.

PART IV

CREATIVE POSSIBILITIES

FOCUSING AND DEPTH OF FIELD

THERE ARE MANY TIMES when the narrow sharpness zones obtained by using a wide aperture are desirable. If you take a look at the depth-of-field scale on the barrel of a 50mm lens, you'll notice that there are generally no apertures wider than $f/4$. This is because depth of field becomes so shallow at such apertures that indicating the range on the lens barrel or depth-of-field scale is impractical. Although $f/3.5$ provides more depth of field than $f/1.4$ does, you'll have to use the depth-of-field preview button to get an idea of what the difference is; the lens barrel will not help. (Some lens manufacturers do, however, publish depth-of-field tables for all apertures.)

Be aware, however, that using a wide aperture to obtain a shallow depth of field can be used creatively to isolate subjects by producing a "soft" background and to emphasize one subject in a busy scene. For example, suppose you're shooting a flower in a greenhouse and want a distracting object in the background to "disappear." If you shoot at close range with a 50mm lens set at its maximum aperture and focus on the petals, everything behind the flower will blur. You can also use a shallow depth of field

for outdoor portraits. Here, you place your subject in front of a colorful background and set the depth of field so that only the subject is in focus; you have instantly created a soft background.

There will be other occasions when you will want to have an extensive zone of sharpness. By using the aperture-priority mode on your camera—which allows you to set the aperture and the camera to select the shutter speed—you can maximize the depth of field: all you need to do is to manipulate the distance marker in relation to the depth-of-field scale. For example, in bright-light situations when you use a moderately fast film, such as ISO 200, and a wide angle lens, such as a 28mm, you can set the aperture on $f/22$ and align the "22" mark on the depth-of-field scale with the infinity symbol on the distance marker. This gives you a zone of sharpness of approximately 2 feet to infinity. While this may yield a fairly slow shutter speed, it shows that a narrow aperture can yield a deep zone of sharpness. Similarly, in average lighting conditions with a moderate speed film, such as ISO 100 film, set the aperture at $f/8$ and align the "8" mark on the depth-of-field

When you move closer to your subject, you'll have to stop the lens down to maintain the same depth of field with the same focal-length lens. Both of these shots were made with a 35mm lens. In the top photo the exposure was $1/250$ sec. at $f/8$, an aperture that yielded sufficient depth of field. The camera was closer to the bush in the photo on the right; however, in order to maintain nearly the same near-to-far sharpness, I had to shift the aperture to $f/16$, which meant that the shutter speed had to drop to $1/60$ sec. to get an equivalent exposure.

Depth of field at any aperture depends upon the focal length of the lens in use. Three of these shots were made at *f*/8; all except the last in the series were made from the same shooting position. The top left and right photos were made with 35mm and 70mm focal lengths respectively, rendering sharp focus from foreground to infinity. However, switching to a 180mm lens at *f*/8 made the depth of field in the bottom left photo too shallow to get all the elements in focus, so the buildings in the background went slightly "soft." In the bottom right photo this problem was rectified by switching the aperture on the 180mm lens to *f*/22, creating a deeper zone of focus and thereby bringing every part of the scene into focus.

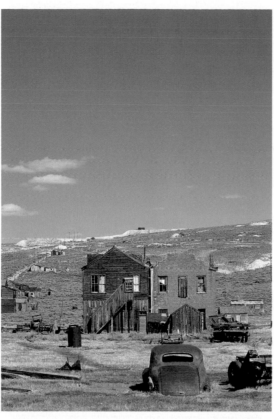

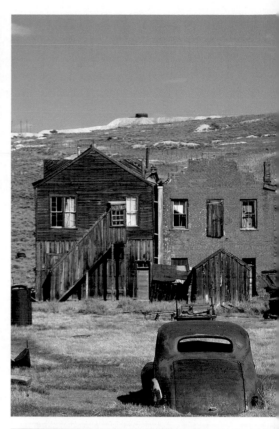

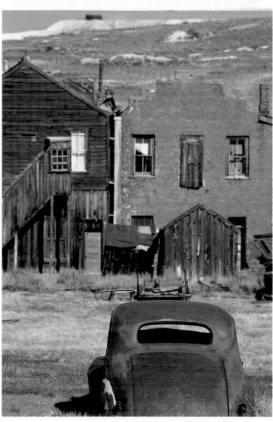

scale with the infinity sign on the distance scale. This gives you a depth of field of approximately 6 feet to infinity. Although the scene may appear to be out of focus when you look through the viewfinder, you can check the sharpness of the image throughout by depressing the depth-of-field preview button. If your camera lacks this feature, you'll have to trust the depth-of-field scale; the proof of its accuracy will be seen in your finished pictures.

When you first begin to experiment with depth of field, remember that the zone of sharpness of any lens depends upon the focal length of the lens. The rule is **THE LONGER THE FOCAL LENGTH, THE LESS DEPTH OF FIELD IS AVAILABLE AT ANY GIVEN *f*-STOP AND CAMERA-TO-SUBJECT DISTANCE;** conversely, the shorter the focal length, the more depth of field available at any given *f*-stop and subject distance. For example, suppose you stand in a specific spot and photograph a scene with both a 28mm lens and a 300mm lens set at *f*/11. With the 28mm lens, you can set the hyperfocal distance so that the zone of sharpness will be approximately 8 feet to infinity; with the 300mm lens, the hyperfocal distance will be, at best, approximately 150 feet to infinity.

Just as the focal length of a lens influences potential depth of field, so does the distance between the camera and the subject. Any decrease in this distance produces a corresponding decrease in the depth of field at any given aperture on the same lens. Consider using *f*/16 on a 50mm lens. If you focus the lens on a subject at a distance of 16 feet, the zone of sharpness will be approximately 8 feet to infinity.

If we lived in a two-dimensional world, we'd have very few problems with focusing and depth of field. Though photographers do make pictures of flat surfaces, such as these wall posters, it is more fun to make focusing decisions about scenes that have more depth, such as the photo on the right that conveys a really three-dimensional feeling of the world.

FOCUSING AND DEPTH OF FIELD

Moving closer to the subject and focusing on it from a distance of about 6 feet, the available depth of field will decrease to approximately 4–10 feet. Moving even closer, to just 3 feet away from the subject, the total depth of field will be only about 1 foot.

Zones of sharpness are, however, quite extensive with ultrawide-angle lenses. For example, with a 20mm lens set at $f/16$, the depth of field could be approximately 1 foot to infinity. This means that you can stand as close to a subject as 1 foot and still get the background in focus by setting the hyperfocal distance. But, even more impressive, when you use a 300mm lens, the zone of sharpness for a nearby subject, such as one at the lens's minimum focusing distance of about 10 feet, can be as narrow as a few inches, even at narrow apertures.

As you can see, you can choose a lens for particular pictures solely on the basis of its ability to provide a greater zone of sharpness. For example, many people associate landscape photography with telephoto lenses because, in a sense, they help to eliminate distracting, unnecessary foreground details and "bring" photographers closer to a distant subject. But ultrawide-angle lenses that allow photographers to focus from 1 foot to infinity are also appropriate for landscape images. With these lenses, even subjects in the very near foreground can be included in the scene and used as a design element.

Some photographers might want to use a wide-angle lens to take in an entire scene and make sure that every part of it is in sharp focus. Still other photographers isolate one element of a scene by using a telephoto lens to get closer to it, and then accentuate the effect by using a very shallow zone of sharpness; as a result, the subject seems to emerge from the background.

Pre-setting the aperture and footage markers on your lens lets you know what depth of field is available even before you shoot; then you can shoot candids quickly, without having to bother about focusing or even bringing the camera to your eye. This style of working is often referred to as "grab" shooting. Many photographers use zone focusing or set the hyperfocal distance when shooting street scenes and when they don't want the subject to be aware that a picture is being taken. Because wide-angle lenses offer a potentially greater depth of field than telephoto lenses, focal lengths such as 28mm, 35mm, or even the normal 50mm are best for these "grabbing" techniques.

Keep in mind that all the elements that go into focusing— lens, aperture, depth of field, and camera-to-subject distance—work in concert. By combining and exploiting these factors, you'll be able to control focus so that you can achieve any creative effect you desire.

Presetting a camera for a certain range of sharpness means that you can shoot quickly without losing time while focusing the lens. This enables you to "grab" candid shots, such as the one on the right.

The shot on the opposite page was made with a 24mm lens; by combining a deep zone of sharpness with a vertical composition, I was able to accentuate the sweep of the staircase.

THE BEAUTY OF BLACK AND WHITE

ALTHOUGH MOST of the discussions here focus on color photography, there is also a wonderful world of black-and-white photography for you to explore. No one can deny the power and glory of this medium; in fact, some "serious" photographers won't shoot anything but black and white. Black and white is quite flexible and inspires different photographers in different ways. Some perceive it as an accurate reflection of the world: no distracting colors get in the way. Other photographers regard black and white as a highly interpretive medium because they can take a negative from black-and-white film and make it into almost anything they want, from a high-contrast graphic to a moody, glowing, silver-rich print.

A few black-and-white films are fine for most outdoor shooting. These films are ISO 100, 125, and 400. All produce good results, but ISO 100 film has finer grain and better sharpness. Keep in mind, however, that ISO 400 film works quite well for outdoor photography. This is because it has an edge over the slower films in terms of bridging brightness ranges and because its inherent contrast is slightly lower. In bright lighting conditions with deep shadows and brilliant highlights, ISO 400 film gives you the greatest chance of recording all the tonal values in the scene. All of these films are extremely "smooth"; each has an exquisite gradation of tones.

When shooting black-and-white film on dimly lit days, use ISO 400 film. It provides a great deal of leeway in exposure settings. There are times when you can "push," or raise the ISO black-and-white films beyond their nominal speed. This comes in handy when you want to shoot an entire roll at a higher speed (see page 132).

These ladies on parade were captured with a 35mm lens on ISO 400 black-and-white film. The exposure was 1/125 sec. at ƒ/8.

This abstract adobe scene was starkly rendered with a 28mm lens on ISO 400 black-and-white film. The exposure was ⅟₁₂₅ sec. at f/11.

FLASH PHOTOGRAPHY

Wʜɪʟᴇ ᴡᴏʀᴋɪɴɢ ᴡɪᴛʜ available light is often a challenge, adding a burst of light from an electronic flash unit is often the most practical approach to shooting in low light. In fact, it may be the difference between getting a shot or missing it. Aside from its advantages in low-light shooting, flash is great for capturing a fast-moving subject in any light.

One highly useful mode available on most modern SLRs adjusts them for fully automatic flash photography. This is commonly called **AUTO-FLASH**, or **TTL-FLASH**. When you buy a flash unit today, you'll more than likely get one that is dedicated to your camera's exposure system. This means that when you mount and activate the flash unit, the synch speed is set automatically. In some cases, the "brains" in the camera calculate and cut down the output of the flash unit according to the amount of light that comes back through the lens (TTL).

The TTL system eliminates many of the problems associated with calculating exposure every time you make a flash shot. Some dedicated flashes offer TTL modes for shooting with wide, normal, or telephoto lenses, or set these modes automatically according to the focal length in use.

Shooting with flash in manual mode works on the same principles as shooting with any other light source, except that flash photography allows you to have a bit more control over the lighting in a scene. But with this increase in control comes an increase in responsibility. You must be aware of the flash-to-subject distance, the flash output, and the type of flash (direct, bounce, soft) you want to use.

GUIDE NUMBERS

Every flash unit has a power rating, which is usually expressed as a **GUIDE NUMBER**, or **GN**. Flash units with higher GNs have more power. If you look up the GN of your flash unit in the accompanying instruction booklet, you will see that the GN is modified by the speed of the film in use. For example, a flash unit may have a GN of 40 with ISO 50 film and a GN of 60 with ISO 100 film. Generally, the designated GN of a flash unit is based on its relation to ISO 100 film, but some companies relate a flash unit's GN to ISO 400 film in an obvious attempt to persuade the consumer that the unit is more powerful than it actually is. When you shoot, keep in mind that flash

Although every flash has a maximum light output, the coverage within that range is determined by the speed of the film in the camera and the *f*-stop setting of the lens. The higher the speed of the film, the greater the coverage (or "throw") at any particular *f*-stop; the wider the aperture, the more the coverage with any speed film. Here, the top three pictures were shot with ISO 100 film at *f*/8, *f*/5.6, and *f*/4 respectively with a flash set on full manual output; the bottom three were exposed the same way but on ISO 400 film. Notice how the coverage increases as the aperture widens, and how greater overall coverage is afforded with the faster-speed film.

Here, the light from the sun was essentially replaced as the main light in the scene by adding an electronic flash. The photo above was made under a noonday sun; exposure was f/11 at ⅟₆₀ sec. Notice how the edges of some of the leaves are overexposed and the colors seem a bit weak. In the photo on the right the exposure was changed to f/16 at ⅟₁₂₅ sec., and the flash was set on full power.

photography shutter speeds are anchored at the sync speed of the camera; you can shoot at speeds slower than sync speeds, but not at higher ones.

To control light in flash photography, vary both the output of the flash and the aperture setting on the camera. First, however, you have to determine the exposure setting by dividing the GN by the flash-to-subject distance. This calculation gives you the aperture setting; the shutter speed remains constant when you shoot with flash. Suppose you're working with a flash unit that has a GN of 80 and ISO 100 film, and your subject is 10 feet away. To determine the aperture that will provide the correct exposure, simply divide the GN by the distance. Here, the equation works out to 80 divided by 10, which equals 8. The aperture, then, should be set on f/8.

While this type of calculation comes in handy when you're doing special effects with flash, or shooting with fill flash (see below), there's very little need for it in ordinary flash photography. Dedicated, thyristor, and other "smart" flashes make these calculations for you. All you might have to do is to program the film speed, or to switch to full-power flash mode if you want to use the flash at maximum **THROW**, or power. But at normal ranges, from 5 to 20 feet, most automatic flashes work quite well.

FILL FLASH

Although this may sound like a contradiction, shooting with flash is sometimes very useful for outdoor photography. For backlit scenes in which exposure compensation is required to light a face that is in shadow, there is another solution: adding light to the face with flash. This is called **FILL FLASH**, and it balances the light between the foreground and background of a picture, without making it look false. Fill flash can be triggered automatically with many modern flash units, but the results may not always be as subtle or natural as you might like. If this happens, cover the flash unit with a translucent cloth or tissue; this softens the burst of light.

FLASH PHOTOGRAPHY

When you use fill flash, you can bring a better balance to scenes where the foreground and background have quite different brightness levels. In the top left picture, there is a very severe backlit situation; exposing for the background means a highly underexposed subject. But exposing for the backlit subject results in a loss of the quality of light in the background, as in the bottom left picture. However, using fill flash as in the shot on the right gives the best of both worlds.

Some of the best fill-flash results come from using manual settings on your camera and flash unit. First, you must set the shutter speed to sync speed, take a normal light reading of the light behind the subject, and note the aperture required for correct exposure. Once you have these settings, check the flash calculator dial to see how to set the output on the flash unit in order to cover the flash-to-subject distance at the f-stop at which you are shooting.

Fill flash offers you a number of creative possibilities—not just making a face appear less shadowy. You can decrease the output by a greater amount than the flash dial recommends to give a softer, perhaps more natural, look to the fill light. You can also underexpose the background and work with only the flash-to-subject distance to determine the light output; this will make the flash unit the main light source and will make some shots look dramatic. You can also add a tiny amount of illumination to all outdoor scenes by using the smallest light output possible.

Some flash units allow you to do more than automatically add fill; they actually let you program the "proportion" of fill you want in a scene. These units first calculate a fill-flash output based on the reading of both the foreground and background; then after you program the unit to, for example, add a slight ¼-stop fill, it puts out just enough flash power to subtly alter the lighting of the foreground subject. These programmable fill flashes eliminate all the calculations that can make fill flash complex.

FILMS FOR FLASH PHOTOGRAPHY

You can use almost any type of film for flash photography because the tube in the flash head is balanced to provide the color equivalent of daylight illumination. Deciding which film to use largely depends on the approximate distance between the flash unit and the subject: the greater this distance, the higher the film speed required. Of course, every flash unit's output has a limit, but using higher film speeds maximizes whatever power the flash has to offer. Also, just as it does with outdoor shooting, using a film with a higher ISO rating gives you a larger range of apertures to work with.

If you were using a flash unit with a GN of 40 for ISO 50 film, a subject at a distance of 10 feet would require an aperture of $f/4$ for correct exposure. But

if you were using the same flash unit with ISO 100 film, and the corresponding GN was 60, the aperture needed for correct exposure at the same distance would be $f/5.6$. As you can see, using a one-stop faster film means you have one stop more to play with when shooting with flash. Using even higher film speeds will enable you to use even higher apertures. For example, using the same flash unit with ISO 200 film, and a GN of 80 at the same distance, the equation would be 80 divided by 10 equals 8; the aperture would then be $f/8$. Similarly, with the same flash unit, ISO 400 film, and a GN of 110 at the same shooting distance of 10 feet, the equation would be 110 divided by 10 equals 11, so the resulting aperture would be $f/11$.

Higher apertures come in handy when you shoot flash exposures of groups. For example, you're photographing a wedding reception and start taking table shots to get pictures of an extended family. If you're using ISO 50 film with a GN of 40, and the first row of people in the group shot are at a distance of 10 feet, an $f/4$ setting (40 divided by 10 equals 4) won't provide sufficient depth of field to keep both the first and third rows sharp. However, with a higher film speed—such as ISO 400 with a GN of 110, which will result in a setting of $f/11$ at 10 feet—you'll probably have adequate depth of field to focus on the group from front to back.

This equation also applies to getting maximum throw from the flash unit. Shooting on Halloween night with an ISO 50 film and a typical flash unit, you might only be able to get a maximum distance of about 15 feet—and a truly effective throw of about 10 feet—from your flash unit. With an ISO 400 film, however, this maximum range would increase to almost 40 feet, with a truly effective range between 30 feet and 35 feet. Keep in mind that the aperture must be wide open with these settings, which you may have to do out of necessity rather than desire.

Of course, every flash unit has a maximum range, regardless of the speed of the film in use. And when you use faster films, you sacrifice some picture quality. Once again, use the slowest film you can, but switch to a higher-speed film when necessary. If you're doing a great deal of closeup flash work, stick to slow film. But if you're shooting for long distance or anticipate needing higher apertures, keep higher-speed films on hand.

SHOOTING IN ARTIFICIAL LIGHT

MANY TIMES A FLASH UNIT won't be any help for shooting indoors. For example, if you're sitting thirty rows up at the circus, a sporting event, or a concert, your flash unit will not have enough power to illuminate the distant subjects. Although some kind of image may come out when you take a picture with your flash unit, rest assured that it will have nothing to do with the light from the flash; you simply would be wasting battery power.

At other times, shooting with flash is prohibited, such as in some museums and churches. Also, the single burst of the flash may illuminate a subject close at hand, but may cause the rest of the scene to go dark, an effect you may not want in your shot. Flash can sometimes ruin the character of existing light, too, regardless of how dim it may be. Used subtly, flash can be beautiful; too often, however, it is used at the expense of the potential magic of an available-light photograph.

While it might seem obvious that you should switch to a higher-speed film in these situations, there's another problem you might have to consider. This involves the "color" of the available light and the way film responds to it. Such scenes include those illuminated by street lamps at night, floodlights in a concert hall or arena, or lamps in your living room. Because certain types of lamps have different colors than normal daylight does, the way film records them differs. But this variation has no significant effect on exposure.

Unlike the human eye, film cannot adapt to changes in the colors of the illumination in a room. Household light bulbs actually emit an amber, or reddish yellow, light, at least when compared with daylight. When we enter a room, our eyes automatically adjust to such changes in the color cast of different lights. Film, however, is balanced to record color as it appears in daylight, which is why the words "daylight-balanced" are printed on film boxes. Because film cannot shift to give correct color balance in artificial light, daylight-balanced film shot in room light ends up looking amber in the print or slide. This holds true for street shots at night and for pictures in arenas and halls that are illuminated with tungsten light.

One way to help film "see" correctly in artificial light is to use a **COLOR-BALANCING FILTER**. The one used to balance daylight film shot in artificial light is a blue-tinted glass referred to as an **80A FILTER**. But keep in mind that this filter cuts the amount of light entering the camera by approximately 1½ stops. As a result, this loss of light might force you to set a wider aperture and/or a slower shutter speed, or to choose a higher-speed film than you would prefer to use for a given scene.

With color-print film, a certain amount of color correction can be made in printing. Unfortunately, high-speed automated printing machines don't always make this correction on the first pass, so you may have to return your prints and persuade the lab

You can get a good idea of the bluish cast of tungsten-balanced film by shooting it outdoors. The picture on the left was shot with a tungsten-balanced slide film, while the other was made with a "normal" daylight-balanced film. There may be times when a tungsten-balanced film can be used outdoors for special effects.

personnel to print the negatives again without the yellowish cast. (The people behind the counter may try to convince you that this cannot be done. But it can be done; they just want to avoid extra work. You can't blame them for that, but neither can they blame you for wanting your money's worth. Be persistent.)

Color-slide films, on the other hand, cannot be color-corrected; there's no printing step to color-balance the pictures. To overcome this problem, you can use a group of slide films made especially for shooting in tungsten light; these films are, appropriately, named **TUNGSTEN-BALANCED FILMS**. They respond correctly in artificial light and approximate the effect of an 80A filter. You can easily see how these films are biased by shooting them outdoors: your pictures will have a bluish cast. But when you shoot these films under tungsten light, they counteract the amber available light and produce slides that more closely resemble what the eye sees. Tungsten-balanced films come in slow- and high-speed versions. The slow films are perfect for copying artwork and for shooting still lifes and portraits under tungsten-balanced lamps. The fast films are ideal for shooting more active subjects under artificial lighting. Because tungsten-balanced films belong to the E-6 group, they can be push-processed to even higher speeds. (Keep in mind, however, that more than a two-stop push will result in a serious loss of image quality.) As a result, tungsten-balanced films are a natural choice for shooting slides in museums, and at indoor concerts and sporting events.

Be aware, however, that these films are balanced for a specific type of tungsten light, so they may not give you the exact color rendition you want in every scene. Also, some arenas now have daylight-balanced artificial lights, and shooting in these environments with a tungsten-balanced film will produce blue pictures. Be sure to check with the information office at arenas before shooting.

In general, the most profound effect artificial-light sources can have on picture-taking is adding a harsh, contrasty look to a scene, especially when the light source is included in the frame. This becomes quite apparent in nighttime scenes: streetlamps in a picture actually seem to "burn up," leaving only the film base in slides and a hot white area in prints. When you shoot at home, where the only artificial light is from household lamps or overhead fixtures, try to

Contrast can be a problem when you shoot in normal room lighting. Though the lighting is dim overall, the light source is still considerably brighter than the surroundings. These pictures were made with two light sources: the table lamp behind the subjects and an overhead ceiling light. As the exposure is increased from top to bottom, the subjects' faces come out of the shadows and begin to be properly exposed. However, notice what happens to the details in the lamp and the painting behind it—they begin to "burn up." In such situations, you'll have to decide which parts of the scene are more important, and expose accordingly.

This picture was made on Halloween on the streets of New York with a high-speed color-slide film. The artificial daylight combined with the daylight-balanced film to create the mix of colors you see here.

A handheld exposure of ⅛ sec. at $f/2$ on ISO 200 film was used to bring an abstract quality to this picture. Although there was camera shake, it contributed to the overall feeling of the whirling carnival ride.

When the subject is *just* lights, you should have little trouble getting the correct exposure. In this scene, made in downtown Las Vegas, the meter was set on program-exposure mode, and the metering pattern was center-weighted averaging. An ISO 400 slide film was exposed for ⅟₃₀ sec. at f/2.8.

compose without including the light source in the frame. Remember, film can't handle contrast the same way our eyes can, so when the light is low and contrasty, the finished pictures may not match what we saw with our eyes.

The main challenge you face when photographing these scenes is getting shutter speed—and, of course, an aperture that suits your needs—that doesn't require the use of a tripod. While tripods are great tools for shooting in almost any light and for making time and special-effects exposures, they can be awkward and, in most 35mm shooting situations, may simply get in the way. Using fast films when you work with "slow" lenses helps to solve this problem.

Color-print film comes in a range of high speeds, and ISO 400, 1000, 1600, and 3200 films produce quite good results. Again, the increase in speed results in some loss of picture quality. But improvements in film-emulsion technology are beginning to solve this problem.

Finally, making pictures at night calls for special exposure techniques. In some cases, the in-camera meter may factor in too much of the darkness, resulting in an overexposure of any lights or light tones in the scene. At other times, you'll have to use very long exposures to see anything on the film. Although one alternative is to use flash, you will soon find that your flash unit may not be able to cover the flash-to-subject distance, or that it alters the personality of the shot you had in mind.

While you can use any film you wish for night shooting if you expose carefully, unless you use the flash or are willing to shoot with very long exposure times, the best choice is a fast film, such as ISO 400. You can get more speed by raising the film's ISO and having a lab "push" the film during processing. Pushing film to a higher speed may make the difference between a steady handheld shot and one marred by camera shake—a result of too slow a shutter speed. Although pushing film does increase grain and contrast, it can come in handy; however, keep in mind that an entire roll of film must be exposed at the same higher ISO setting.

PUSHING FILM

THERE ARE TIMES when you may want to PUSH a film, or radically increase its speed. This is usually done for shooting in low light conditions, when the speed of the film you're using is too slow to make good pictures. When you push a film, you increase its ISO by setting a speed one or two stops, or fractions of a stop higher, and instruct the lab to develop the film accordingly. Pushing usually means at least a doubling of the film's speed, but you can also push a film by as little as one-third stop. Pushing a film doesn't actually raise its speed; it means deliberately underexposing the film and then later adding more time to the film's development, which intensifies the density of some of the tones recorded on it. With both color- and black-and-white-negative films, the brighter areas develop more than the shadow areas. Although most pushed film has a fairly grainy, contrasty look to it, it is used daily by photojournalists and sports photographers.

Most labs offer push-processing service for color-slide and black-and-white films for a small additional fee. Some color-negative films can also be pushed, but this is more expensive. Be aware that not all color-slide films can be pushed with good results. There are two basic types of slide films: Kodachrome, a Kodak product developed via a process called K-14, and all the rest, which are developed via a process called E-6. All the E-6 films can be pushed one stop with good results and two stops with fairly acceptable results, but with an increase in contrast and grain. Kodachrome films, on the other hand, require a very complicated processing procedure, and pushing may result in some changes in colors. Try to confine pushing to E-6 type slide films.

Although it's always better to shoot a higher-speed film than to push a slower-speed film to a higher speed, pushing can sometimes prevent missed opportunities. Suppose you get a call from a friend who has suddenly received courtside seats at a basketball game. As you gather your camera gear, you realize that you have only ISO 200 slide film. The stores are closed, and the tip-off is just an hour away. When you get to the arena, you take a light reading and find that, even with your lens set at its widest aperture, the fastest shutter speed you can use is ½125 sec.

However, experience tells you that you'll need to shoot at least ½250 sec., or perhaps ½500 sec., to freeze action. Here, you would push the film to ISO 400, or ISO 800 if necessary, to get the extra stops needed for increasing your shutter speed accordingly. After the game, you would have the film push-processed one stop if you set an ISO 400 rating, or two stops for ISO 800. Remember, you should shoot the whole roll at the same rating; because all the film is being developed longer, any shots made at ISO 200 will probably be overexposed.

There are limits to how many stops you can reasonably push film. A one-stop push will give you a slight increase in grain and contrast; a two-stop push will result in even more grain and contrast. Anything beyond two stops is impractical: it will result in a very harsh, grainy image and washed-out highlights. Also, color film will have very poor color, with a definite cast overall.

ISO 400 black-and-white film can also be push-processed to speeds of ISO 800, 1600, and 3200. Again, pushing film is subject to the law of diminishing returns: the higher the push, the lower the overall quality of the final images. A special high-speed black-and-white film made specifically for push-processing produces excellent results up to speeds of ISO 3200, 6400, and even 12,000! Some professional color-print films can be pushed to very high speeds as well.

All in all, high-speed films have created a completely new realm of picture-taking. Long ago, the fastest color film available was ISO 10; now, speeds of 1600 and 3200 are commonly used. What the higher speeds mean is greater shooting freedom, which is not limited to taking pictures in low light, but also offers new possibilities for working with super-high shutter speeds and narrow apertures in broad daylight.

Keep in mind, however, that pushing also encourages you to break the rules. At times, you might want to push to extreme speeds and experiment with the way color and contrast turn out. In fact, some photographers do successful—and profitable—fashion and commercial work by using two- (or more) stop pushes to good effect.

This shot was made during a New Year's celebration in New York City's Chinatown. The film in the camera was an ISO 200 color-slide film, but because of the dark overcast sky and heavy shadows on the narrow streets, the fastest exposure possible was f/3.5 (the maximum aperture of the lens) at $\frac{1}{15}$ sec. In order to get a faster, handholdable shutter speed, the film rating was set on the camera at ISO 800. Then, when the film was processed, the lab was instructed to push it two stops.

In order to capture this action sequence, I had to shift to an even higher film speed. Here, I pushed an ISO 400 slide film to ISO 1600 (a two-stop push); this enabled me to get a handholdable shutter speed of $\frac{1}{125}$ sec. in a dark, shadowed area of the street. Film speeds have increased dramatically over the past few years, but you may still have to push if you have only a slow-speed film with you and the lighting conditions force your hand.

PRACTICE AND PLAY

I HOPE THIS BOOK has shown you that exposure and focusing automation has its limits, both practical and creative. I also hope that, as you shoot, you'll begin to experiment with juggling the numbers—using various shutter speeds, apertures, and exposure compensations—to jot down what you do, and to see how the various combinations affect your final image. Find a colorful subject and bracket exposures; shoot action with fast and slow shutter speeds; under- and overexpose prints and slides; test the practical implications of shifting numbers; waste a few frames; see what you get. One frame of film may open up a new visual world to you. Don't allow anyone to tell you there's only one way to make a picture. Play with flash: use diffusing material over it or vary its output in daylight and indoors to understand what happens when you control the light. Experiment as much as you can. Remember, the words and pictures in this book can only take you so far; you have to take your camera in hand and learn which techniques work for you.

I have attempted to give you a foundation that will allow you to express yourself better through this craft, as well as a basic understanding of what makes photography work so that you can easily master any future camera or automation system. Most of all, I hope that I have communicated to you what you can do with your pictures to make them your own personal "takes." Photography covers many points of view, and the many ways to express them, but there's always something new to explore—most of all, yourself.

Good luck, and good shooting!

GLOSSARY

AMBIENT LIGHT. The light in the scene, as opposed to the light provided by the photographer with electronic flash or photofloods.

ANGLE OF VIEW. A lens's angle of coverage measured in degrees but usually expressed in terms of focal length. The shorter the focal length, the wider the angle of view.

APERTURE. The size of the opening in a lens's adjustable diaphragm. The term "aperture" is used to designate f-stops, such as $f/4$ or $f/5.6$, which are actually arrived at by dividing the focal length of the lens by the diameter of the aperture. Thus, $f/11$ on a 110mm focal-length lens means the opening is 10mm. The wider the opening, the lower the f-number, the more light is let through the lens.

APERTURE PRIORITY. An autoexposure mode in which you select the aperture and the exposure system selects the appropriate shutter speed for a correct exposure. It is sometimes referred to as "AV" or simply "A" on exposure-mode control panels.

ARTIFICIAL LIGHT. Any light not directly produced by the sun: tungsten, flash, household bulbs, sodium vapor street lamps, etc. In many cases, the color produced by artificial light is deficient in the blue end of the spectrum; thus daylight-balanced color films will record light as being warm/red/amber. Using tungsten-balanced slide films or putting color-balancing filters over the lens will generally correct this. With color-print films, such deficiencies can sometimes be rebalanced when prints are made.

AUTOEXPOSURE. A method of exposure in which aperture- and/or shutter-speed settings are determined and set by the camera itself. Various autoexposure modes allow you to customize, or bias, the automation.

AUTOEXPOSURE LOCK. A pushbutton, switch, or lever that locks in exposure values after you have made a reading, regardless of a change in camera position or light conditions; also found in the shutter-release button in nonautofocusing cameras. Releasing the lock button returns the exposure system to normal. This feature is useful for making highlight or shadow readings of select portions of the frame, and

is essential for critical exposure control with automated cameras.

AUTOFOCUS. A method of focusing in which distances are set automatically; in 35mm SLRs, a passive-phase detection system that compares contrast and edge of subjects within the confines of the autofocus brackets in the viewfinder and automatically sets focusing distance on the lens. Autofocusing motors may be in the camera body or the lens itself. Active IR (infrared) autofocusing systems may also be in 35mm SLRs in the form of beams in dedicated autofocus flash units or, in a few models, built into the camera itself. These beams are emitted from the camera or electronic flash unit, bounce off the subject, then return and serve as signals for the camera to set focusing range, a useful feature when light or contrast is too low for passive systems to work.

AUXILIARY LENS. An add-on optical device that alters the focal length of the prime lens for closeup, telephoto, or other special-effects photography.

AUXILIARY LIGHT. An electronic flash, strobe, or tungsten lamp or bulbs used to change the character of light in a scene; any light under the control of the photographer.

AVAILABLE LIGHT. The light that's normal in a scene, although the term is generally used when the light level is low. Available light shooting often involves fast film, low shutter speeds and apertures, and/or the use of a tripod.

AVERAGING. A light-metering system in which the reading is taken from most of the subject; its many values are then averaged to determine an exposure for the scene. This setup works fine in normal lighting conditions.

"B" OR BULB. A shutter setting that indicates that the shutter will remain open for as long as the shutter release is pressed. The term originated with the rubber air-shutter bulbs used to operate shutters in the old days. "B" settings are generally used in nighttime and time/motion photography.

BACKGROUND. The portion of a scene behind the main, foreground subject. You can make the background

sharp or de-focused through the use of different lens apertures and special focus techniques.

BACKLIGHTING. Strong light that comes from behind the subject. Often, a backlit main subject will be underexposed or silhouetted, unless the metering system is set to read selectively off the subject and/or the exposure is compensated for accordingly. See also fill flash.

BATTERY. The power supply of the camera and flash. In many of today's cameras (and all flash units), no power means no pictures.

BLACK AND WHITE. A photographic film or paper used to create monochromatic images. Though we think of black and white mainly in terms of neutral gray shades, prints can have a wide variety of subtle image tones, from blue- to brown-black, which can be further manipulated through chemical toning techniques. Though the overwhelming majority of photography today is in color, black and white has attracted a fiercely loyal and dedicated group of photographers.

BLUR. Unsharpness because of camera or subject movement during exposure. Although images should usually be sharp, blur can be used for many creative effects.

BOUNCE LIGHT. In artificial-light photography, directing the light so it literally bounces off a ceiling, wall, or other surface before it illuminates the subject. This method is often preferred because it softens the overall light and eliminates the harsh, unflattering quality of frontal illumination.

BRACKET. Increasing or decreasing exposures from the indicated exposure (whether manual or AE). This fail-safe method is useful for getting "correct" exposure in difficult lighting conditions. Bracketing can also be used to make subtle changes in the tonal nuance created by small exposure adjustments.

BRIGHTNESS. The luminance of objects. The brightness of any area of the subject depends on how much light falls on it and its actual color and tone. A brightness range is the relationship perceived between the light and dark values in a scene.

BURNT-OUT. Refers to loss of detail in the highlight portion of a scene due to overexposure; also referred to as "washed-out."

C-41. The current developing process for all standard color-negative films.

CABLE RELEASE. In mechanical models, a flexible encased wire attached to a threaded metal coupler that screws into the shutter-release button on the camera. When the plunger on the other end of the wire is depressed, it activates the shutter. Electronic cable releases work with electrical impulses, rather than mechanical plungers. Usually, the two types are incompatible. Using a cable release during long exposures prevents camera shake and permits the remote release of the shutter.

CAMERA. A light-tight box designed to accept light-sensitive film that is used to make photographic images. Today's cameras incorporate microprocessors and sophisticated exposure systems.

CENTER-WEIGHTED. In an exposure system, the metering pattern that bases the exposure primarily on the center portion of the frame. Center-weighted systems also take additional readings from the surrounding area but weight the reading towards the center.

CLOSE DOWN. Jargon that means going from a given f-stop to one that lets in less light; also referred to as "stop down." For example, going from $f/8$ to $f/11$ means that you have closed down the lens by one stop.

CLOSEUP. Any photograph made from a distance that is generally closer than our normal viewing distance. Closeup pictures are often startling in the detail they reveal.

COLD TONE. A print or slide with overall color biased towards blue, although the colors in the image itself aren't necessarily blue. "Cool" or "blue-biased" is also used to describe this cast, or tendency.

COLOR BALANCE. Refers to the kind of light under which a film will render faithful color reproduction without the need for filters. Most films are daylight-balanced, which means that in daylight, or with a

daylight-balanced flash, colors will be more or less representative of those in the original subject. A tungsten-balanced film can be used under incandescent artificial light to give true colors without filters or special printing techniques.

COLOR COUPLER. A substance contained in color-film emulsions that, when exposed to chemical developing baths, forms the color dyes that make up part of the layers of processed color films.

COLOR-NEGATIVE FILM. A film that forms a photographic image in which light tones are rendered dark (and vice versa) and colors are reproduced as their complements; all tones and colors are then reversed again in printing to form a positive print. Color negatives have an orange mask (an aid to printing), so they can be difficult to "read."

COMPOSITION. The arrangement of subject matter, graphic elements, tones, and light in a scene and their relationship to the "frame"; can be harmonious or discordant, depending on the photographer, his or her mood, and the subject. There are no set rules, just suggestions; successful compositions express your particular feelings about the subject.

CONTINUOUS. In motorized-advanced cameras, the mode that allows you to continually release the shutter for a series of pictures without lifting your finger from the release button or advancing film manually. In autofocusing SLRs, the mode in which the camera focuses continually as you track the subject. In continuous AF mode, the camera will fire regardless of whether the subject is or is not in focus. Many AF cameras have both.

CONTRAST. The relationship between the lightest and darkest areas in a picture. A small difference means low contrast, a great difference high contrast. High-contrast scenes usually cause the most exposure problems. Though contrast is often linked with scene brightness, there can be low contrast in a bright scene and high contrast in dim light. Contrast can also describe attributes of color, composition, and inherent qualities of film.

CONVERSION FILTER. A filter that allows daylight film to record color faithfully in artificial light or, conversely,

for tungsten-balanced film in daylight. For example, orange conversion filters are used when exposing tungsten-balanced films in daylight, and bluish filters are used for daylight-balanced films in tungsten light. Conversion filters are most useful with slide films, as color-print-film imbalances can be corrected somewhat when prints are made.

CORRECT EXPOSURE. The combination of aperture and shutter speed that yields a full-toned negative or slide. The constants in an exposure calculation for a particular scene with a certain film in the camera are the speed of the film and the brightness values of the scene; the variables are the aperture and shutter speed.

CROP. To select a portion of the image as your final picture. Cropping is done in the darkroom by the photographer or by an appointed surrogate in a commercial photo lab. By analogy, you also "crop" when composing with a zoom lens by going from a wide-angle to a telephoto focal-length setting.

DAYLIGHT-BALANCED. A film that will reproduce colors faithfully when exposed in daylight. All (electronic) flashes put out daylight-balanced light.

DEDICATED FLASH. An electronic flash that coordinates with the camera's exposure and focusing systems. Dedicated flashes may, among other things, automatically pick up the loaded film's ISO to use in its calculations, set the camera shutter speed to X-sync, and "tell" the camera when it is ready to fire. Flashes dedicated to autofocusing cameras may also vary their angle of flash coverage according to the focal length in use (even with zoom lenses), and contain autofocus aid beams that help the camera focus in very dim light or even total darkness.

DENSITY. In general terms, the measure of the light-blocking power of silver or dye deposits in film. A "dense" negative or slide is more opaque than a "thin" one.

DEPTH OF FIELD. The zone, or range of distances, within a scene that will record on film as sharp. Depth of field is influenced by the focal length of the lens in use, the f-number setting on the lens, and the distance from the camera to the subject. It can be

shallow or deep; either way, it has a profound effect on your pictures.

DEPTH-OF-FIELD PREVIEW. A switch, button, or electronic pushbutton that allows you to preview in the viewfinder the depth of field that an aperture will yield. Having a depth-of-field preview allows you to see an approximation of the zone of sharpness of the actual image.

DEVELOPING. A series of chemical and physical actions that convert film into an image that can be viewed directly or printed.

DIAPHRAGM. A set of blades or plates within the lens that move together to create openings to the film surface. By varying the diameter of the opening of the diaphragm, more or less light enters the camera.

DIFFUSION. The spreading of light in various directions as it passes through a translucent material. Diffusion filters can be added to a lens.

DISTORTION. Any aberrant change of line or form by photographic materials, such as lenses or filters.

DX-CODING. A system of film-cassette coding read by "pins" in the film chamber, which informs the camera's exposure system that a specific speed and exposure-length film is loaded. If your camera has such a setup, you usually needn't worry about setting the film's ISO number when you load.

E-6. The current developing process for the majority of today's color-slide films; the term also refers to films developed by this process.

EV NUMBERS. A system of expressing exposure values that combines apertures and shutter speeds to come up with a number that yields a correct exposure in a certain scene brightness with a certain speed film. For example, EV 15 with ISO 100 film might mean $\frac{1}{1000}$ at $f/5.6$, or $\frac{1}{500}$ at $f/8$, and so forth. EV numbers are also used to express a lightmeter's range of sensitivity to light.

18-PERCENT GRAY CARD. A neutral-gray card used as the standard for reflected (in-camera) light readings. This card reflects about 18 percent of the light striking it,

which is about the average reflectance of a "normal" photographic scene with a distribution of light and dark tones and colors.

ELECTRONIC FLASH. A flash unit that consists of a gas-filled tube fired by an electrical charge. It can be mounted directly on the camera hot shoe (which triggers the flash when the shutter opens) or on a bracket or stand and be connected to the camera via a sync cord.

EMULSION. Sometimes used alternatively with film, but refers specifically to the light-sensitive coating on the acetate film base.

ENLARGEMENT. Making a print from a negative or slide larger than the original, such as an 8×10 or bigger "blowup."

EXPOSURE. The total amount of light that enters the lens and strikes the film. Exposures are described in terms of both aperture, which is the diameter of the opening of the lens, and shutter speed, which is the amount of time a set of curtains or blades behind the lens stays open to allow light to hit the film. Thus, exposure is a combination of the intensity and duration of light.

EXPOSURE-COMPENSATION CONTROL. A camera function that allows you to bias, or shift, exposure in full or partial stops from what the autoexposure system recommends. Can also be used to bracket exposures by partial ($\frac{1}{3}$, $\frac{1}{2}$, or whole) stops. Used in conjunction with an autoexposure system, it makes the subtle manipulation of light easy.

EXPOSURE METERS. Light-reading instruments yielding signals that are translated to f-stops and shutter speeds. Reflected-light meters measure the light reflected off the subject; incident meters measure the light falling upon the subject. All built-in SLR meters are of the reflected-light type.

F-NUMBERS. A series of numbers designating the apertures, or openings, at which a lens can be set. The higher the number, the more narrow the aperture. For example, $f/16$ is more narrow (by one stop) than $f/11$—it lets in half as much light. F-numbers are arrived at by dividing the diameter of the opening

into the focal length of the lens, thus a 10mm diameter opening on a 110mm lens is $f/11$. Alternately used with "f-stops."

FAST. A term used to describe a film with a relatively high light sensitivity, a lens with a relatively wide maximum aperture, or a shutter speed, such as $1/1000$, that will freeze quick action.

FILL FLASH. Flash used outdoors, generally to balance a subject that is backlit. It can also be used to reduce excessive contrast by lightening shadows or to brighten colors on an overcast day.

FILM. A layered sandwich composed of light-sensitive silver-salts, color couplers (in color film), and other materials suspended in an emulsion coated on an acetate base.

FLARE. In lenses, internal reflections and/or stray light that causes fogging or light streaks on film. In general, zoom lenses have more potential for flare than fixed-focal-length lenses; in either case a screw-on lens hood helps reduce the problem.

FLAT. Low in contrast, usually caused by underexposure or underdevelopment of film. Also, a subject with low contrast.

FOCAL LENGTH. The distance from the lens to the film plane when the lens is focused at infinity. The length, expressed in millimeters, indicates the angle of view of a particular lens. A shorter focal-length lens, such as a 28mm, offers a wider angle of view than a longer one, such as a 100mm.

FOCUS. Making light form a sharp image on film.

FOCUS LOCK. In autofocus-camera systems, a button, lever, or pushbutton control that allows you to lock focus at a particular setting, often used when your main subject is off to the side of the frame or not covered by the autofocus brackets in the viewfinder.

GRAIN. The appearance of the film's silver crystals in the final negative or positive image. In color film, grain is actually the "memory" of the silver crystals, preserved in clouds of dye. The larger the surface area of the silver crystals in the film emulsion, the more sensitive the film is to light; the more sensitive it is to light, the "faster" it is.

GRAY SCALE. The range of tones, from pure white to pitch black, that can be reproduced in black-and-white photography.

GROUNDGLASS. A specially prepared light-scattering glass used as the foundation of the focusing screen in the eye-level finder in 35mm SLRs.

GUIDE NUMBER. A number relating to the output of electronic flash when used with a given film speed.

HIGH CONTRAST. A scene where the range between the brightest and darkest areas is extreme or is such that it may cause exposure problems; any lighting condition where both dark and very bright tones are present.

HIGH KEY. A picture with very few dark tones or one that is overexposed to give a washed-out, or ethereal look; often used in fashion and portrait photography.

HIGHLIGHTS. The brightest parts of a scene. It is best to expose slide film for the highlights in order to preserve detail in those areas. Overexposure of bright areas can give a burnt-up look to slides.

HOT. Very intense colors; also, highly reflective surfaces that can cause exposure problems on film; any overexposed highlights.

HOT SHOE. The mount on the camera body for an electronic flash unit. Hot shoes usually contain electrical contacts that signal the flash to discharge when the shutter is fired. Some also serve as the conduit for exchange of information between camera and flash on exposure, focus, and film.

HYPERFOCAL DISTANCE. The nearest point of a scene which is in focus when the lens is focused at infinity. This distance changes according to the focal length of the lens and the aperture at which it is set. Knowing this distance is one way to maximize depth of field with any focal-length/aperture combination.

ISO. A prefix on film-speed ratings that stands for International Standards Organization, the group that

standardizes the figures that define the relative speed of films.

IMAGE. The representation of a three-dimensional subject in a two-dimensional medium; a picture; the light creating that image, as in "image path."

INCIDENT LIGHT. The light that falls on a subject, rather than that which is reflected off it. Many handheld meters are of the incident-light-reading type; all in-camera SLR meters are of the reflected reading type.

INFINITY. On the lens's distance scale, the distance greater than the last finite number, and beyond.

KODACHROME. The one and only type of film brand that is developed in the K-14 process; noted for its fine grain and sharpness.

LATENT IMAGE. The invisible image formed when the silver-halide compounds in film are struck by light. Upon development, this image, or series of light and dark tones, is made manifest.

LATITUDE. In exposure, the amount of under- or over-exposure a film can receive and still yield acceptable tones. Slide films have less exposure latitude than color-print and black-and-white films, and thus will lose details with less deviation from the correct exposure than will negative films.

LENS. A combination of shaped glasses and air spaces set in a specific arrangement within a barrel. Within the lens is a diaphragm that can be opened and closed to allow in specific amounts of light. This is controlled manually by a ring on the outside of the lens barrel, or electronically via pins in the coupling ring that mounts the lens to the camera. Lenses have two primary functions: one is to focus light onto film. The other is to control the amount of light hitting the film, which is done by changing the lens's aperture. Autofocusing lenses may contain small motors for racking the lens back and forth in focusing.

LENS COATING. A thin layer of transparent material applied to glass surfaces in a lens to control light reflections, reduce flare, and increase image contrast.

LOW KEY. A scene with no bright tones or highlights.

MACRO. Another word for closeup photography, but it specifically refers to taking pictures at or near life-size. A 1:2 macro shot means that the subject is rendered on film at half life-size.

MANUAL. Any exposure mode in which you make the settings or perform the function yourself.

MAXIMUM APERTURE. The widest opening, or f-stop, a lens affords. An $f/1.4$ lens is referred to as "fast" because it has a relatively wide maximum aperture; an $f/4.5$ lens is "slow" because of its relatively narrow maximum aperture. Fast lenses work well in low light.

MINIMUM APERTURE. The smallest opening a lens affords. Generally, wide-angle lenses have a minimum aperture of $f/22$; normal lenses of $f/16$; and telephotos perhaps of $f/32$.

MIRROR LENS. A lens in which light is bent and reflected internally to increase the lens's focal length.

MODE. A camera setting with a specific function. Exposure modes are user-selectable ways of making and/or biasing the readings from the exposure system, such as aperture-priority mode, shutter-priority mode, and program-depth mode. Autofocusing modes allow you to choose how the camera goes about autofocusing.

MOUNT. In lenses, a specific set of pins that couple a particular lens to a particular camera body. The proper mount guarantees that the lens will fit snugly and that the interchange of essential information about exposure and focus will go from camera to lens.

NEGATIVE. With color-print and black-and-white film, the storage place of the picture information. When printed, the negative reproduces a positive image of the colors and/or tones that appeared in the original scene.

OVEREXPOSURE. Too much light hitting the film for its specific sensitivity. Minor overexposure may cause a loss of details or texture in the scene highlights; severe overexposure will cause a serious deterioration of picture quality in color-print and black-and-white film.

GLOSSARY

OVERRIDES. Making adjustments or intervening in the camera's autoexposure system. Some important overrides include exposure compensation and changing the ISO ratings.

PANNING. A shooting technique where you follow the subject and shoot as it moves past.

PERSPECTIVE. The perception of the relative scale of objects when a three-dimensional scene is recorded on a two-dimensional plane, such as film.

PHOTOFINISHING. Generally, mass-production that involves processing and printing film, although custom labs and mini-labs also do photofinishing.

POLARIZING FILTER. A filter that transmits light waves vibrating in one direction. Used to deepen blue skies with color film and to eliminate or reduce unwanted reflections; also called a polarizer.

POSITIVE. Another word for slide, as is "transparency"; also, a print made from a negative.

PROGRAM-EXPOSURE MODES. A preset arrangement of aperture and/or shutter speed that is programmed into the exposure system of a camera to respond to a certain level of brightness in a scene when the camera is loaded with a certain speed of film.

PUSHING, PUSH-PROCESSING. An exposure/processing technique in which you set a film speed higher than the normal speed of the film when you shoot, then extend developing time in order to "push" or make up for the loss of density in exposure. Pushing raises the contrast and increases grain, but it can be used effectively for creative and corrective shooting under dim lighting conditions.

REFLECTED LIGHT METER. A meter that measures light reflected from the subject; in all SLRs.

REFLEX-VIEWING SYSTEM. A system of mirrors in an SLR that makes the scene appear right-reading in the camera's eye-level viewfinder and simply relays the lens image to the viewfinder.

SATURATION. A measure of the intensity of colors produced in photographic film. Some films have more inherent color saturation than others. Saturation can also be increased by slightly underexposing certain slide films.

SELECTIVE FOCUS. Focusing on one part of the subject in the frame. Selective focus is achieved through the use of various focal-length lenses, by altering camera-to-subject distance, and by changing f-stop settings.

SHARPNESS. The perception that a picture, or parts of a picture, are in focus; also, the rendition of edges or tonal borders.

SHUTTER. A set of curtains or blades that travels past the film gate, allowing light to strike the film within a set period of time.

SHUTTER PRIORITY. An autoexposure mode where you select the shutter speed and the exposure system chooses an appropriate aperture for correct exposure.

SHUTTER-RELEASE BUTTON. The button that activates the shutter and "fires" the camera. Many shutter-release buttons have two stages; slight pressure actuates the meter or autofocus system (or both), further pressure fires the shutter.

SILVER HALIDE. A silver compound whose crystals are the light-sensitive element in film.

SINGLE. In autofocus SLRs, the mode in which the camera will not allow the shutter to be released until the system has focused on a subject. In motorized-advance cameras, the mode in which the shutter is released once each time the shutter button is pressed.

SLIDE. A positive image on a transparent film base; used for projection viewing or printing.

SLOW. A term used to describe a film with a relatively low sensitivity to light, a lens with a fairly narrow maximum aperture, or a shutter speed at or below $\frac{1}{30}$.

SOFT FOCUS. A picture, or an area in a picture, that is left slightly out of focus for effect, or a lens or filter that diffuses light and "softens" the overall scene.

SPECIAL EFFECTS. Any technique, lens, filter, accessory, or use of film that converts or distorts the "reality" of

nature in a picture. Special effects can be sublime or ridiculous, depending on how they're used. If the photographer has too heavy a hand, the technique overwhelms the picture.

SPEED. With a shutter, the duration of time in which light strikes the film; with film, the sensitivity to light; with a lens, the maximum aperture. All can be described as either fast, medium, or slow speed.

SPOT METERING. Taking an exposure reading from a very small portion of the frame. Cameras with built-in spot metering indicate this portion with a circular ring in the viewfinder screen. Some spot meters have coverage as broad as eight degrees (this might also be called selective field metering) or, with a handheld spotmeter, as narrow as one degree.

STOP. A measure of light used in the exposure system to designate an aperture setting. To stop down means to narrow the aperture; to open up means to expand it. A stop can also be defined as the difference between shutter speeds, such as from 1/500 to 1/250 sec.

SYNCHRONIZATION, OR SYNC. The timing of the firing of the flash to coincide with the opening of the shutter so that the full image records on the film. X-synchronization is the setting used with SLRs and electronic flash.

TTL. Through-the-lens metering.

TELEPHOTO. A generic name for a lens with a focal length of more than 50mm and an angle of view less than 45 degrees. A moderate telephoto might be in the 80mm class, a medium telephoto in the 135mm grouping, while a long-range, or super telephoto might have a 300mm or higher focal length.

THYRISTOR. A circuit in automatic flash units that cuts light off when enough has been reflected back and stores whatever power is remaining.

TIME EXPOSURE. A long exposure, usually not hand-held, for recording scenes at night or in very dim room light.

TRIPOD. A three-legged device with a platform or head for attaching the camera; used to steady the camera during exposure. It is most useful for exposures longer than 1/30 sec. or when a very definite framing must be maintained throughout a series of shots.

TUNGSTEN-BALANCED. Film that is balanced to reproduce colors faithfully when exposed under artificial tungsten light sources.

UV FILTER. A clear, colorless filter that stops most ultraviolet rays from recording on film and is often used to protect the lens. It is handy for shooting distant landscape shots, as it helps eliminate the bluish haze that might otherwise veil the picture.

UNDEREXPOSURE. Failure to expose correctly because too little light has struck the film. Underexposed pictures are dark; the more the underexposure, the darker and less detailed they become. Color also suffers when film is underexposed.

VIEWFINDER. The viewing screen in an SLR on which you compose the picture; viewfinders also contain various guides to exposure, focus, and flash-readiness.

WARM TONE. The look or mood of a print or slide that tends toward amber, or yellow/red. In black and white, a brown- or sepia-toned print, or a brown-black printing paper.

WASHED-OUT. Seriously overexposed slides, or overexposed highlight areas within slides and prints. The appearance of colors diluted to the extent that all pigments have been "washed-out."

WIDE-ANGLE LENS. A lens that offers a wide angle of view, usually 35mm or shorter. Ultrawide-angle lenses range from 20mm to 8mm.

ZONE FOCUSING. A way to focus that utilizes the depth-of-field scale rather than the actual distance from camera to subject. Zone focusing is most useful for candid street photography.

ZOOM LENS. A lens that allows you to vary the focal length and thus the angle of view. Zooms come in various focal-length ranges, such as 35–105mm; all focal lengths included within this zoom range can be utilized.

INDEX